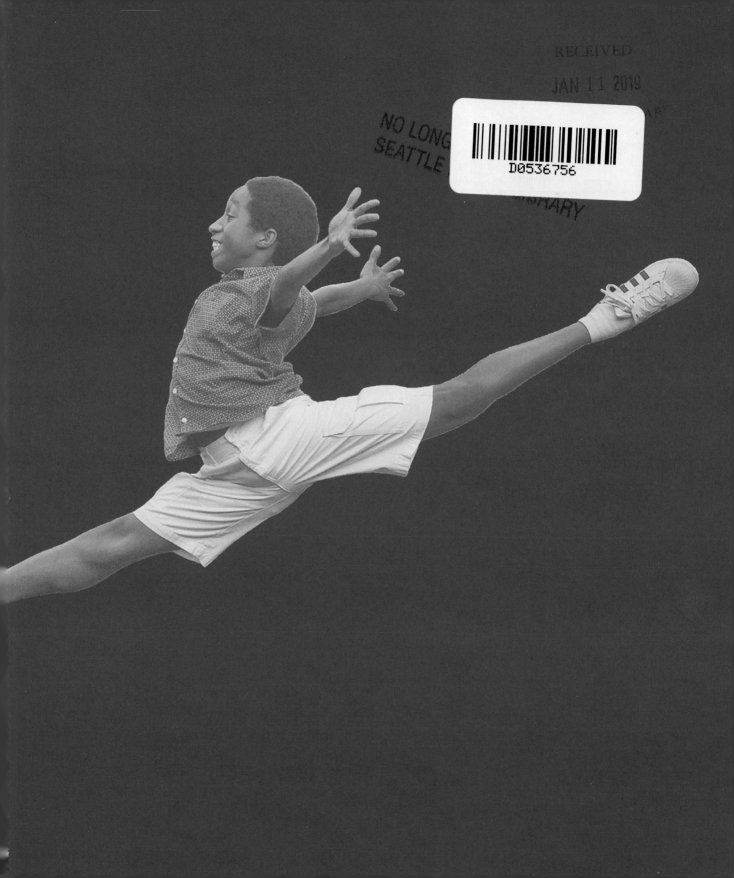

RECEIVED

JAN 11 2019

NO LONG
SEATTLE

D0536756

NO LONGER PROPERTY OF
SEATTLE PUBLIC LIBRARY

born to dance

Brave, Kate,
Olivia, Billie, Daisy,
Ayshia-Mila, Kaiya
AGES 9 TO 15
MELBOURNE, AUSTRALIA

born to dance

Celebrating the Wonder of Childhood

jordan matter

Workman Publishing • New York

Check out the video!

You'll see this QR code on several photos. Use the camera on your phone—or a downloadable QR reader app—to scan the code. It instantly takes you to one of Jordan's viral videos on YouTube. You'll see when and how the photo was taken and what it's like to work with Jordan Matter at his most energetic!

Copyright © 2018 by Jordan Matter Photography, LLC

All rights reserved. No portion of this book may be reproduced—mechanically, electronically, or by any other means, including photocopying—without written permission of the publisher. Published simultaneously in Canada by Thomas Allen & Son Limited.

Library of Congress Cataloging-in-Publication Data is available.
ISBN 978-0-7611-8934-3 (PB)
ISBN 978-1-5235-0549-4 (HC)

Cover and interior design by Galen Smith
All photos by Jordan Matter

Workman books are available at special discounts when purchased in bulk for premiums and sales promotions as well as for fund-raising or educational use. Special editions or book excerpts can also be created to specification. For details, contact the Special Sales Director at the address below, or send an email to specialmarkets@workman.com.

Workman Publishing Co., Inc.
225 Varick Street
New York, NY 10014-4381

workman.com

WORKMAN is a registered trademark of Workman Publishing Co., Inc.

Printed in China
First printing August 2018

10 9 8 7 6 5 4 3 2 1

The circumstances depicted in these photographs are not digitally altered or composited, and no hidden wires or other devices have been used in the making of these images.

FRONT COVER Salish AGE 4 Ashley AGE 12 **NYACK, NY**

···

Years ago, I was working as a waiter in New York City when I had this brief exchange with my wife:

"I think I want to take a photography course."

"You should do it. You never know. You might like it."

"It's really expensive."

"We can always eat less."

Behind every great woman there is a man who married up. I am that man. Nothing I've achieved in my life would have been possible without the support and encouragement of my wife, Lauren. Thank you, my love.

Hudson and Salish, I traveled a lot to make this book, and missed many bedtimes. Thank you for your understanding. You inspire me every day to be the best version of myself. I love you.

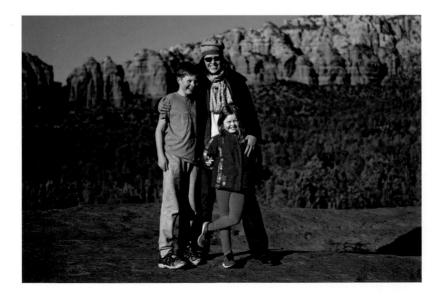

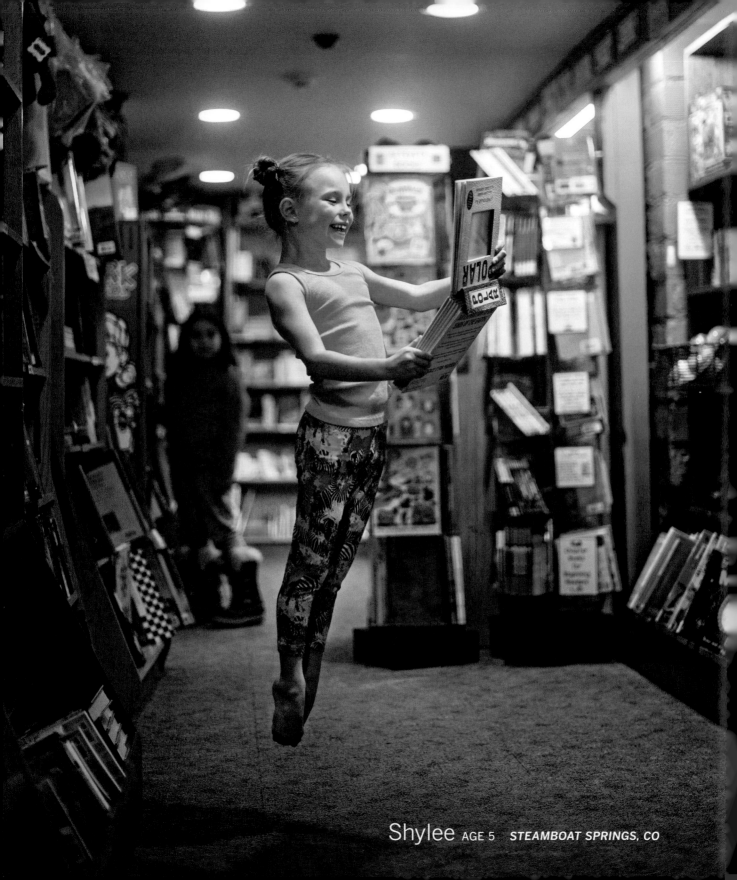

Shylee AGE 5 *STEAMBOAT SPRINGS, CO*

contents

foreword

by Holly Hatcher-Frazier and Nia Sioux

Some of you may know my daughter, Nia Sioux, from the hit television show *Dance Moms*. Nia learned a lot from her time on television. She had fun, honed her dance skills, experienced heartbreak, and really grew up there. The life lessons that we hold most dear have come from dance. Dance is storytelling and language; it is a means of expressing emotions both powerful and beautiful. Dance requires you to build your problem-solving and critical thinking skills. Dance is multicultural. It transcends boundaries; it creates and connects friends.

Dance allows you to discover and convey your unique sense of self. Dance invites you to take risks; it challenges you to overcome your own perceived limits, and in so doing fosters confidence and courage.

These lessons encompass so much of what Jordan achieves in his photographs. Whether it is a video of his 10 Minute Photo Challenge or having a dancer do the same jump for the tenth time, Jordan believes in the story each dancer has to tell—and he translates it into photography with exquisite beauty and emotion. He captures a visual representation of the commitment, dedication, and love of dance. Working with him has been a joy—as is viewing these exceptional photographs.

—Holly Hatcher-Frazier

From the moment I first read Jordan's book *Dancers Among Us* I wanted to work with him. I loved the book because it showed dancers of all ages, races, and abilities—all of them different and beautiful in their own way. It inspired me, gave me joy, and made me laugh.

My goal is to make people feel something through dance. Being on *Dance Moms* gave me a vehicle to do this. Growing up is hard, regardless of your background, age, or whether you are on television or not. It's just hard. It was important for me to show girls that you can be whatever you want to be and that

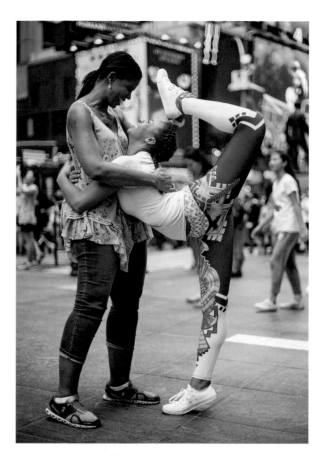

you are beautiful just the way you are. If kids do not have examples of independence and beauty, it can be hard for them to envision it. I want them to know that it's a good thing to be uniquely you.

Dance Moms also inspired me to develop a weekly series on my social media called "Role Model Mondays" where I share stories of ordinary people doing extraordinary things.

I love showcasing these stories because it reminds us that people can follow their passions while making a difference and impacting the world.

It has been a privilege and honor to work with Jordan. He captures what I value most in dance—beauty, risk-taking, storytelling, and diversity. He sees and affirms the individuality in each dancer, and he makes it his mission to have his photographs reflect the beauty of each dancer's movements and strengths. I love that this book shows the beauty in the development of dancers. It takes years of preparation, hard work, and diligence to become a dancer, but it

also takes a spirit of fun mixed with adventure. I am excited for you to see these young dancers through Jordan's lens. I know his work will inspire you as it continues to inspire me as a dancer, an artist, and a person.

—Nia Sioux

introduction

I pulled my daughter away from a warm fire and hot chocolate to help me shovel snow off the sidewalk. She sagged her shoulders and gave me a look, then noticed her brother was almost out the door and rushed to beat him. She had settled in to the task when I glanced over and saw a dress peeking out from under her jacket. It was irresistibly cute, so I quickly grabbed my camera. She looked right at me and hit an awkward arabesque. With that action, she had taken a mundane task and imbued it with beauty, humor, and passion. *Born to Dance* was conceived!

One way or another, each kid in this book told me they were born to dance. They spend almost every waking moment dancing, even (and especially) when they're not on stage. A trip to the grocery store is not complete without a pirouette or grande jeté, and good luck getting through dinner without a chassé. They don't choose to dance. Dance has chosen them.

There are challenges. They can be bullied and ostracized. There is sweat, pain, exhaustion, and disappointment, but their lives are filled with triumph. Not always the kind they imagine. Prizes and medals aren't always awarded. It is a triumph of courage. While they probably don't realize it, they have found the piece that makes them whole, and they do not allow peer pressure or self-doubt to discourage them—at least not for long.

The children in this book are, like all kids, exceptional. *Born to Dance* celebrates the limitless possibilities of childhood, and the authenticity with which kids live every moment.

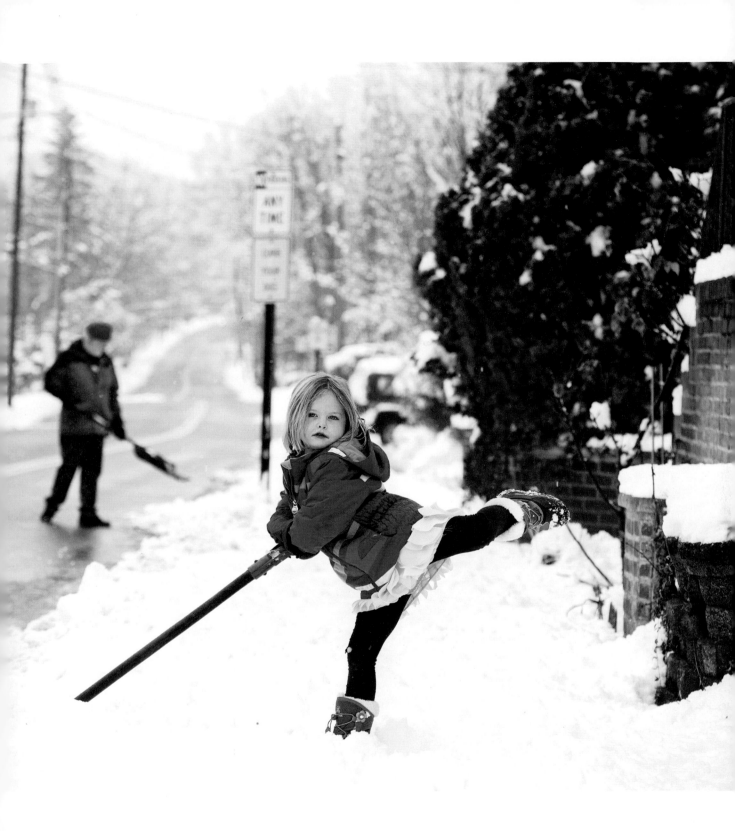

Salish
AGE 7,
PALISADES, NY

"play with me"

I am as boisterous and loud as my wife is calm and content. She is the exception in our family; both our kids seem to have inherited my penchant for overexcitement. When I get home after a day at my studio, the ensuing mayhem can be enough to drive even a sober person to the nearest cocktail lounge. One day I arrived with my daughter's favorite treat— a tin box of spearmint Altoids. I held them just out of her reach. The squealing began immediately, followed by laughing, shrieking, and chasing around the house. She had to have those mints! My wife, exhausted from a very long day, quietly asked me if our game had to be quite so intense. "Honey," I said, "she cares about

mints. Mints! How much longer will this last?" This resonated with her too, and she stopped what she was doing to play along with us.

Am I nostalgic, or have these moments become less common recently? When did play become such hard work? A "play date" increasingly seems to be an opportunity for kids to sit next to each other while they zone out on their devices. If someone suggests they go outside and play, the befuddled look on their faces would be hysterical if it wasn't so tragic. Of course, parents are not immune to this curse either. My kids will say without hesitation that my top priorities are 1) my phone, and 2) my computer (they constantly argue about which one of them is third).

Yet all of us need to play about as much as we need to eat and drink. It is essential to our emotional health. So go, one and all, to a magical place away from Wi-Fi signals and power cords, and do the unthinkable . . . play! I'll be right behind you.

...

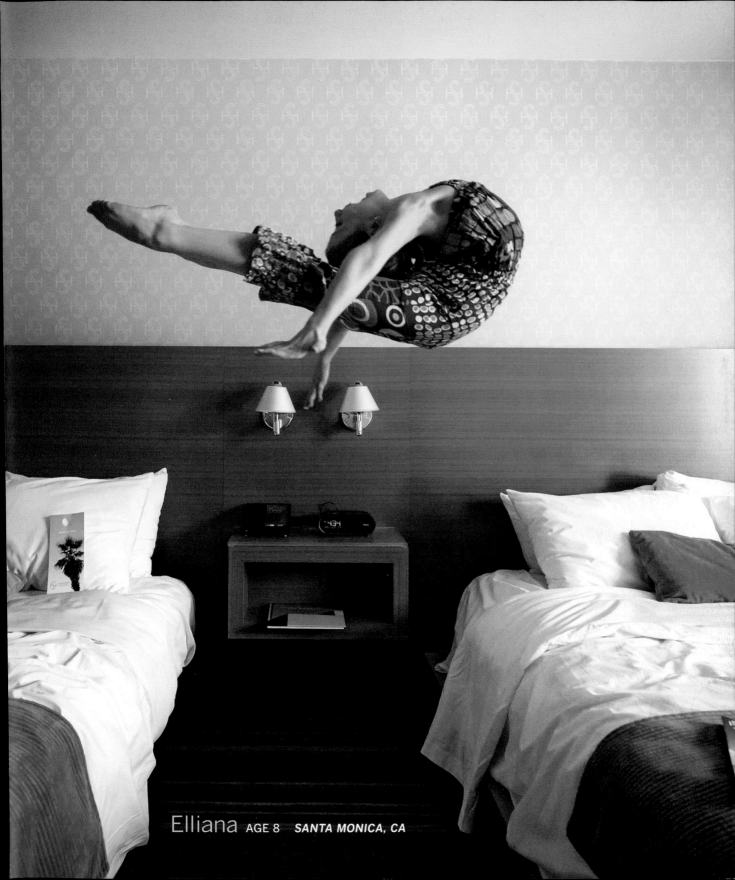

Elliana AGE 8 SANTA MONICA, CA

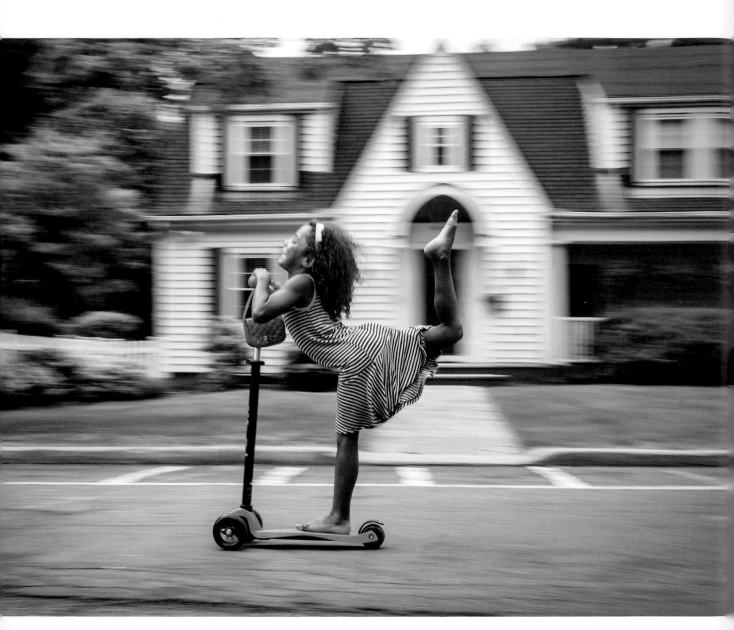

Lirit AGE 8 *NYACK, NY*

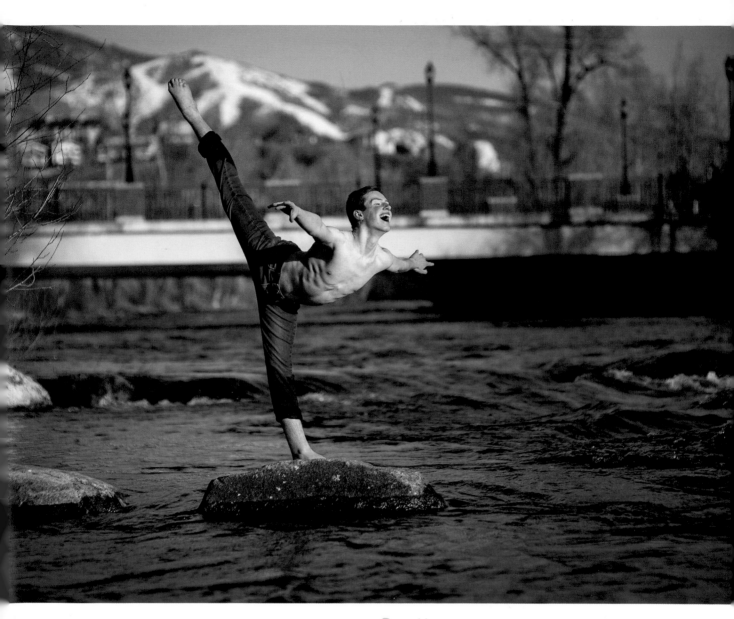

Scott AGE 14 *STEAMBOAT SPRINGS, CO*

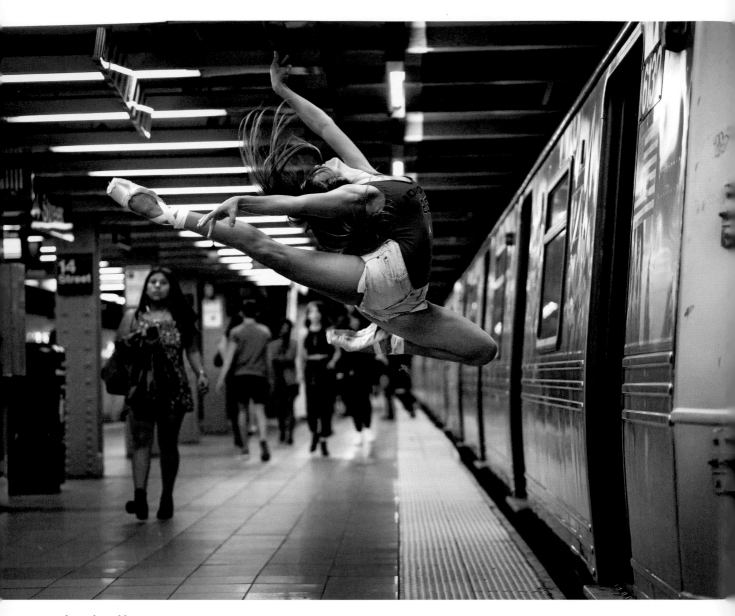

Isabella AGE 17 *NEW YORK, NY*

Check out the video!

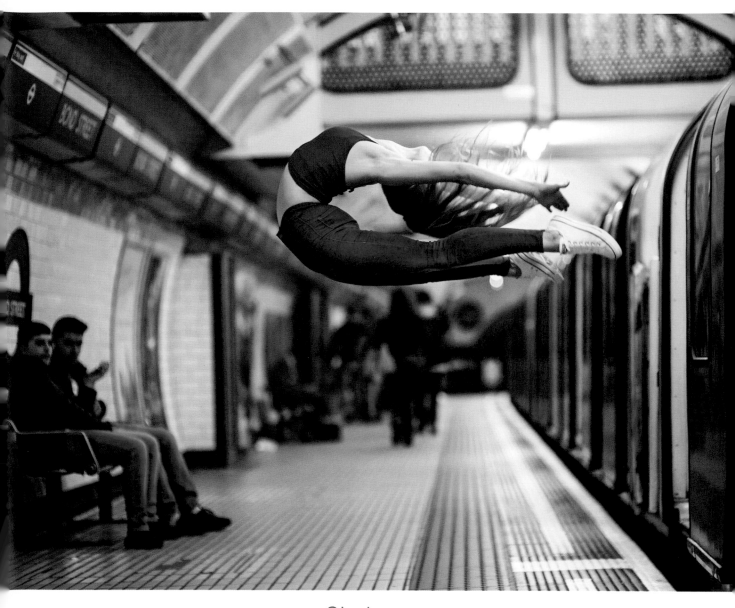

Clarice AGE 15 *LONDON, ENGLAND*

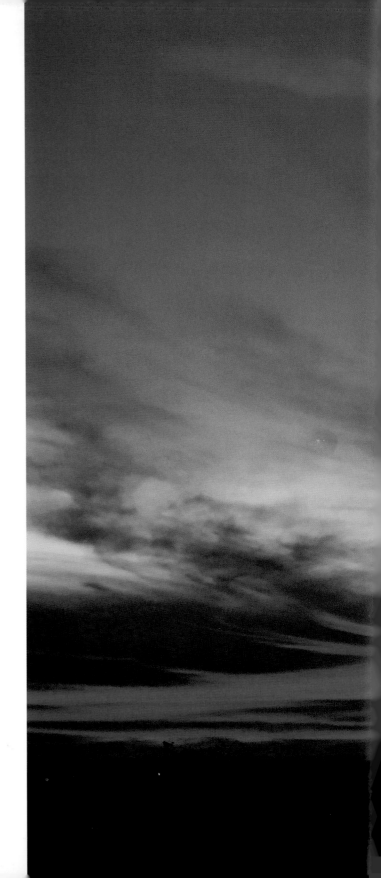

"If you don't like what you see in front of you, turn around. You might find a beautiful sunset."

..

Avaree AGE 10 *CULVER CITY, CA*

Check out the video!

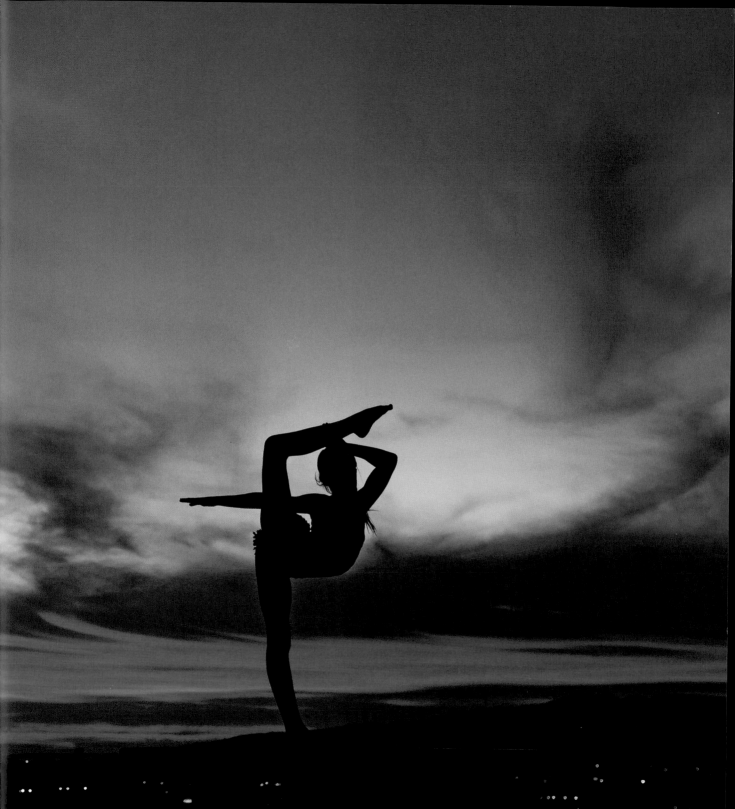

"When I was eight, playing was a way of life. Now it's a treat."

...

Kalin AGE 13 *MIAMI, FL*

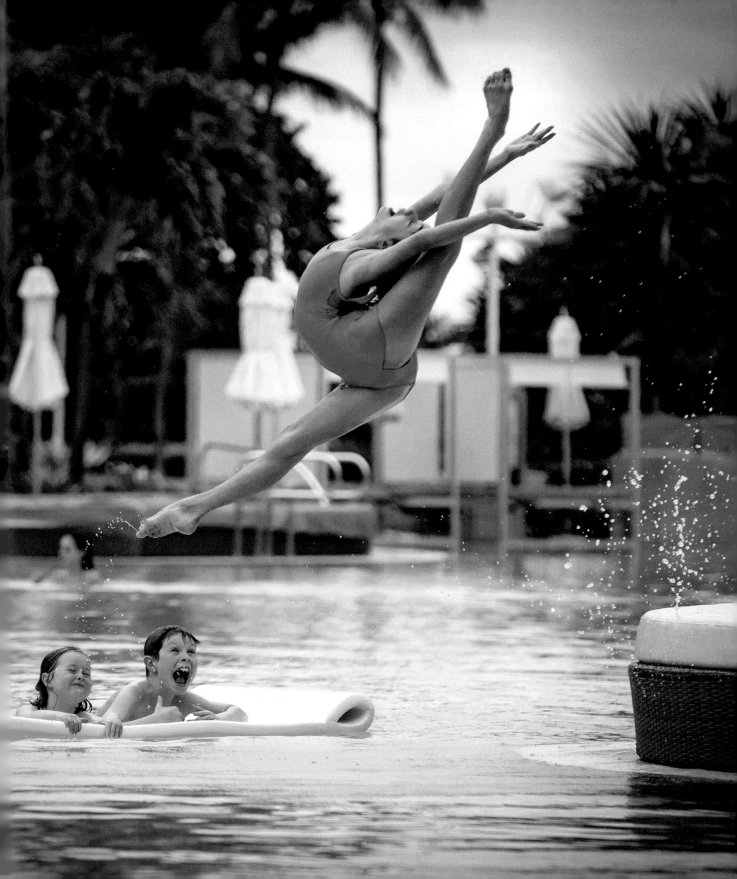

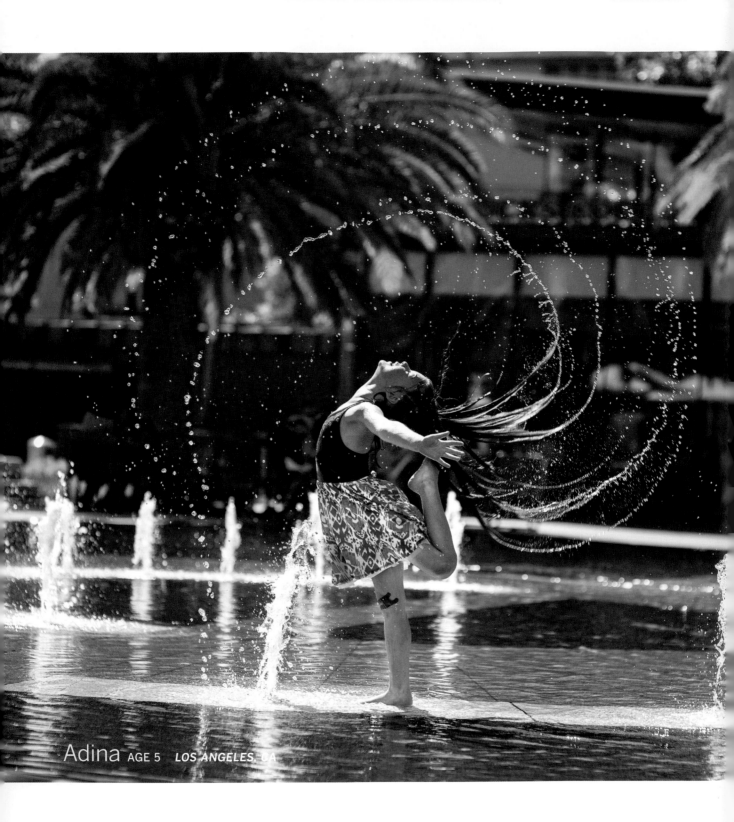

Adina AGE 5 *LOS ANGELES, CA*

Check out the video!

"Dare to do things differently."

...

Sofie AGE 16 *LOS ANGELES, CA*

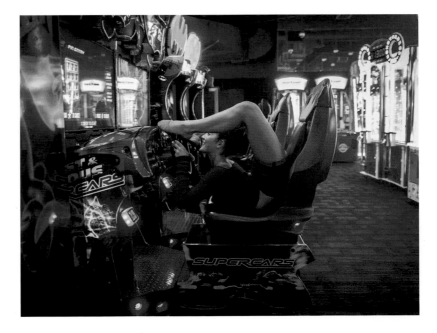

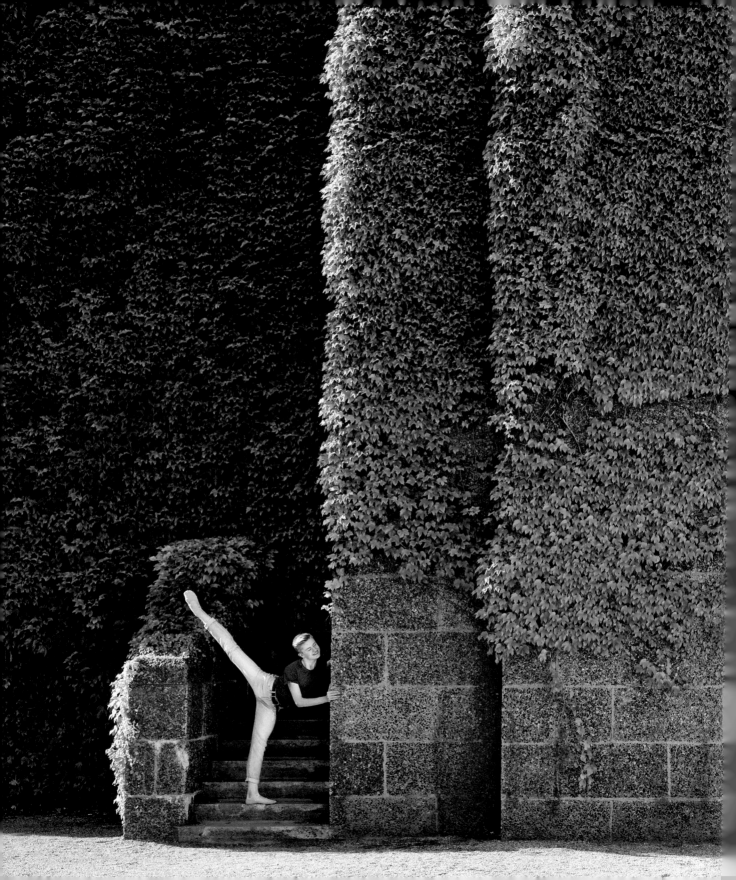

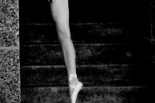

Scott AGE 14 ❉ Mary AGE 13 ❉ *LONDON, ENGLAND*

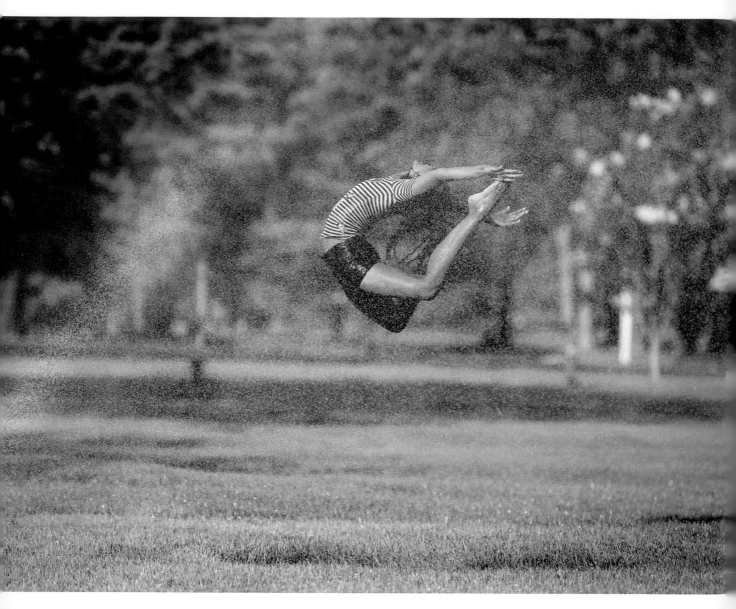

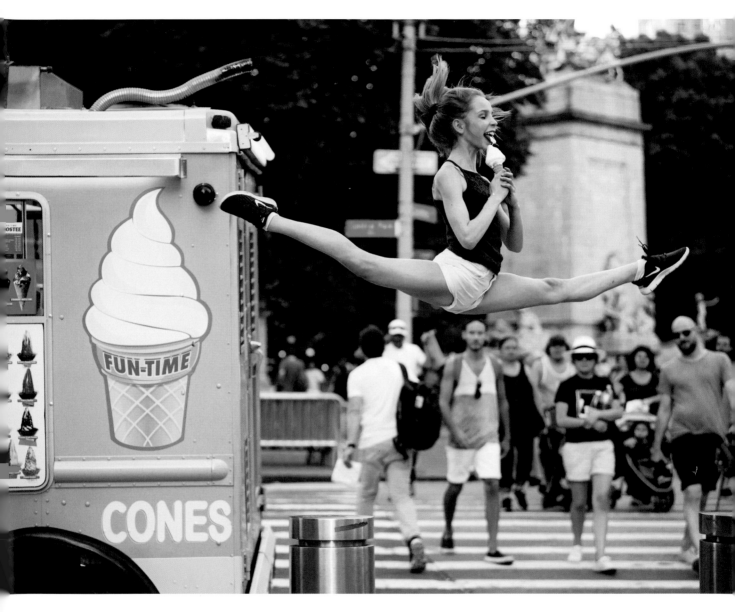

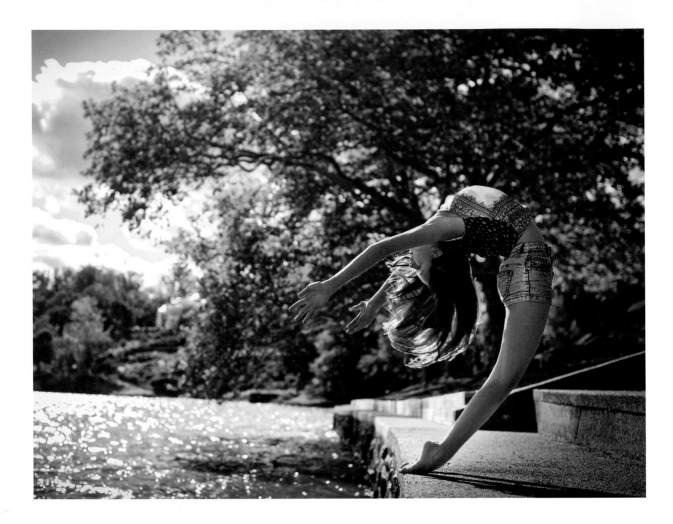

"Reaching for perfection can rule your life if you let it. Sometimes I let it, and sometimes I fight it."

Hailey AGE 14 *NYACK, NY*

Le Petite Cirque
AGES 10 TO 16 *SANTA MONICA, CA*

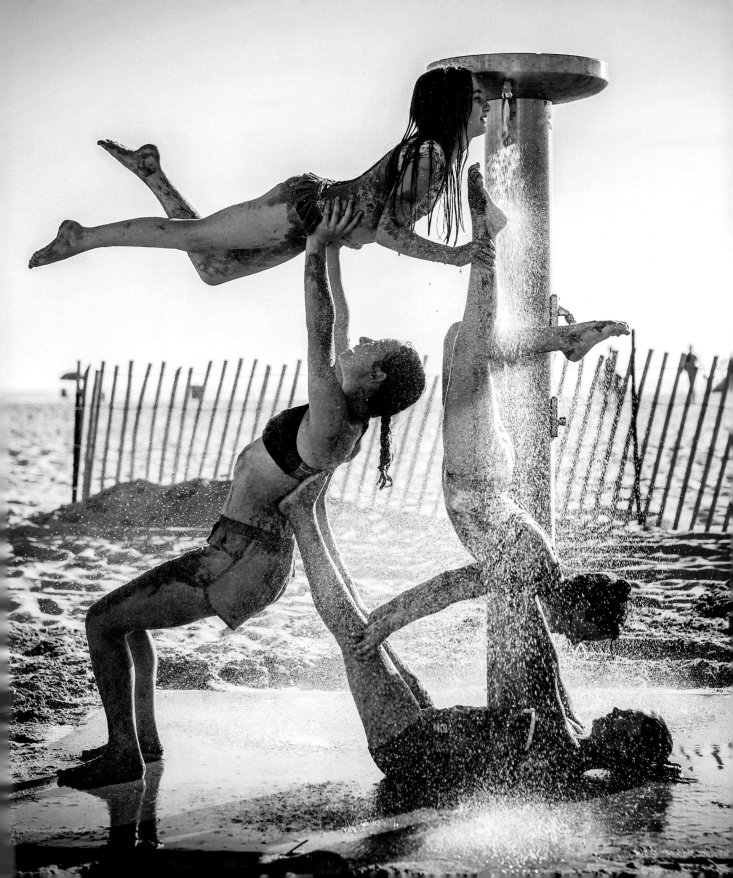

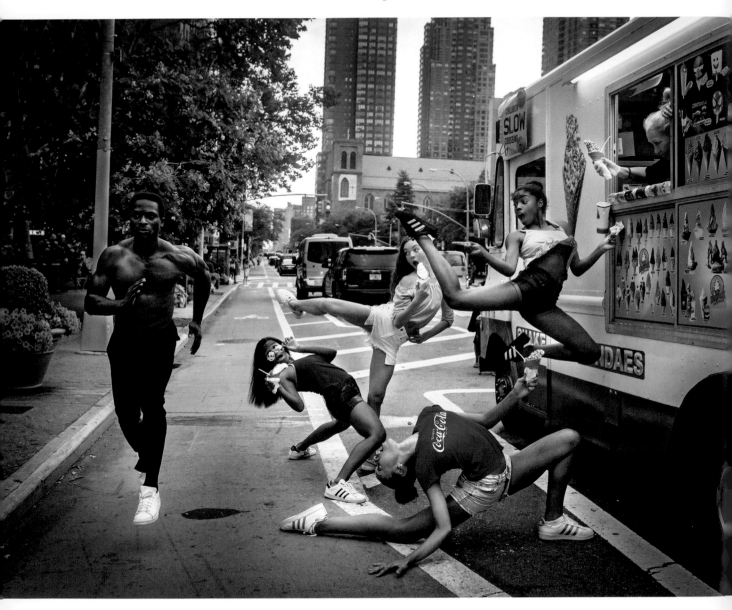

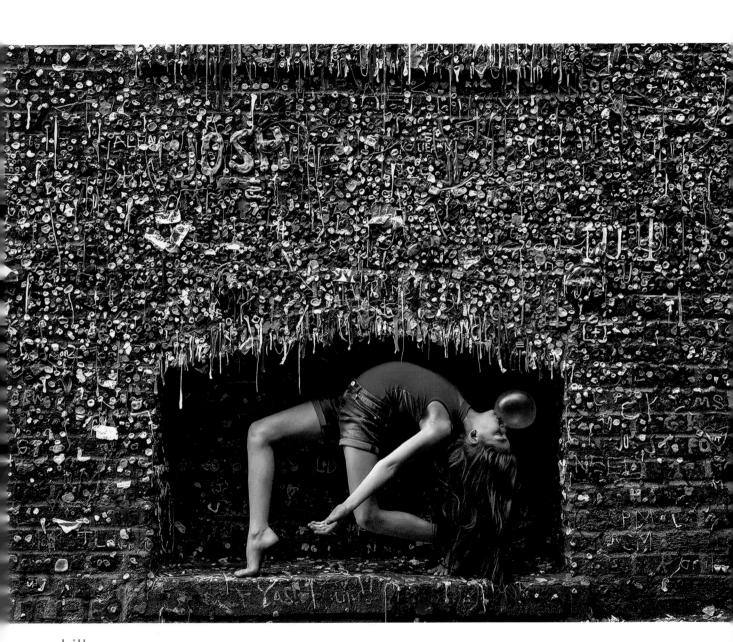

Lilly AGE 12 *GUM WALL, SEATTLE, WA*

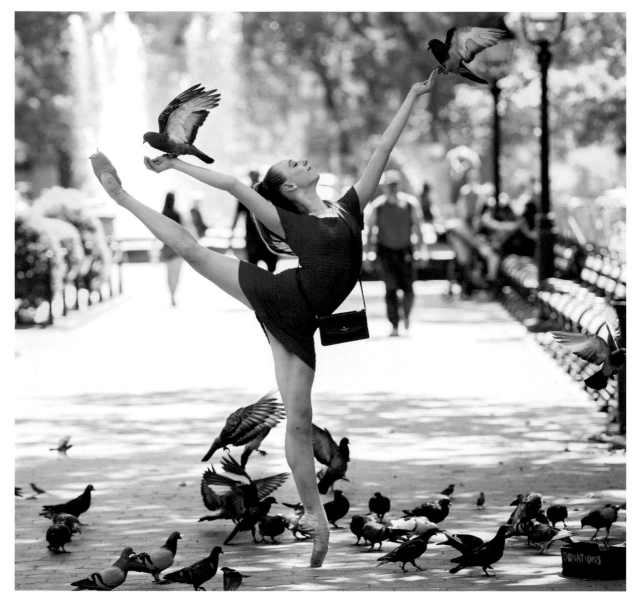

"**Freedom is always and exclusively freedom for the one who thinks differently.**"

Rosa Luxemburg

Anna AGE 15 JT AGE 12 *NEW YORK, NY*

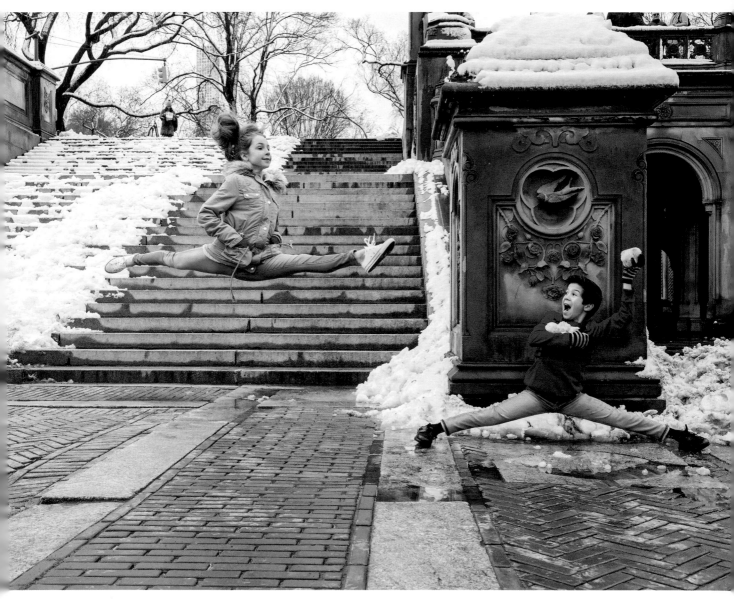

Check out the video!

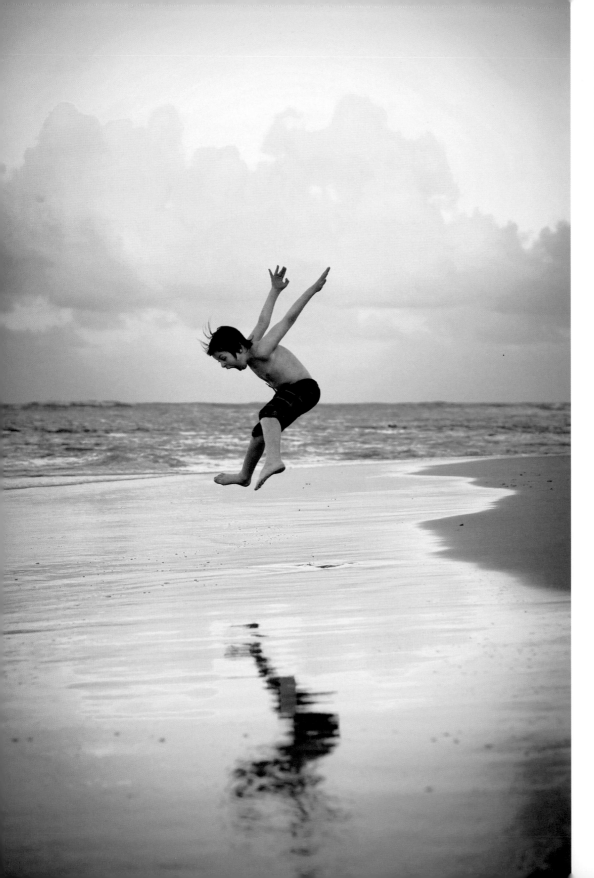

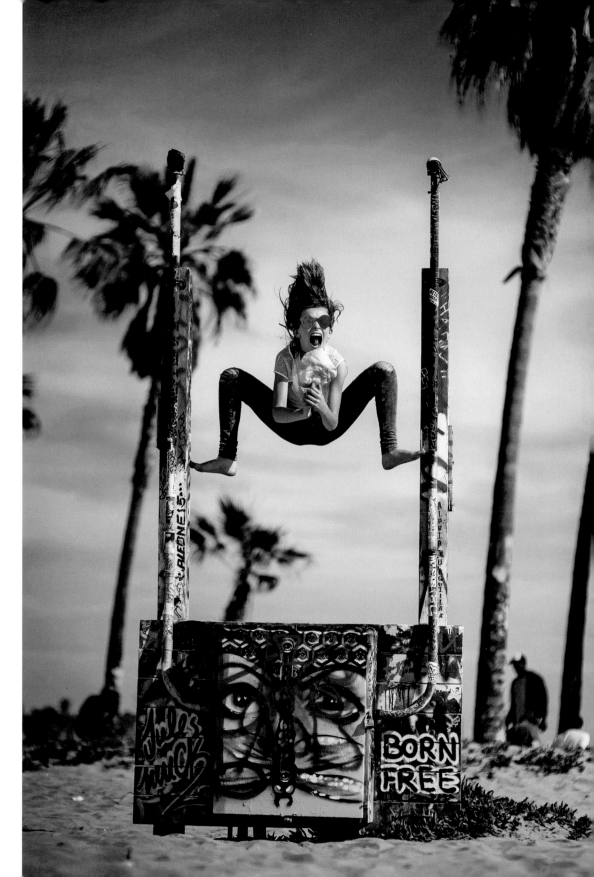

Taylor
AGE 13
VENICE, CA

"My motto is, 'Be fearlessly authentic.'
It's easy to want to change so that
others accept you, but the right people
will like you just the way you are."

...

Diana AGE 12

Check out the video!

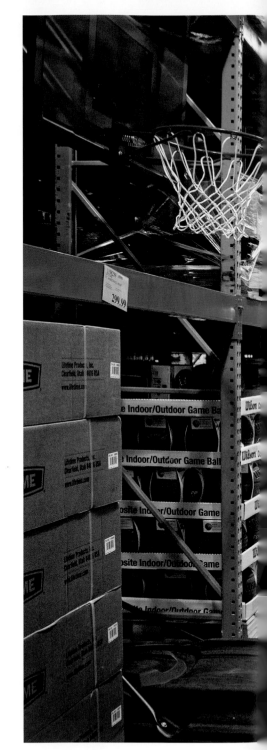

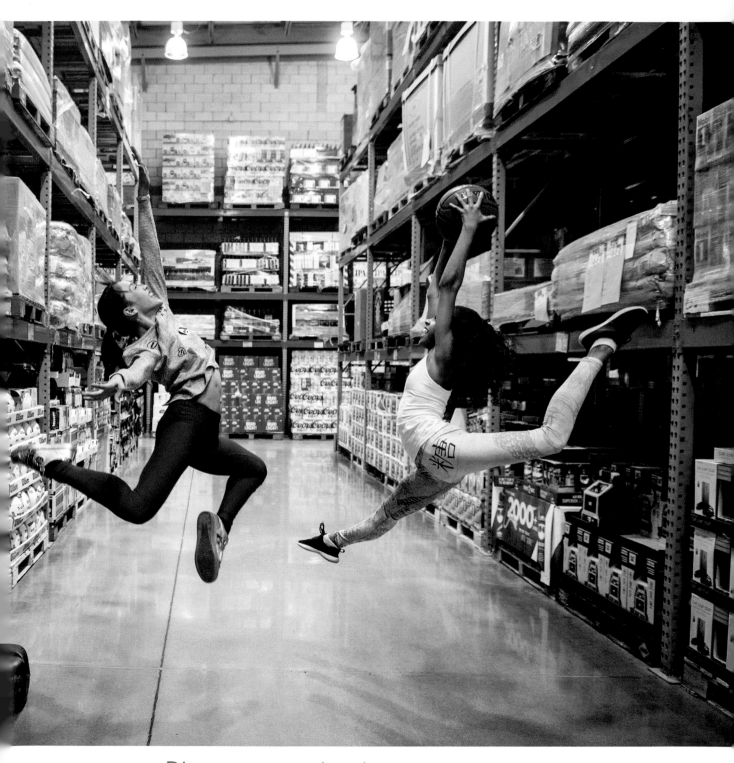

Diana AGE 12 Janai AGE 10 *LOS ANGELES, CA*

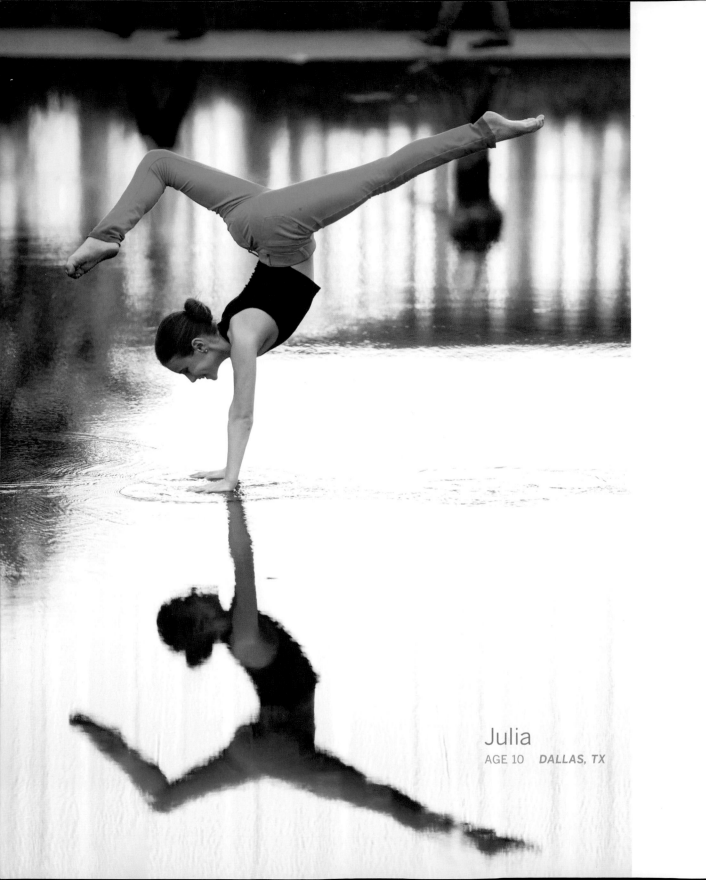

Julia
AGE 10 DALLAS, TX

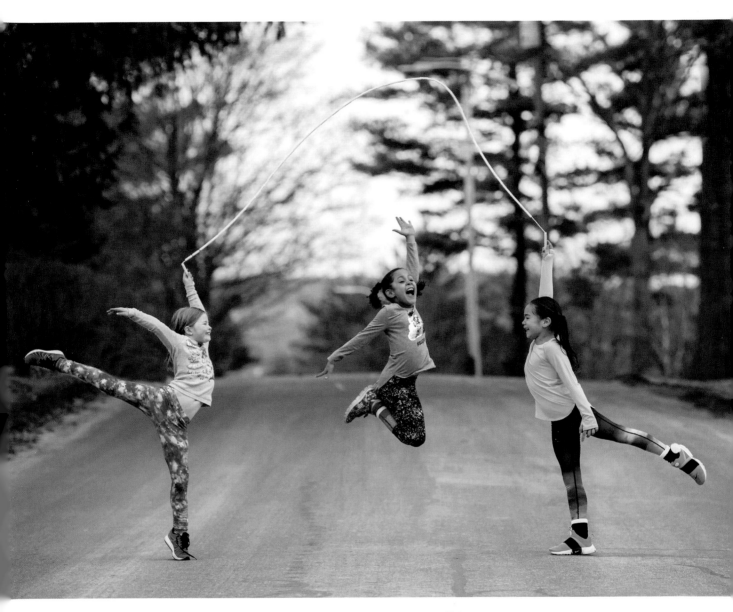

Salish AGE 8 Lirit AGE 8 Sloane AGE 7 NYACK, NY

Payton AGE 7 Krimzyn AGE 9 *SANTA MONICA, CA*

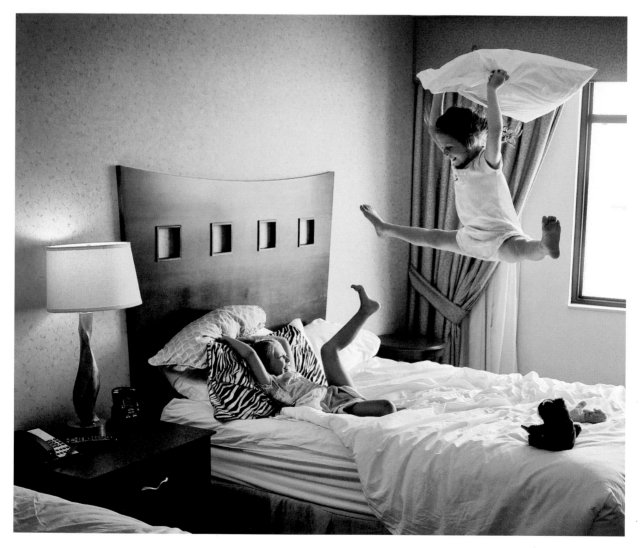

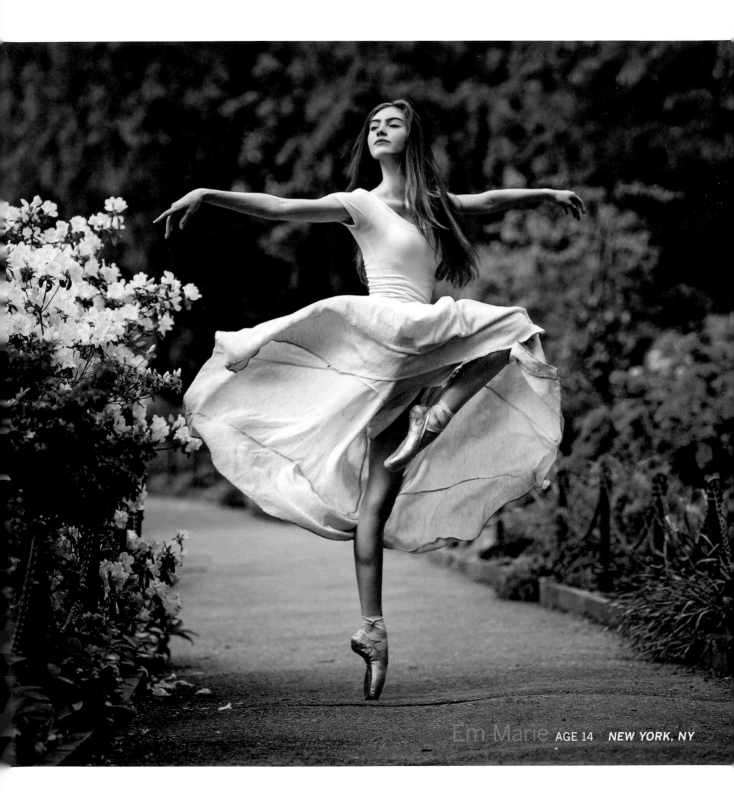

Em Marie AGE 14 **NEW YORK, NY**

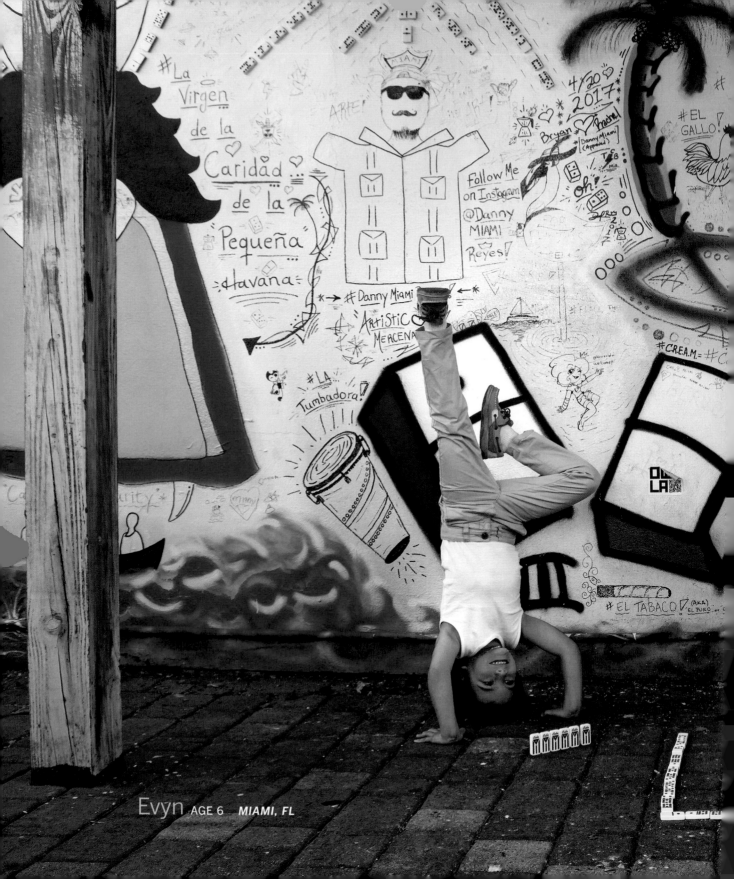

Evyn AGE 6 MIAMI, FL

"Youth is wholly experimental."

Robert Louis Stevenson

Check out the video!

Brynn
AGE 14 *PHOENIX, AZ*

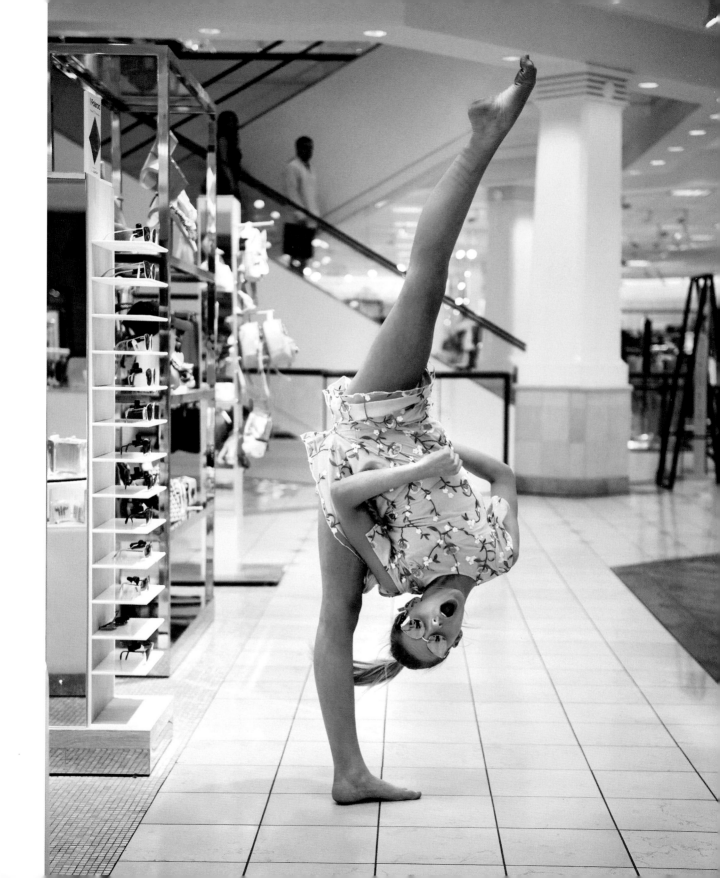

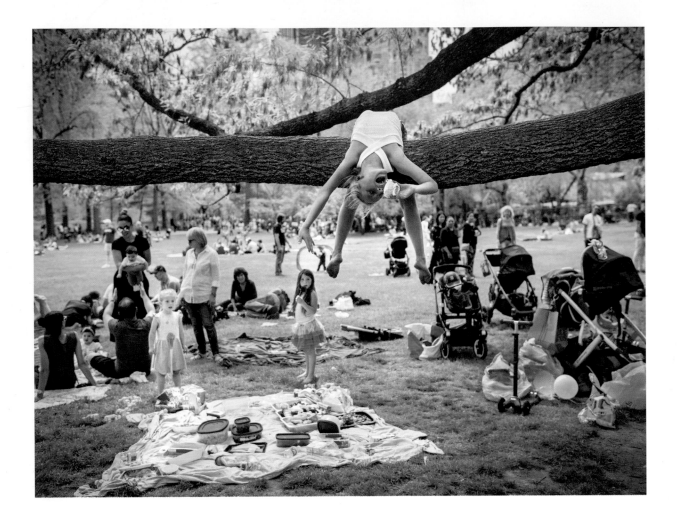

"There will always be someone who can't see your worth. Don't let it be you."

Maesi AGE 13 *NEW YORK, NY*

Check out the video!

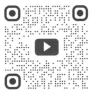

Rachel AGE 13 NEW YORK, NY

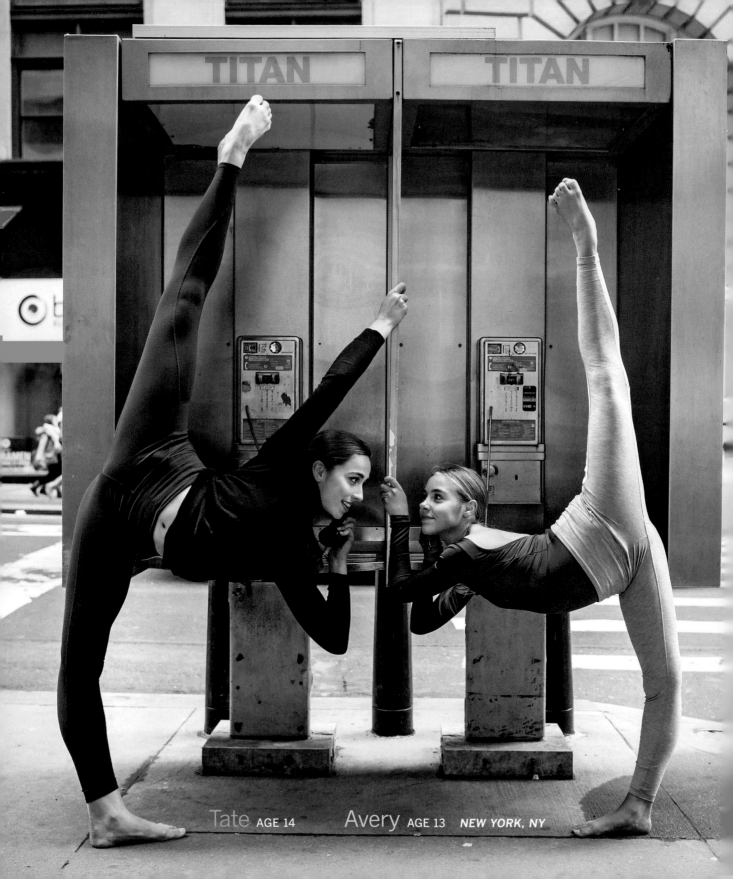

Tate AGE 14 Avery AGE 13 NEW YORK, NY

Salish, Helena, Pacey, Hudson, Elliana
AGES 8 TO 12 *STEAMBOAT SPRINGS, CO*

"I miss the days when shouting 'Not it!' was an effective way of getting out of things you didn't want to do."

...

Unknown

Check out the video!

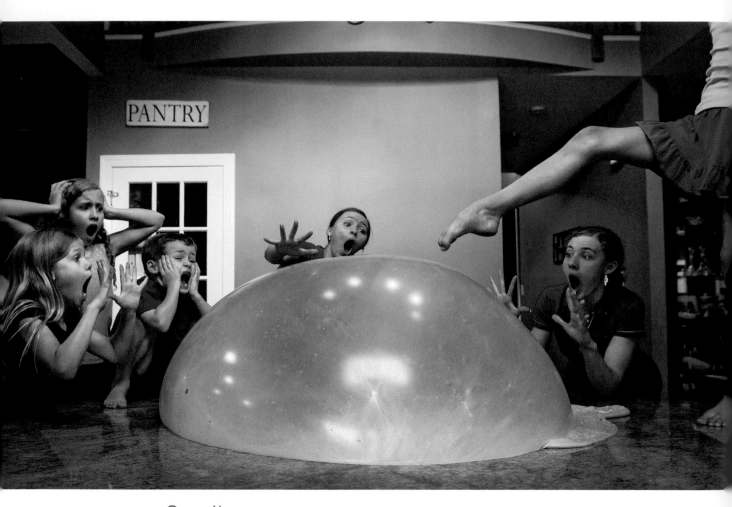

Caroline AGE 10 *LONG VALLEY, NJ*

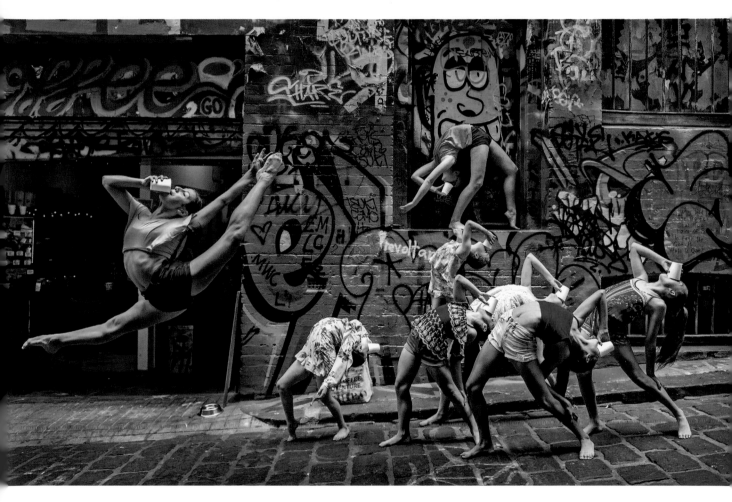

Check out the video!

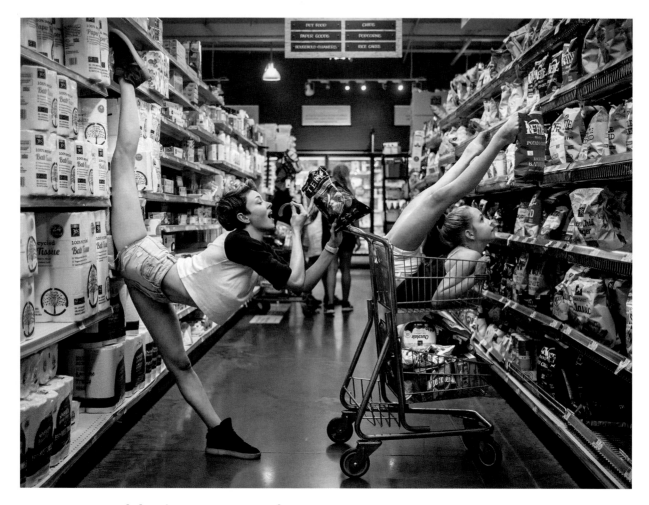

Maria AGE 17 Anna AGE 15 *NEW YORK, NY*

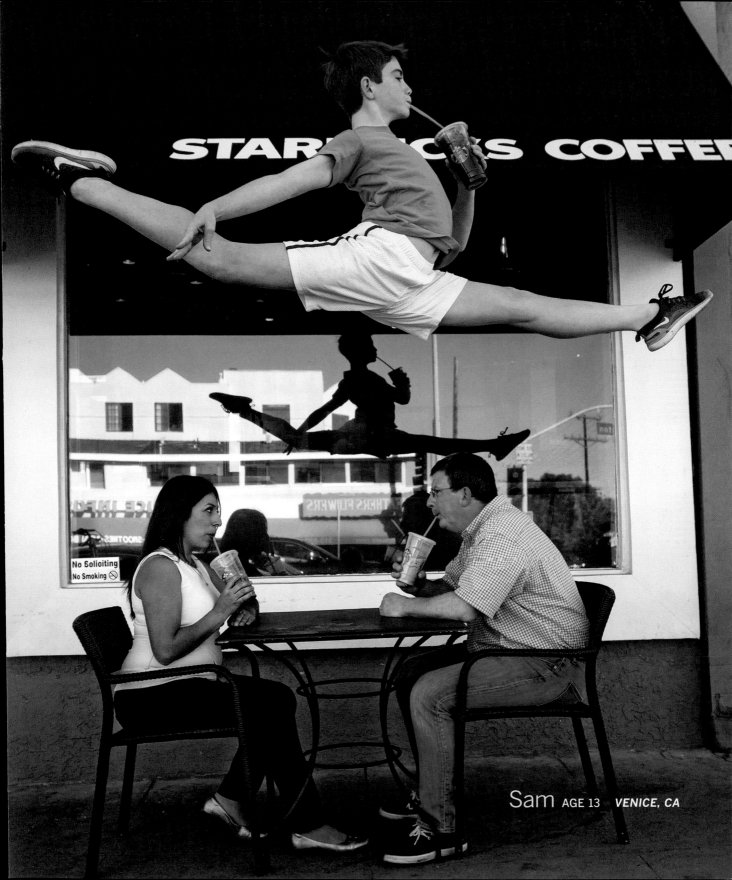

Sam AGE 13 VENICE, CA

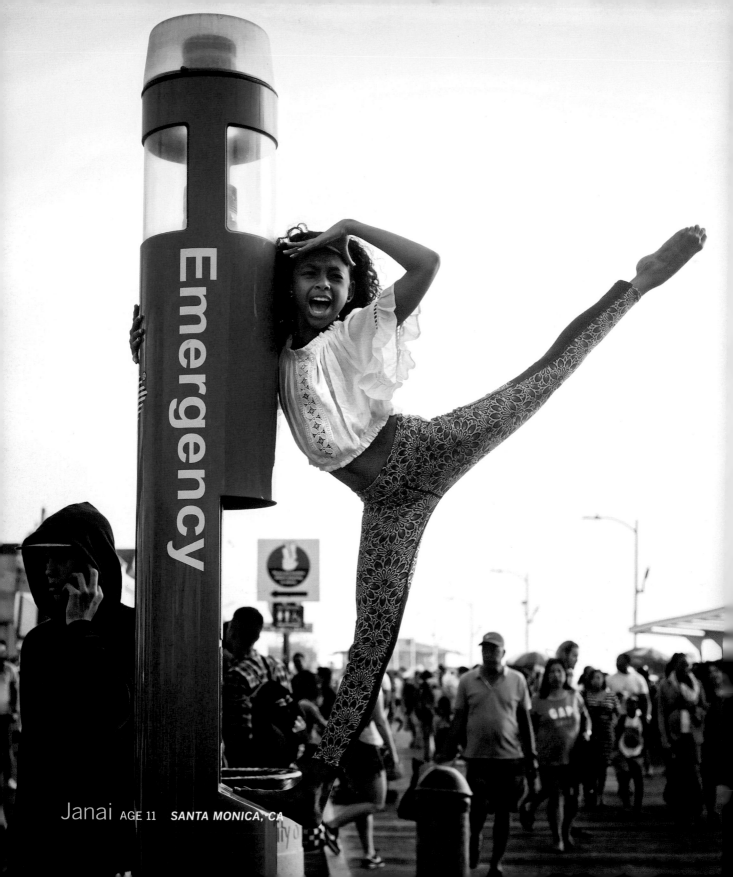

Janai AGE 11 SANTA MONICA, CA

"i had a bad dream"

I was preoccupied with finding my misplaced wallet. I was in my studio at home, rooting through drawers, utterly lost in thought. I had ten things to do at the same time.

Suddenly, I was frozen by a sound. It was a flute, distant and scratchy; a beautiful and haunting memory from my childhood. I recognized the musician immediately. It was my mother. She had died two years before.

In the studio, three-year-old Salish had discovered an old tape recorder under a pile of books and pressed the play button. When I had gathered the books from my mother's apartment, I hadn't had the courage to look through them. The pain of her death was too intense, so I shut it off and just left everything piled in a corner.

"What is this, Daddy?" Salish asked as she saw my face go white.

"It's my mommy. She played music."

"Where is she?"

"She died, Salish."

We sat quietly and listened to the music. My eyes began to tear up. Salish wasn't looking at me. She was staring intensely at the wall.

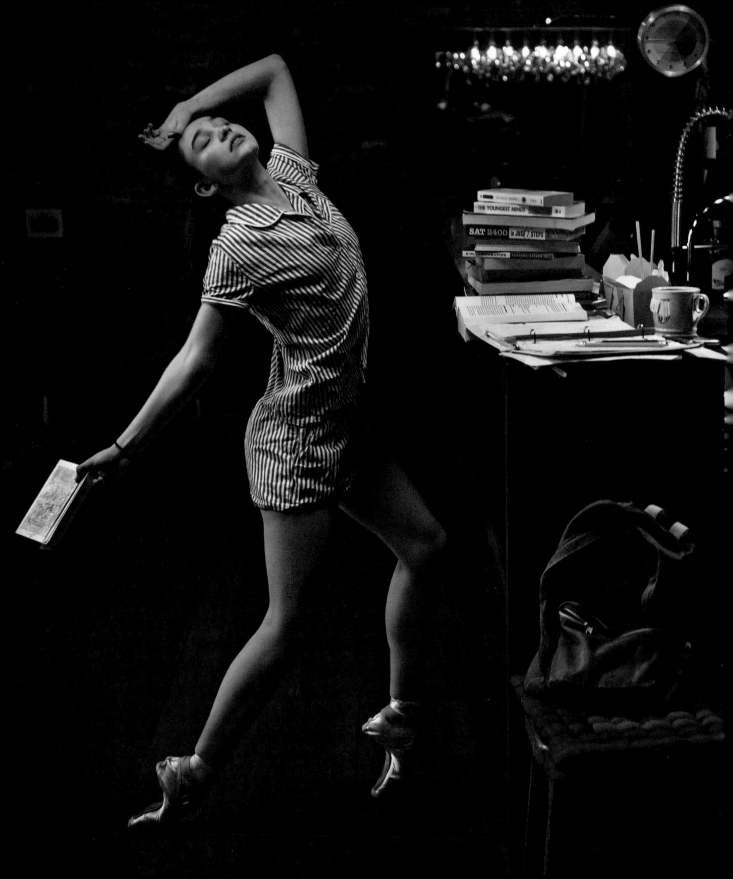

Jenna AGE 13
BROOKLYN, NY

"Is she calling out to you, Daddy?" she asked.

The question was like a kick in the stomach. Where did she hear that phrase?

"I don't know. I don't know." I said.

"Is she sad, Daddy? Is she crying?"

"I don't think so, Salish."

"Is she hurt? Is she okay?" Her face was filled with compassion.

"She was sick and stopped playing music, but I don't think she's in pain anymore."

"Is she calling out to you, Daddy?" she repeated.

I was silent. We listened to the dreamy melody until the refrain ended. I felt like a child back in my living room, and it made me smile. Salish startled me from my nostalgia. "It's time to go now, Daddy. Let's go." We left the studio together, and Salish grabbed my hand. "I love you, Daddy," she said.

Three hours later I was driving to work, the earlier event a distant memory. I was once again spending the day wrapped up in tomorrow's tasks. I looked at my phone and gasped as I saw the date.

It was my mother's seventieth birthday.

I suddenly recalled a conversation I'd had with her as I was setting up her email account.

"What would you like your name to be?" I asked.

She thought for a minute. "Flutist at rest," she said, smiling.

Throughout my childhood, my greatest fear was the death of my mother. When it finally happened, years later, I immediately distracted myself, waiting and hoping for the memories to fade. It worked, but that day with Salish I learned a valuable lesson. A bad dream is never so awful once you wake up. The memories were not a painful reminder of her death but a celebration of her life. Perhaps my mother got tired of waiting around for me to realize that.

Lina AGE 15 NEW YORK, NY

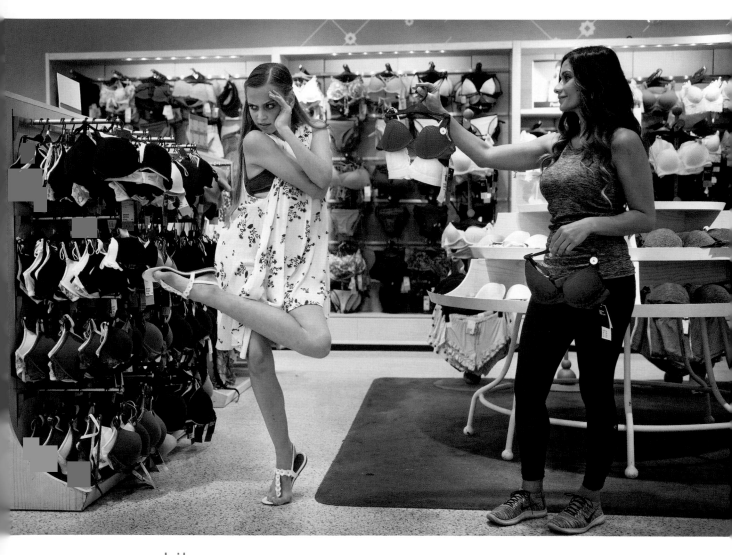

Lily AGE 13 *NEW YORK, NY*

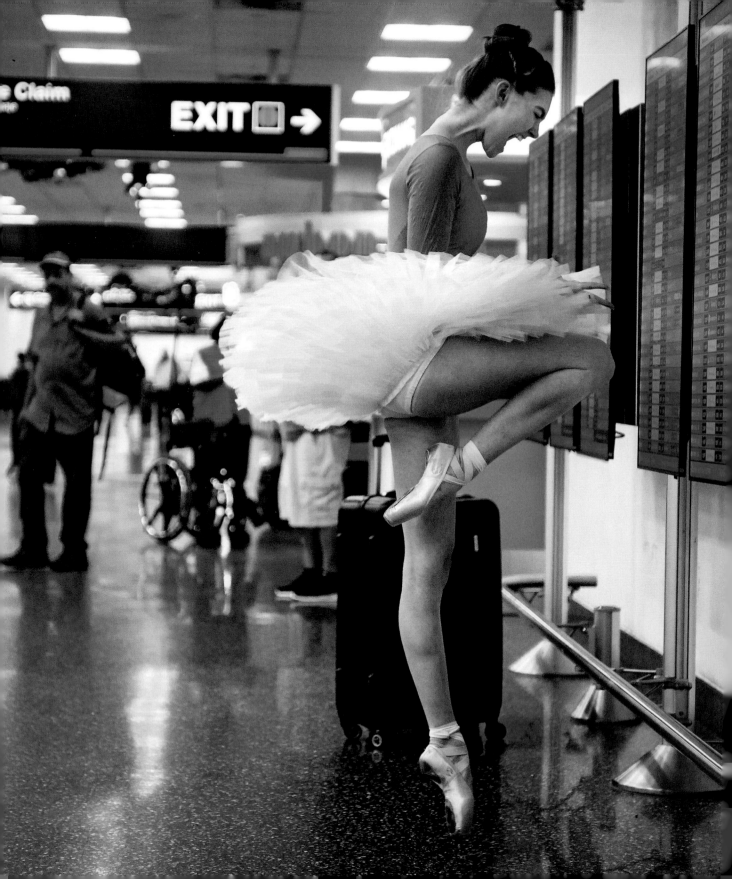

"Adults say life is full of changes. Dreams are made and lost. Doors open and close. Blah, blah, blah. Truth is, more doors of opportunity would remain open if grown-ups could just make the flights arrive on time!"

Em Marie AGE 15 *MIAMI, FL*

Check out the video!

Melinda AGE 9 NYACK, NY

My Name Is Melinda

...

Above me are beautiful white clouds
Below me are dog haters
Behind me are people who don't take anything seriously
All around me are people who will always be remembered
I see forgiveness
I smell awesomeness
I hear honesty
I move fearlessly
I feel compassion
Sometimes I go crazy over little things
I know to believe in myself
I am hardworking
I am responsible
I am imperfect
I think my best is just enough
I give my everything
I fear a B+
I believe in peace
I remember Avielle, my bestie
I dream of my future college
I do not understand guns
I am Melinda

...

Melinda wrote this poem after losing her best friend in the school shooting in Newtown, Connecticut.

Jadon and mom AGE 14 THE WOODLANDS, TX

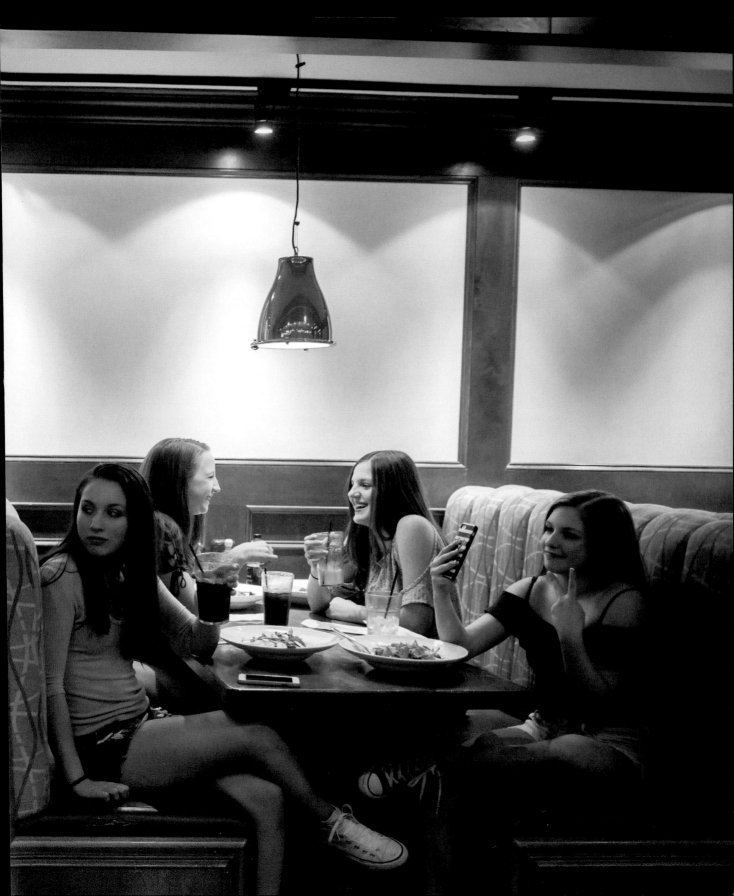

> "Sometimes it is really hard being a boy dancer. People make fun of me. But it's okay, I like being different. I like being me."

Brady AGE 12 *GREENWICH, CT*

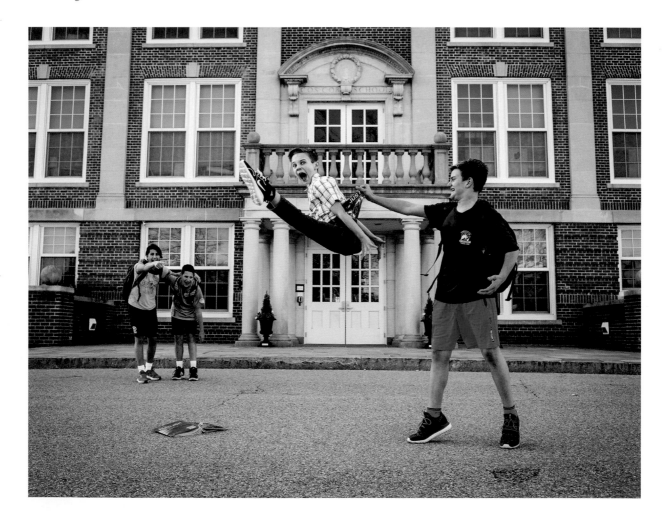

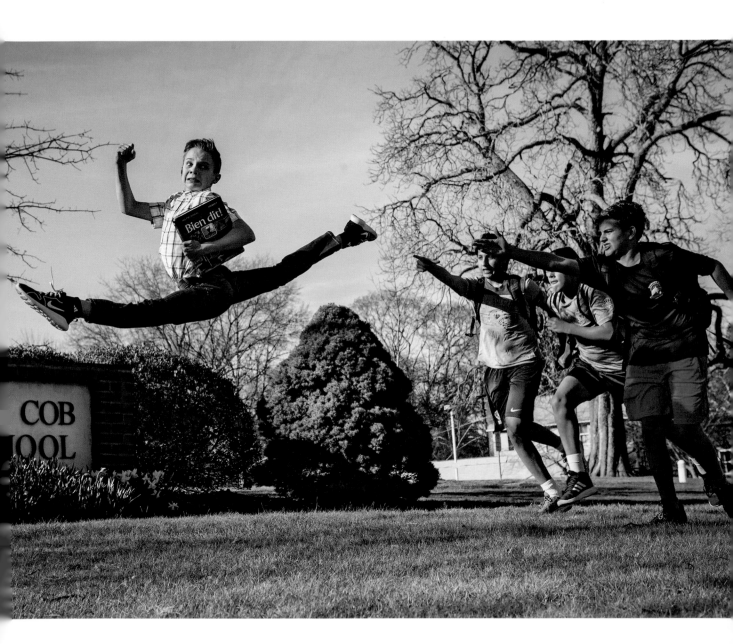

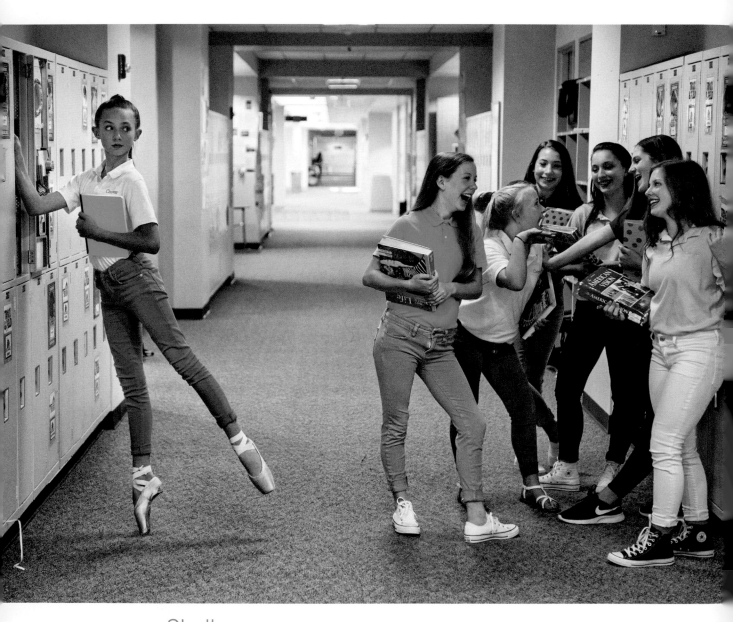

Shelby AGE 13 *THE WOODLANDS, TX*

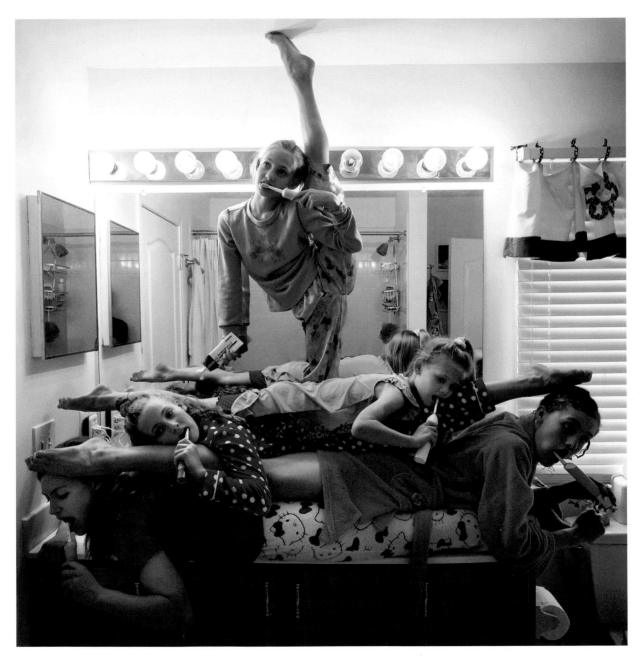

"Disappointment is the gap that exists between expectation and reality."

John C. Maxwell

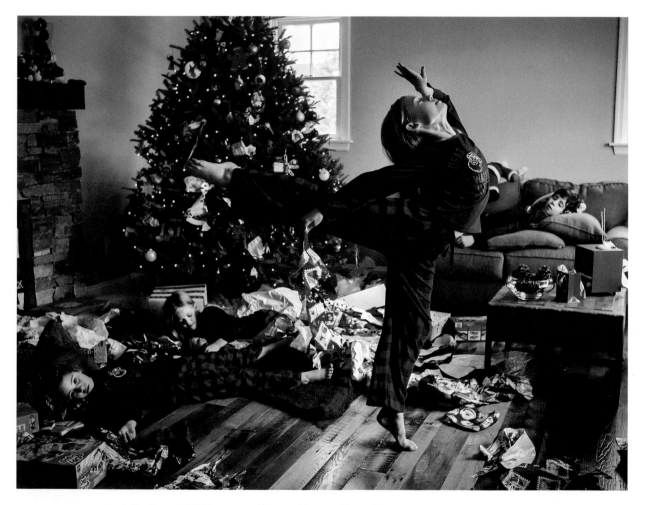

Kinley, Elliana, Caroline, Becket
AGES 10 TO 14 *NYACK, NY*

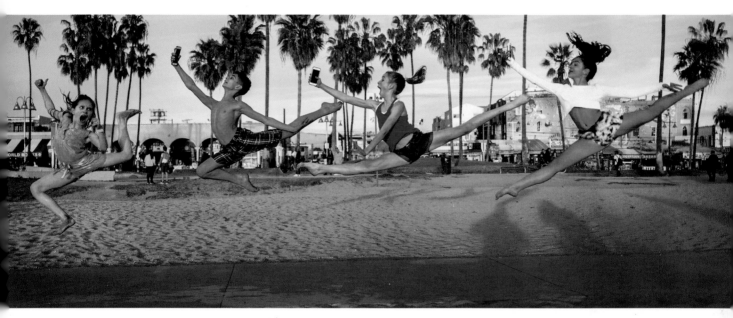

Elliana, Gavin, Charlotte, Daniella
AGES 10 TO 14 *VENICE, CA*

Check out the video!

"I felt like I was dancing for every girl who had ever been misunderstood, for every girl who had ever been bullied, belittled, dismissed as nothing because they didn't fit society's version of perfection, for any girl who had been made to feel like social media is the core of ego and emotional strength. It isn't. No matter who you are or who you wish to be, you are your own perfect body, your own perfect mind, your own perfect dream."

...

Em Marie AGE 13 *NEW YORK, NY*

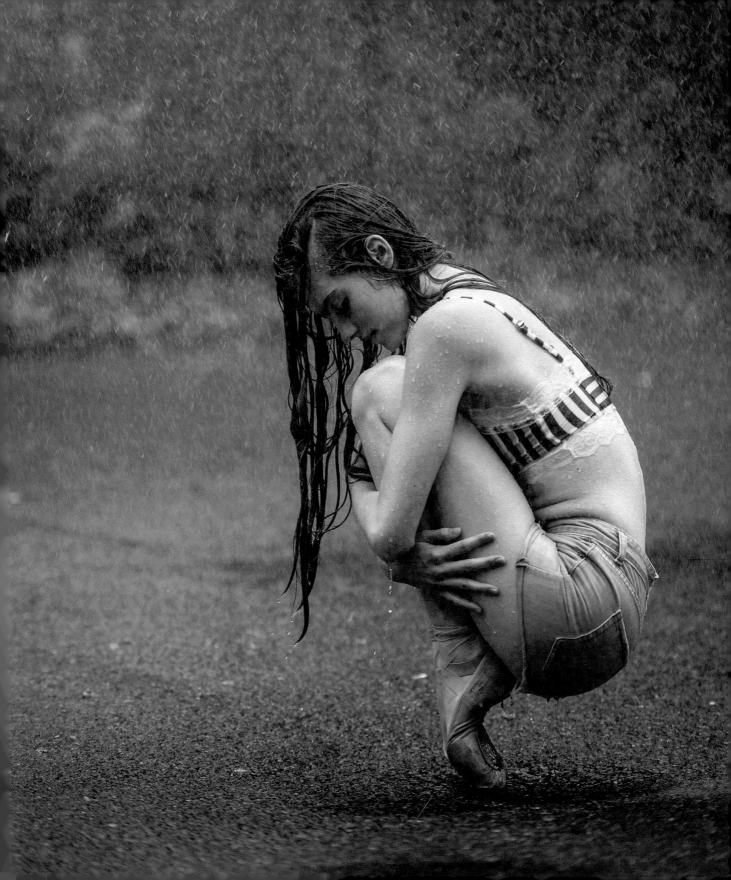

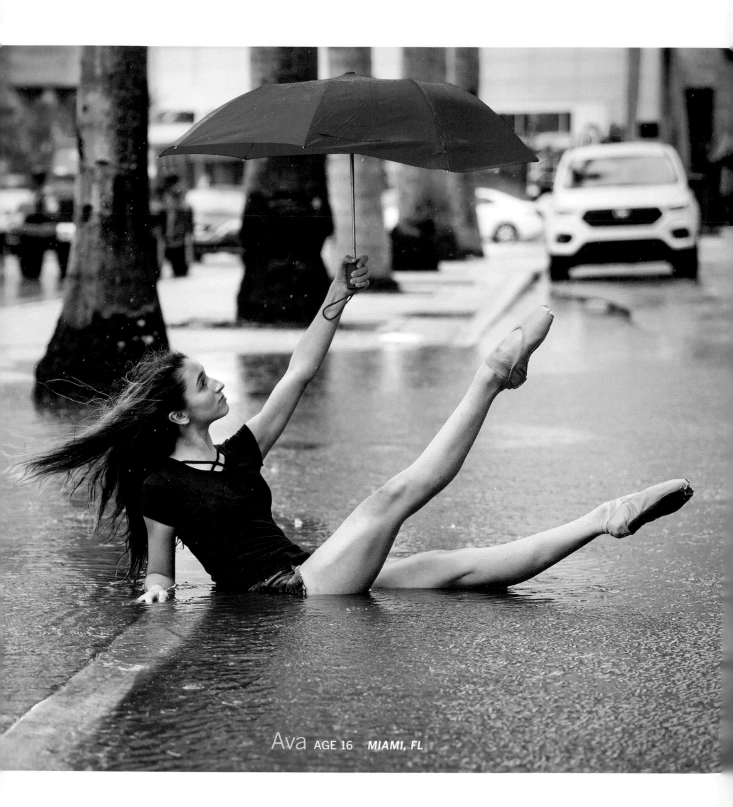

Ava AGE 16 MIAMI, FL

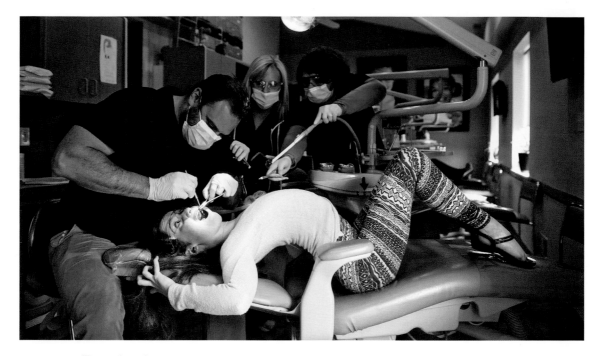

Rachel AGE 12 *NEW CITY, NY*

Bella AGE 10 *NEW YORK, NY*

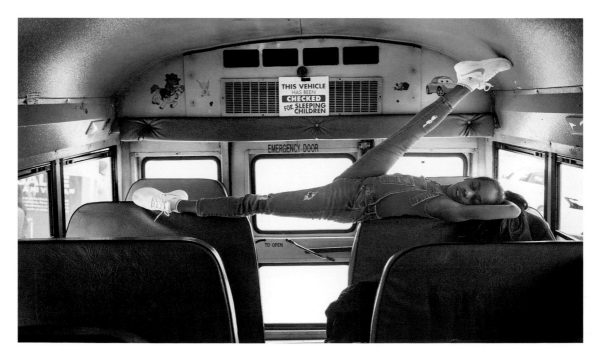

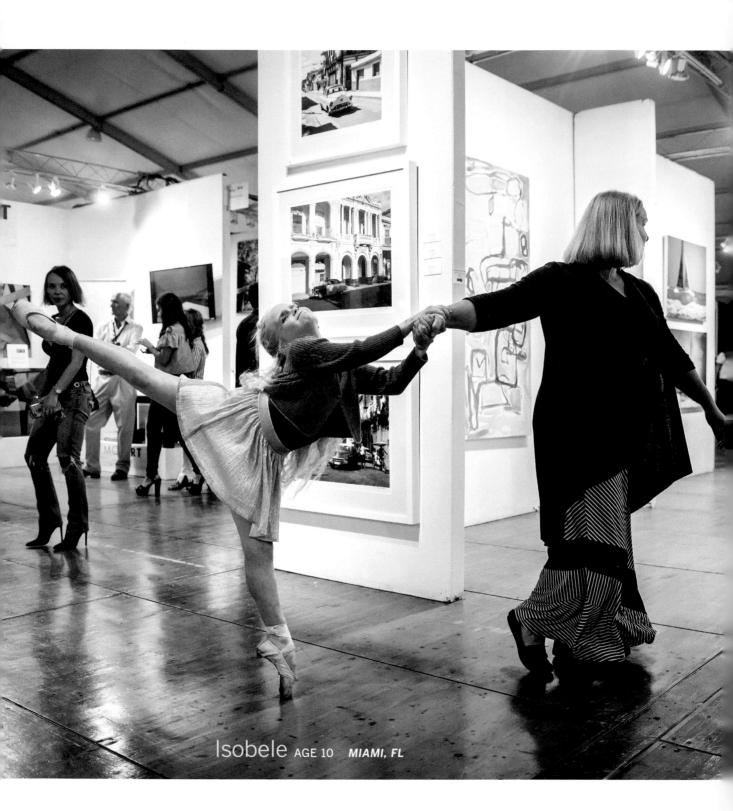

Isobele AGE 10 *MIAMI, FL*

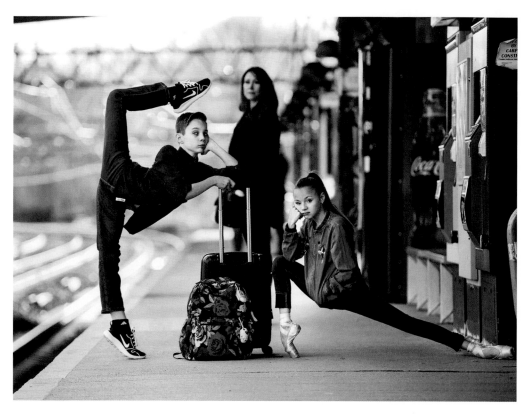

Brady AGE 12　　Ava AGE 12　*GREENWICH, CT*

"What you take for granted, someone else is praying for."

Unknown

"When things get rough at home, I use dance as my escape. It makes some of the sad things in my life a little easier. I wish my parents could dance away their stress too."

Elliana AGE 10 NYACK, NY

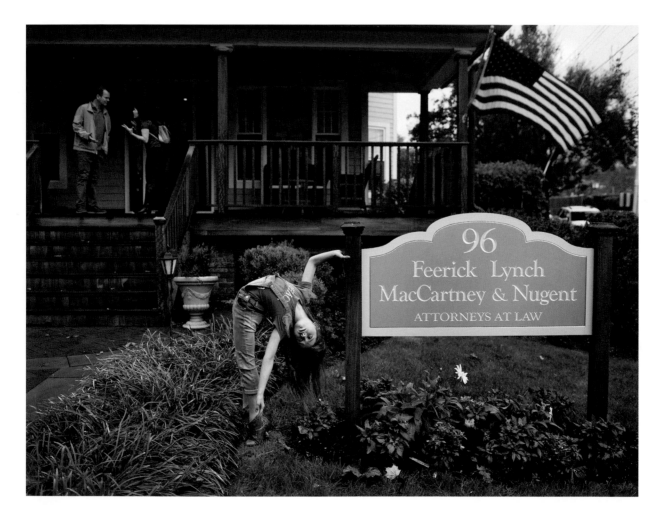

Check out the video!

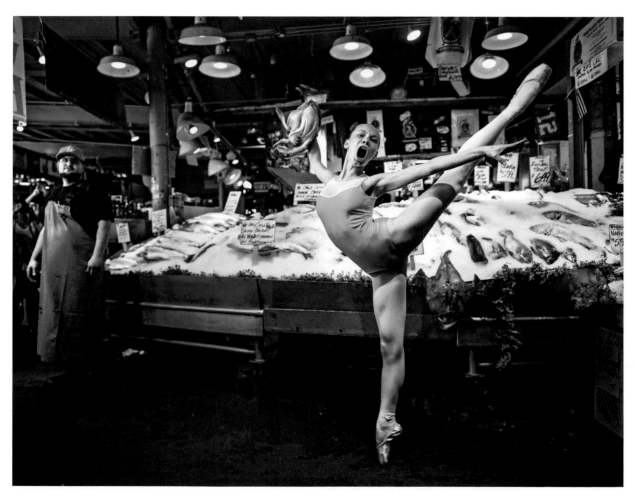

Lina AGE 16 *SEATTLE, WA*

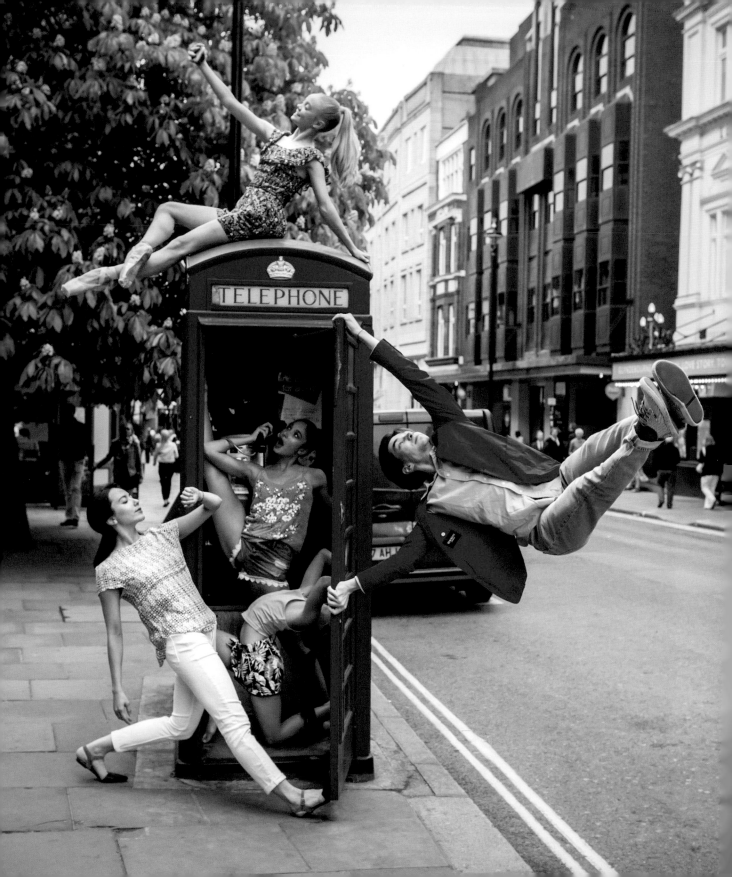

Celine AGE 23
Ruby AGE 11
Isabelle AGE 14
Jessica AGE 15
Philipp AGE 30

ST MARTINS LANE, LONDON, ENGLAND

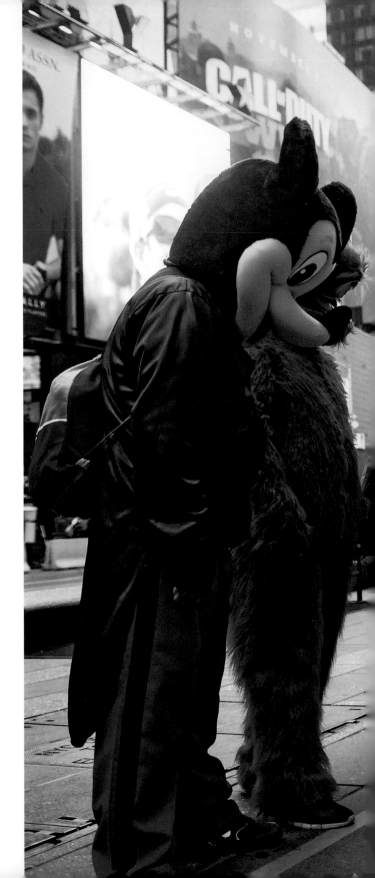

"Learn to see the world backwards, inside out, and upside down."

John Heider

Check out the video!

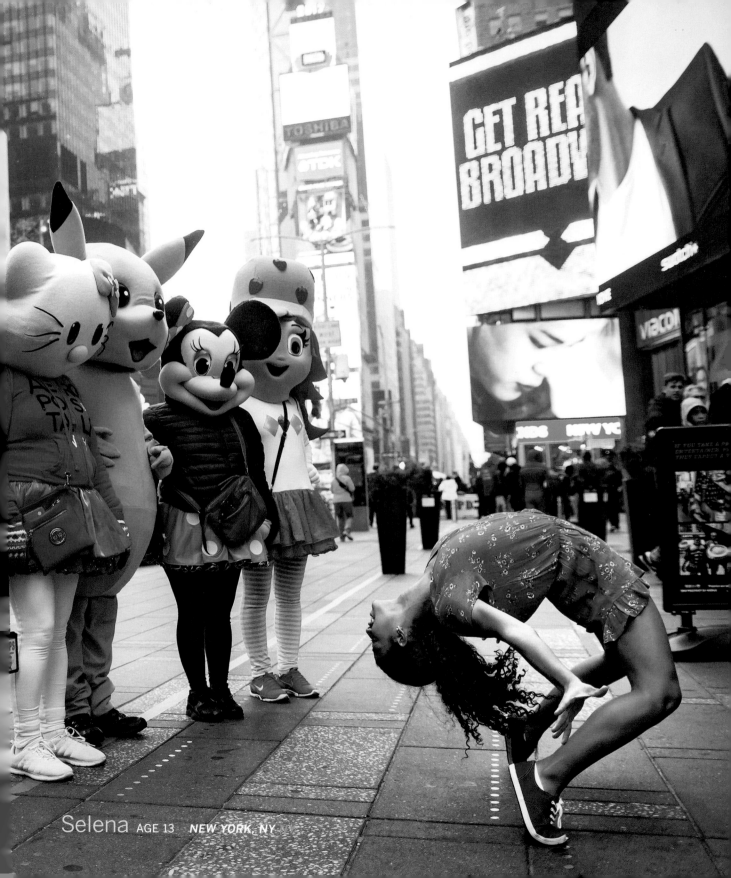

Selena AGE 13 NEW YORK, NY

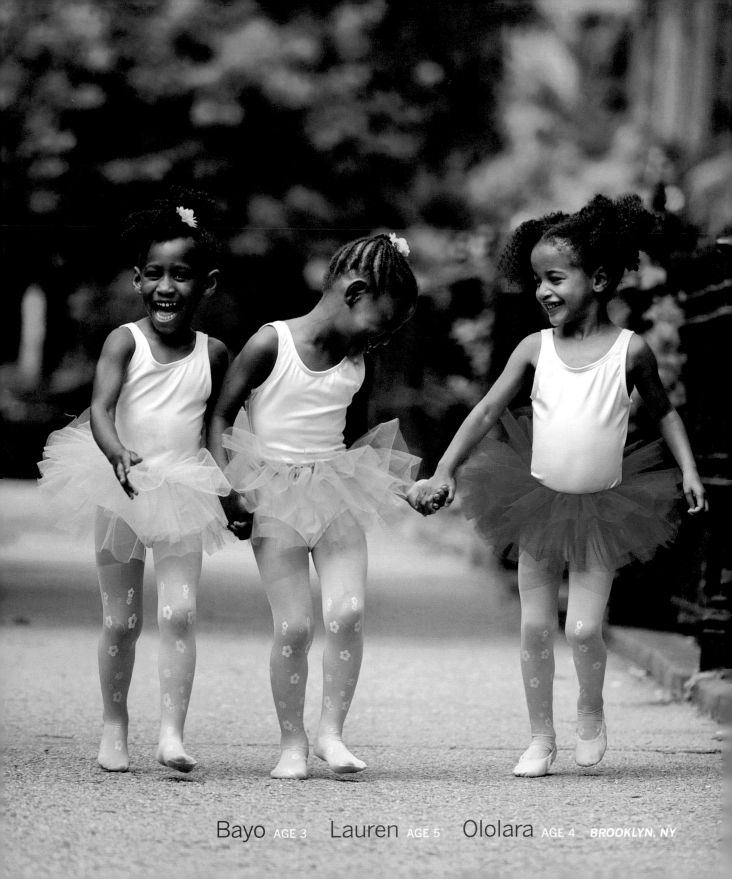

Bayo AGE 3 Lauren AGE 5 Ololara AGE 4 BROOKLYN, NY

"when i grow up"

One afternoon my wife and I listened as our kids planned out their futures. When they grow up, Salish will be a professional gymnast and Hudson will be a famous basketball player, singer and YouTuber. They will live together in a mansion in Phoenix with loads of money. Being a typical Daddy Downer, I asked them how they planned to achieve these goals, seeing yet another opportunity to lecture them on the value of hard work and perseverance. Yet, sitting at my desk now, I realize that was exactly the wrong question. I shouldn't have asked how they

Salish AGE 7 GRAND CANYON, AZ

planned to achieve their dreams, but why. As adults, we spend too much time focused on what we do, and too little time on who we are. As a result, our self-identities become tied up with our job titles. Our children see this pattern and repeat it. Initially kids fantasize about having a career doing what they love, but as they get older the focus often shifts to money and fame, and then finally to practicality.

This is evident in dance. The youngest dancers are in it purely for the joy, without much concern for technique. As they gain more experience, they begin to compare themselves to the most popular dancers on social media and feel pressure to be the best. Finally, as they consider a dance career, they choose specialties and focus on elite training programs. As a result, they can easily lose sight of why they started dancing in the first place.

Imagine a world in which the first question when meeting someone isn't "What do you do?" but instead, "What do you love to do?" Imagine how much more of their story you'd get—and how much more connection there would be. Try it.

"A flower does not think of competing with the flower next to it; it just blooms."

Koshin Ogui

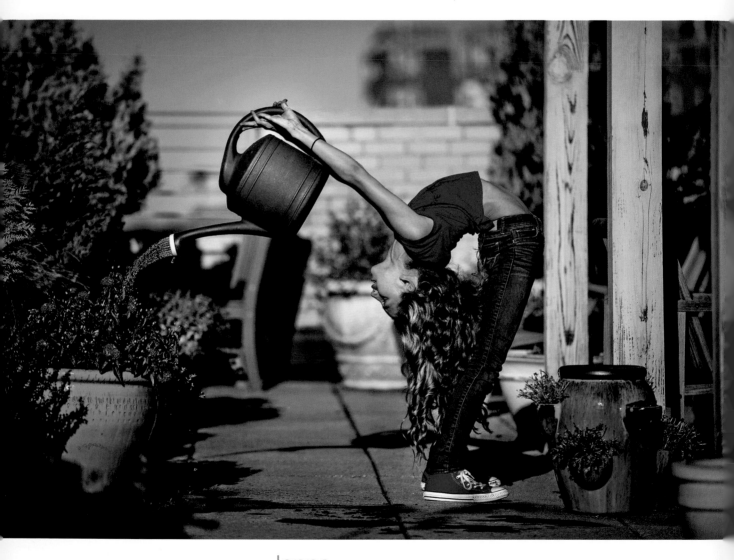

Jenna AGE 13 NEW YORK, NY

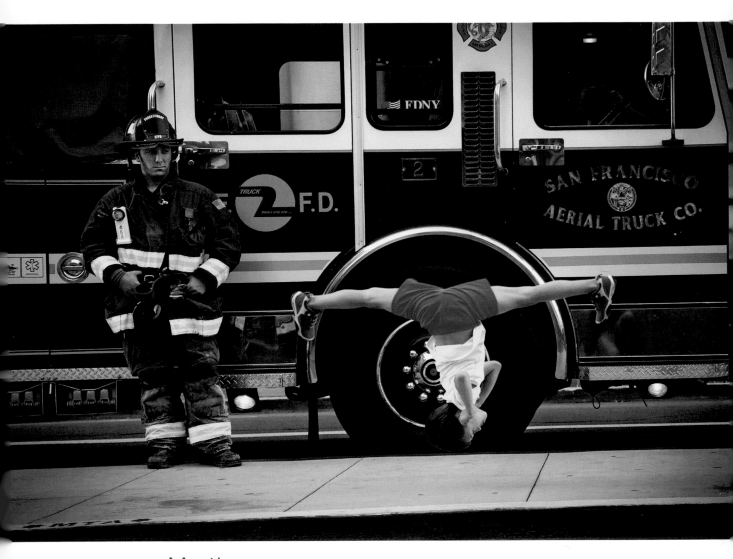

Mystic AGE 6 *SAN FRANCISCO, CA*

Check out the video!

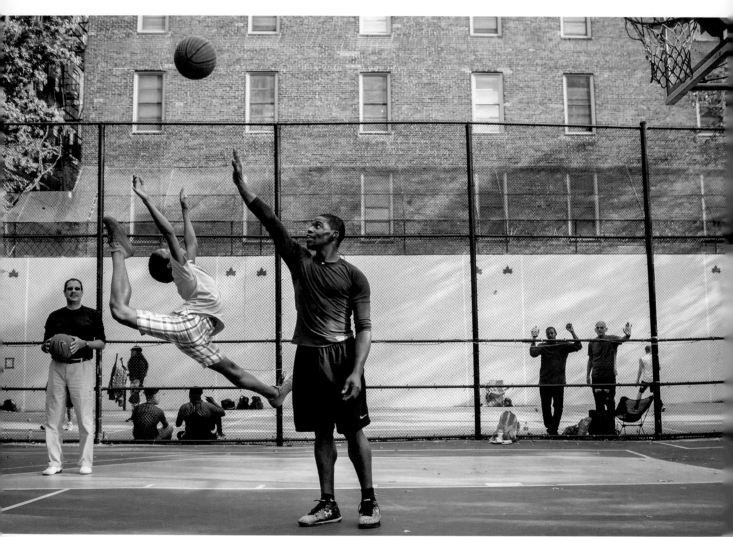

Jeremy AGE 12 NEW YORK, NY

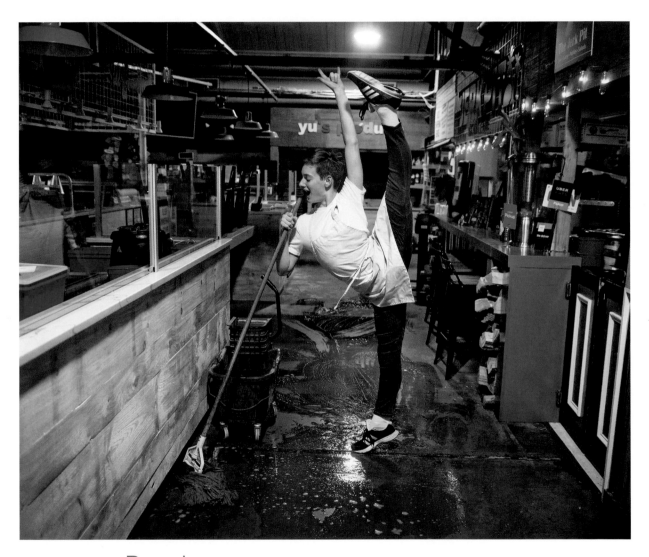

Brandon AGE 15 *PHILADELPHIA, PA*

"Just when people think they're way ahead of you is when you go full throttle."

Ryan AGE 15

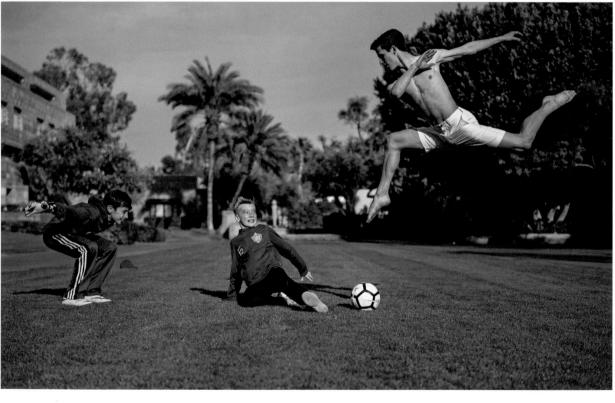

Shey AGE 11 Miles AGE 11 Ryan AGE 15 PHOENIX, AZ

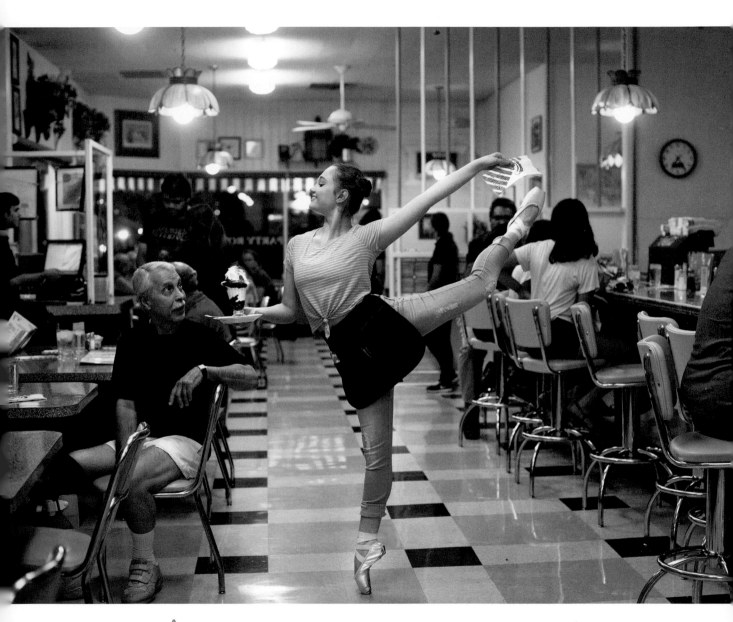

Avery AGE 16 *PHOENIX, AZ*

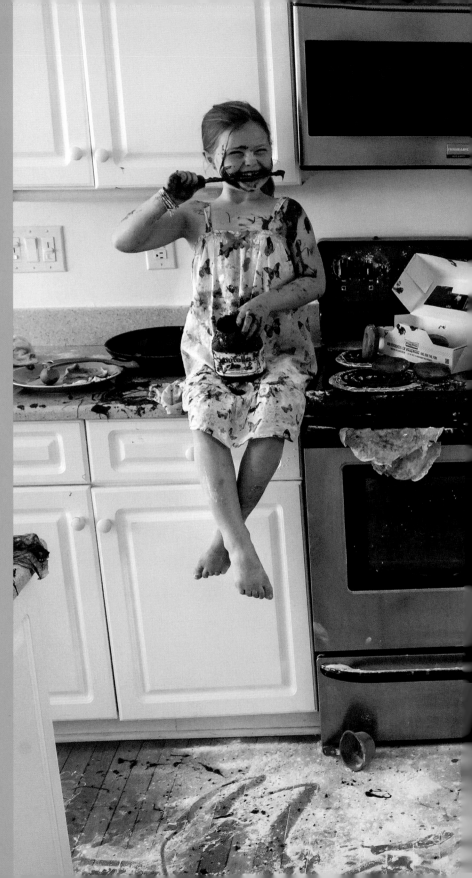

"Sometimes messy is the necessary beginning to the makings of extraordinary."

Michele Cushett

Salish
AGE 7

Lilliana
AGE 9

EMERALD ISLE, NC

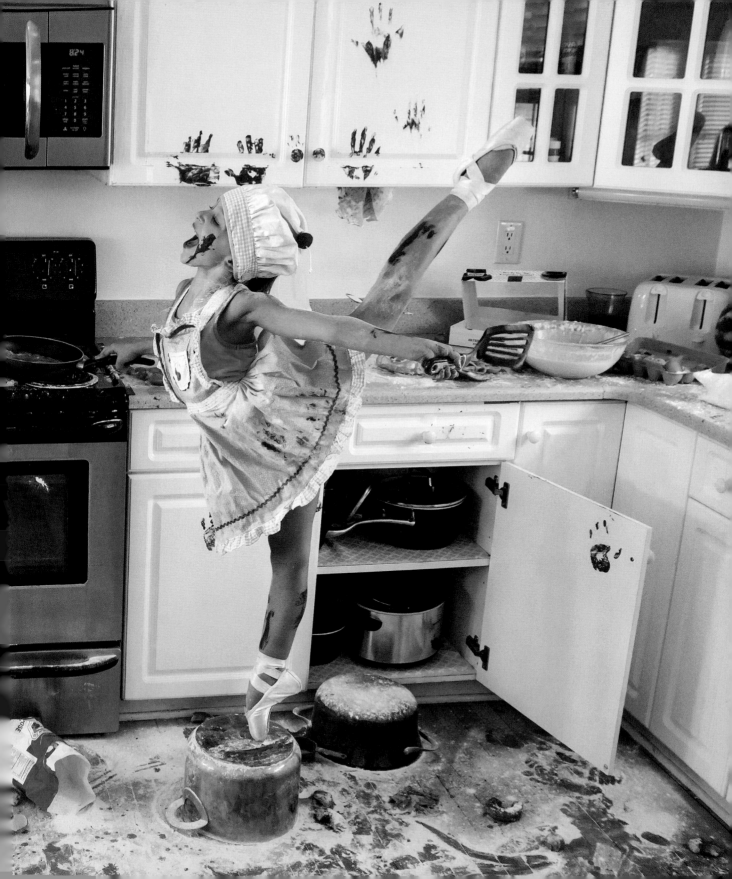

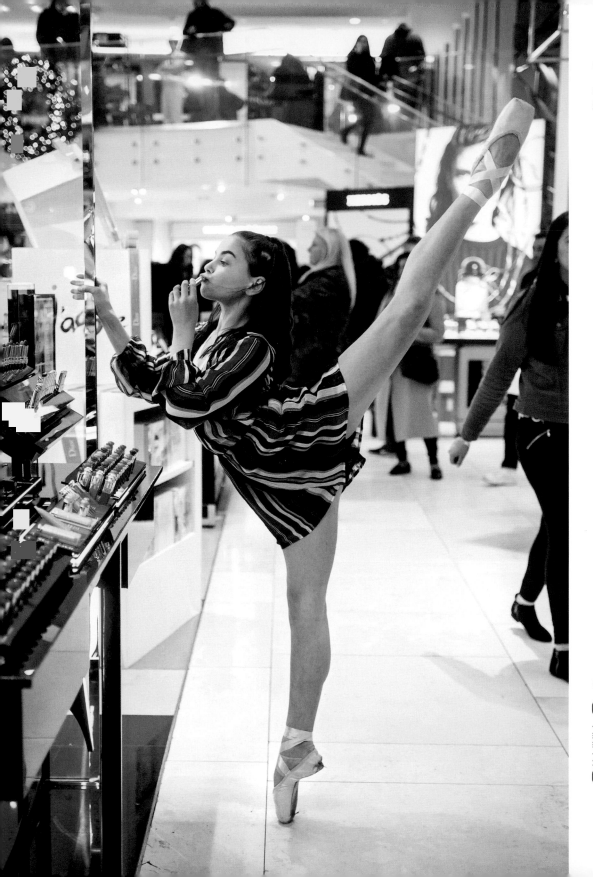

Caroline
AGE 13
NEW YORK, NY

Check out the video!

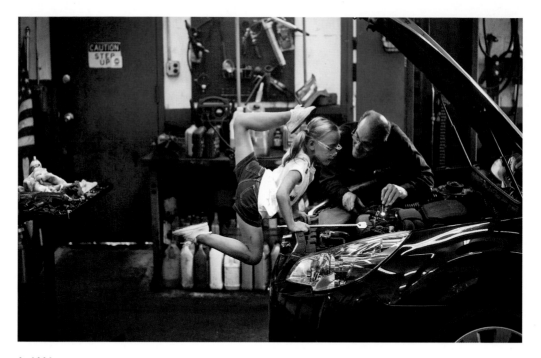

Lilliana AGE 9 *NYACK, NY*

Luke AGE 9 *LONDON, ENGLAND*

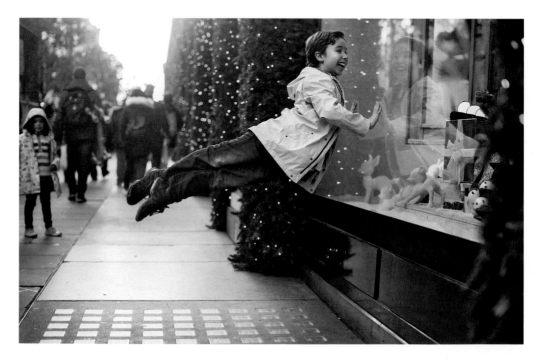

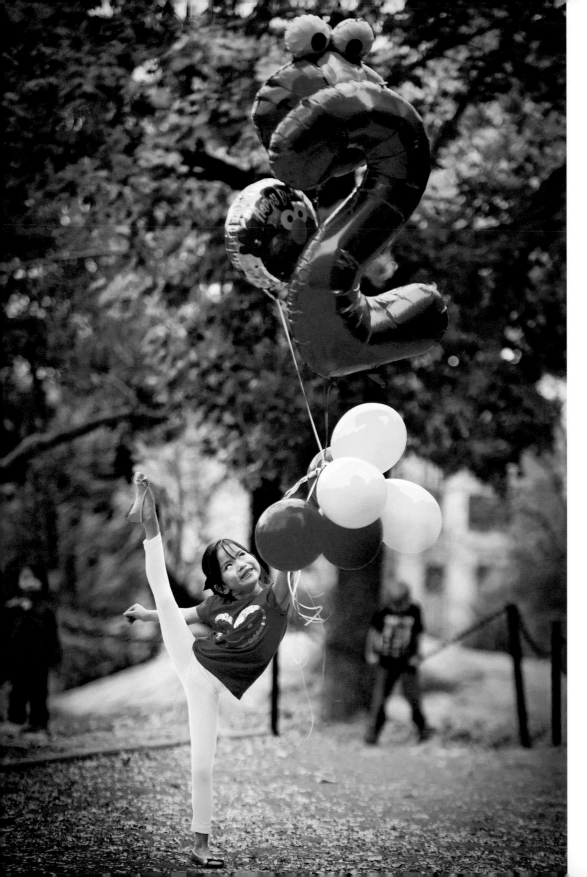

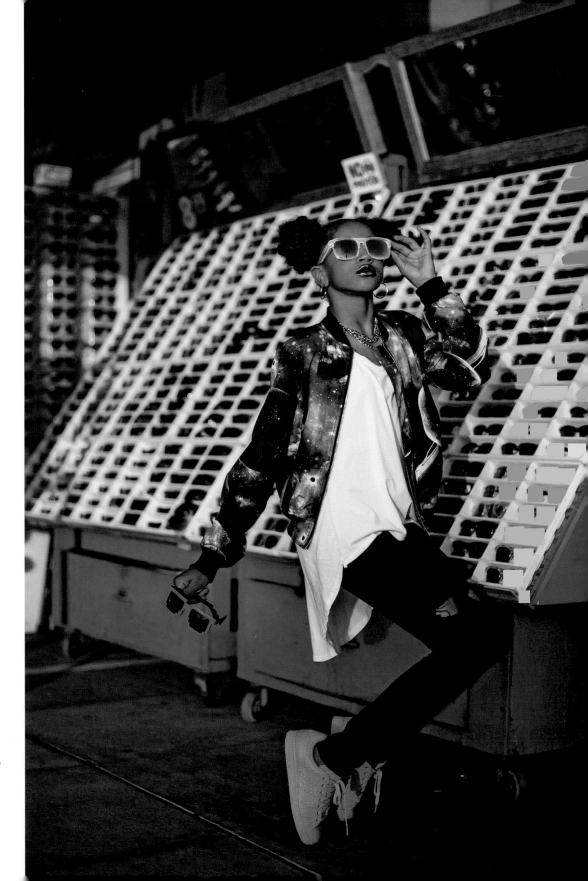

Kyndall

AGE 12
LOS ANGELES,
CA

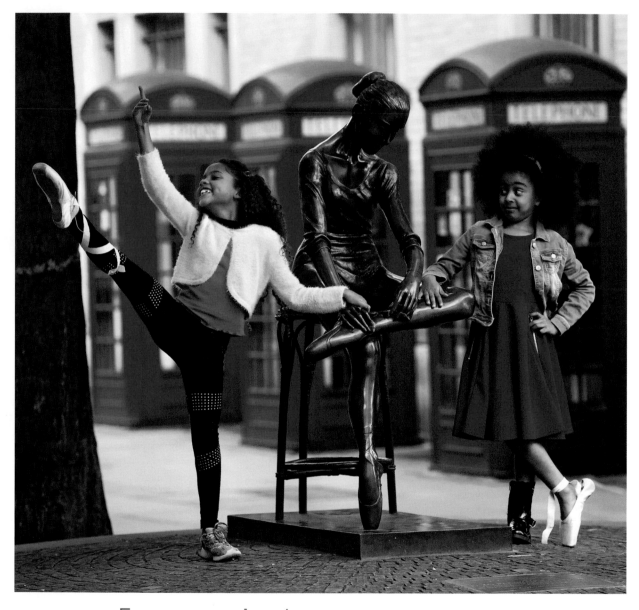

Eve AGE 8 Azaria AGE 7 *LONDON, ENGLAND*

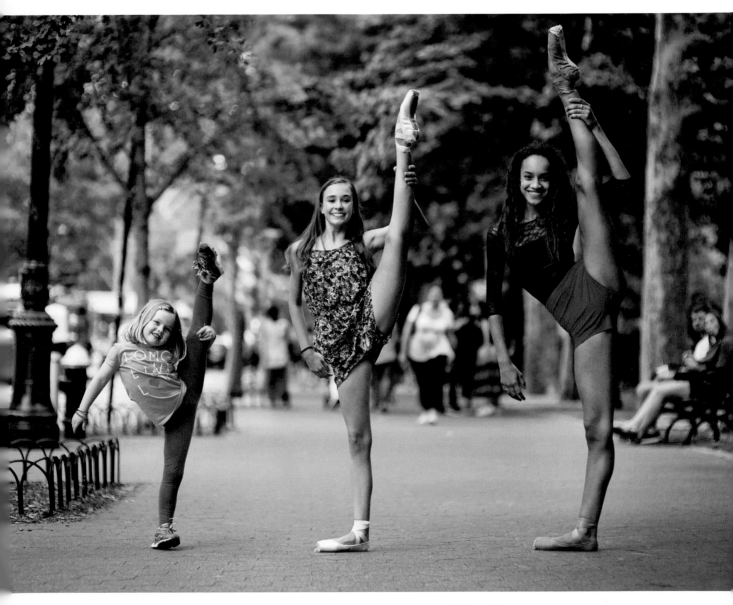

Salish AGE 6 Tillie AGE 12 Kaeli AGE 15 *NEW YORK, NY*

Lilah AGE 4 PHOENIX, AZ

Sofie AGE 16 NEW YORK, NY

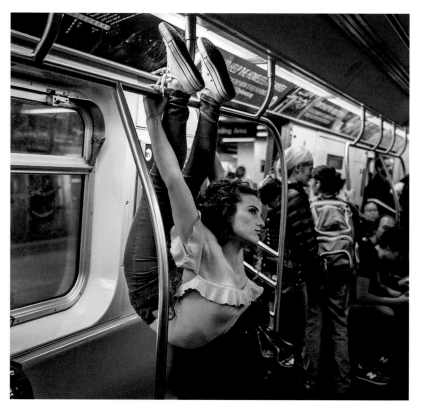

Check out the video!

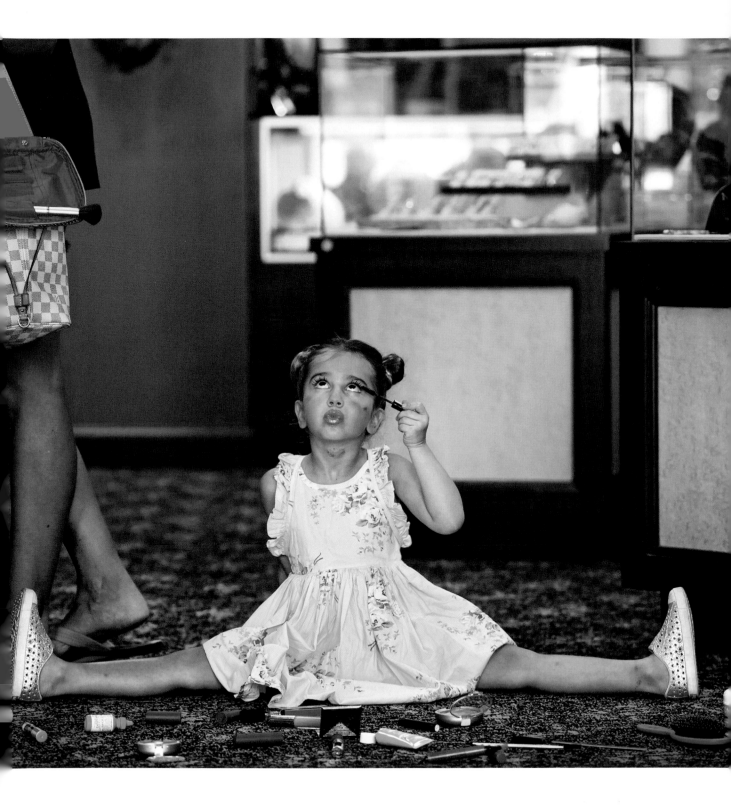

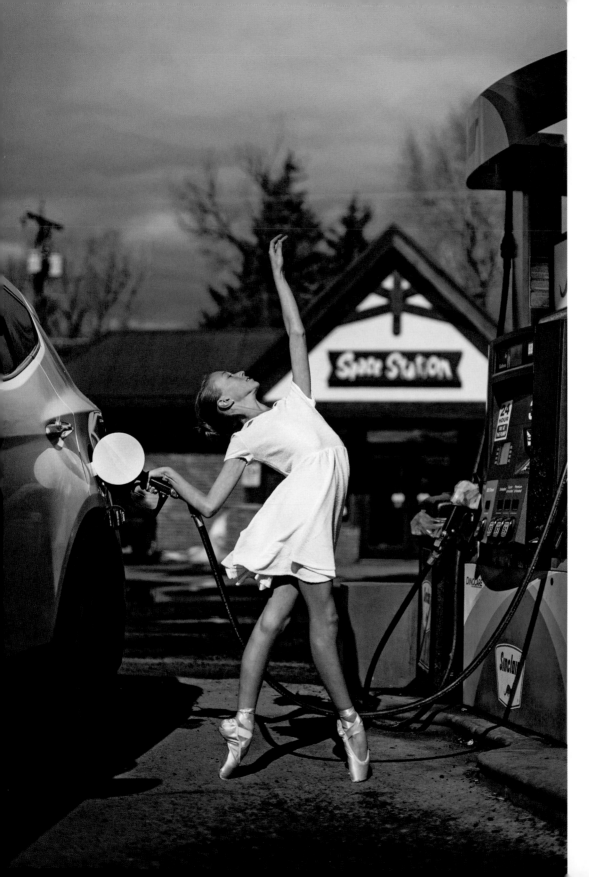

Jaden
AGE 10
STEAMBOAT SPRINGS, CO

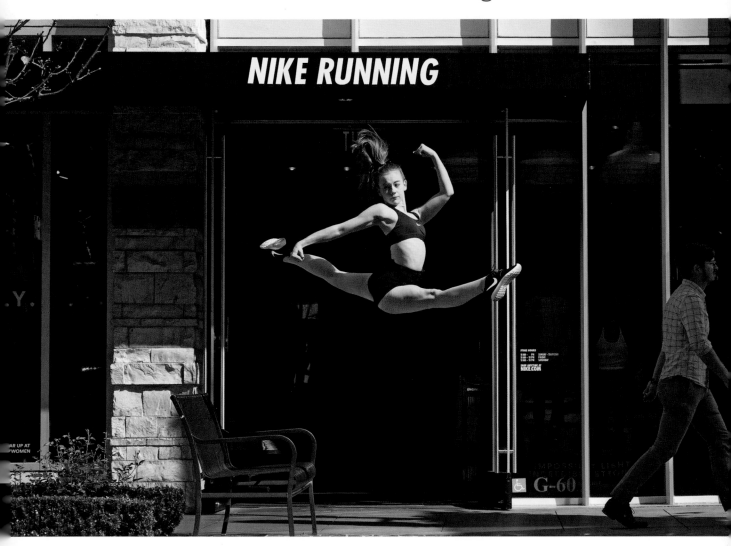

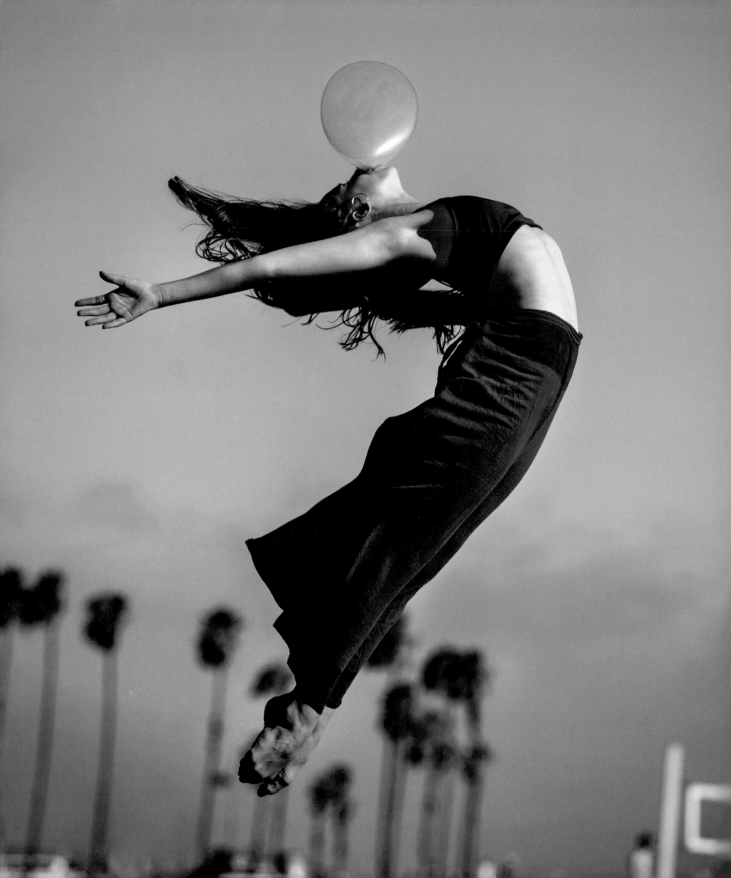

To All Teens lyrics by Tate McRae

..

If you think I'm perfect, I am not.
Like I know my way, well I am lost.
If you think I have my life laid out, I don't . . .
But Imma work it out.
Get to know me and you'll see,
We're all the same, slightly crazy.
If you think I'm on a better route, I'm not . . .
But Imma work it out.
We fail, we fall, we think we've lost it all.
We love, we hate,
We make a lot of mistakes.
We grow, we learn,
It's scary thinking it's our turn,
But right now let's just live.
Cuz we are young,
And we don't know who we are.
But that's okay,
Because we're not that far
From figuring it all out . . .

..

Tate AGE 14 *VENICE, CA*

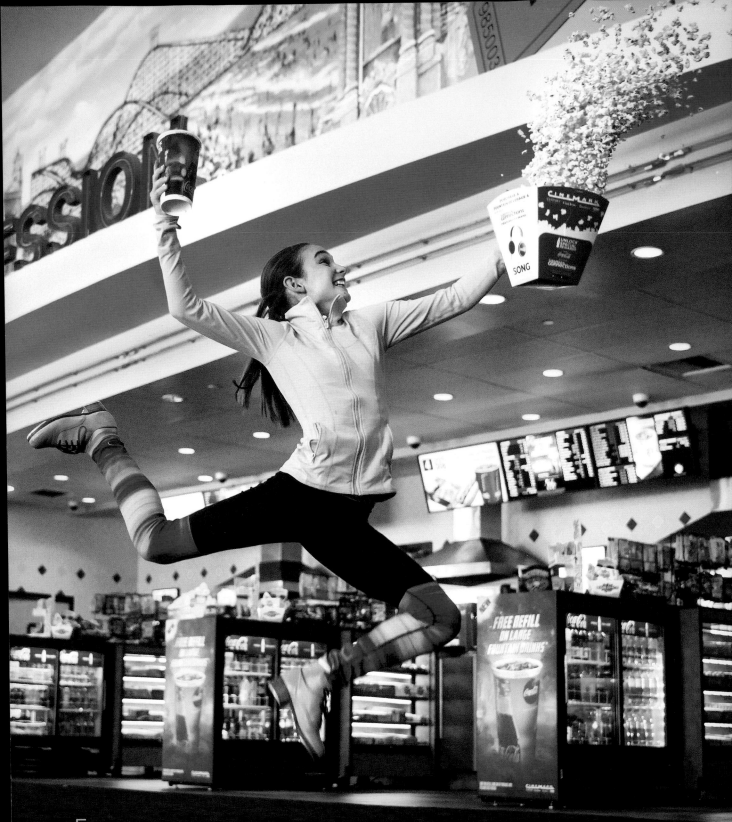

Emma AGE 12 *LONG BEACH, CA*

"oops"

The fear of making a mistake and being teased for it can be paralyzing. It keeps people from taking chances, discovering their abilities, and just having fun. This little four letter word is a miracle. When you make a mistake, and loudly proclaim "oops!" you are telling the world that this wasn't the plan, but what's the big deal? We're all okay, and maybe it's even kind of funny, so let's all be in on the joke. It defuses the tension and allows everyone to enjoy it and then move on.

One of the qualities I admire most in my children is the same quality I like in any other person—their ability to not take themselves too seriously. They are fun, often silly kids—the kind of people I would hang out with even if we didn't share a bloodline. One afternoon, we were all taking a family bike ride. The path abutted a steep cliff, and there was no railing. It was quite treacherous. As we rode, I was lecturing the kids about when it's appropriate to cry. "When you get hurt, sure. But if you don't get a toy or something, not okay." Hudson

got bored quickly and pulled ahead. Going around a corner, he went left and the path went right. Suddenly he disappeared from sight over the edge of the cliff. It was the scariest ten seconds of our lives as we sped to the spot where he vanished. I looked over the edge and saw him hanging onto a bush growing out of the side of the cliff, his bike pressed against him. Shaking, I climbed down quickly and pulled him up. He stood on the path, bloodied and bruised, and looked right at me. We were all in shock. He smiled and asked, "Would it be appropriate to cry now, Dad?"

Here's what kids try desperately to avoid: doing, saying, or wearing the wrong thing, standing out, being silly. Here's what kids should do all the time: do/say/ wear the wrong thing, stand out, be silly. The more you fall down, the quicker you learn how easy it is to get back up. Making mistakes is as natural as breathing, and there is no better educator than failure. So the next time you trip over your shoelace or dramatically fall off your bike, don't hide your face . . . take a bow!

Emma AGE 9 SANTA MONICA, CA

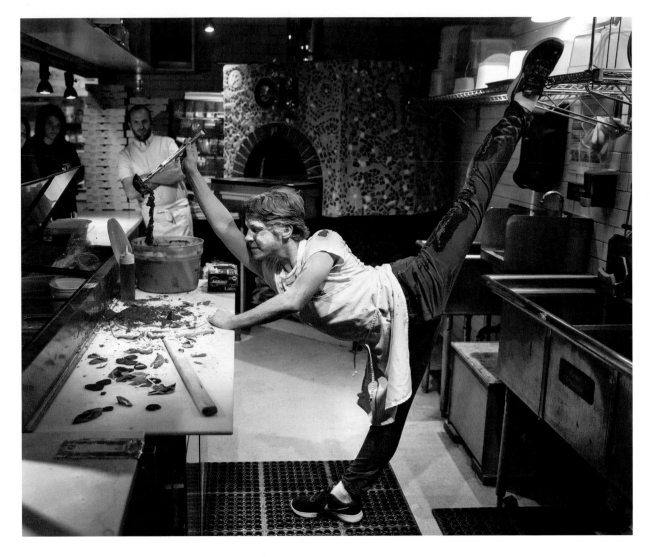

"If you're wondering how this turned out,
I'll tell you this—'Oops' is pronounced
the same in every language."

Zoe AGE 13 *AMSTERDAM, NETHERLANDS*

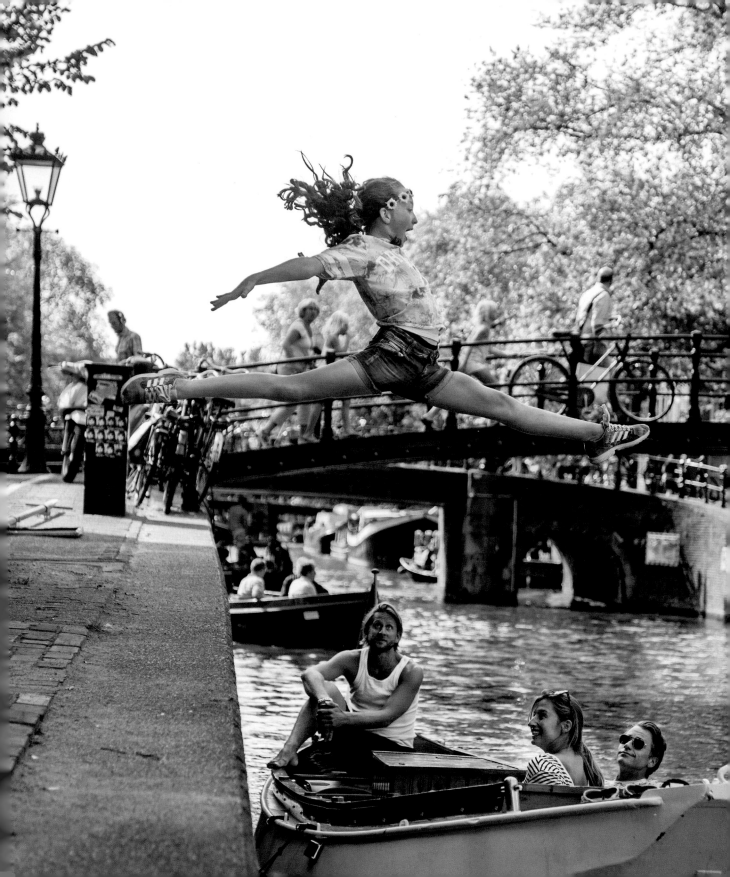

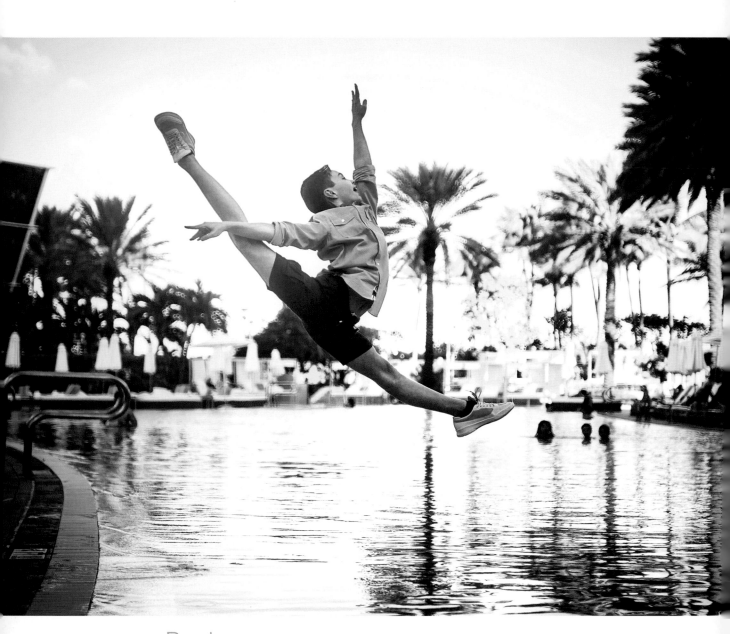

Brady AGE 12 *MIAMI, FL*

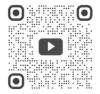

Check out the video!

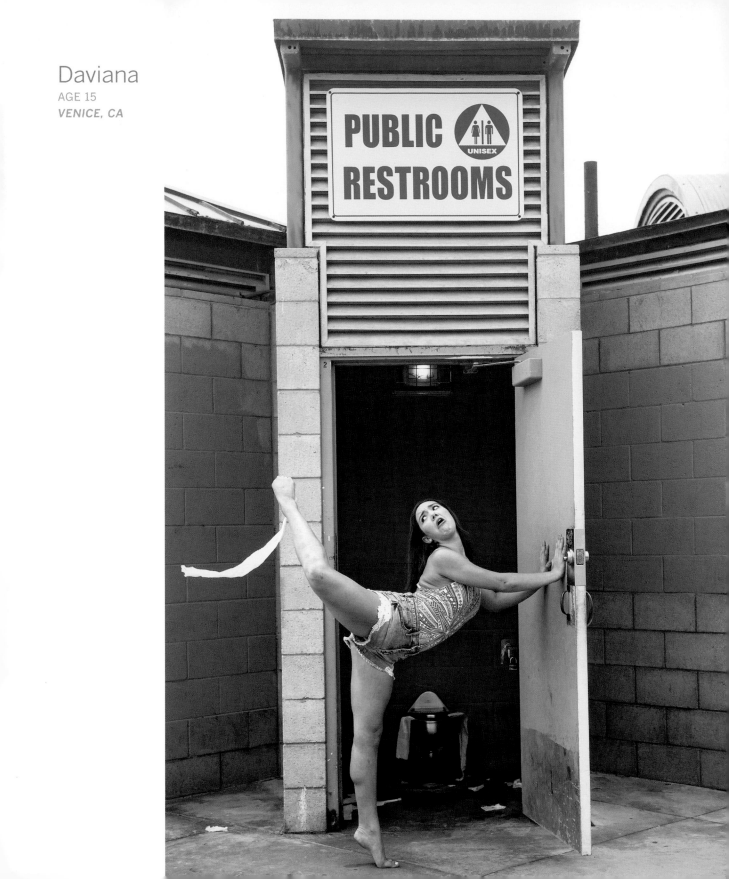

Daviana
AGE 15
VENICE, CA

"Life isn't about waiting for the storm to pass. . . . It's about learning to dance in the rain."

..

Unknown

Elliana AGE 9 NEW YORK, NY

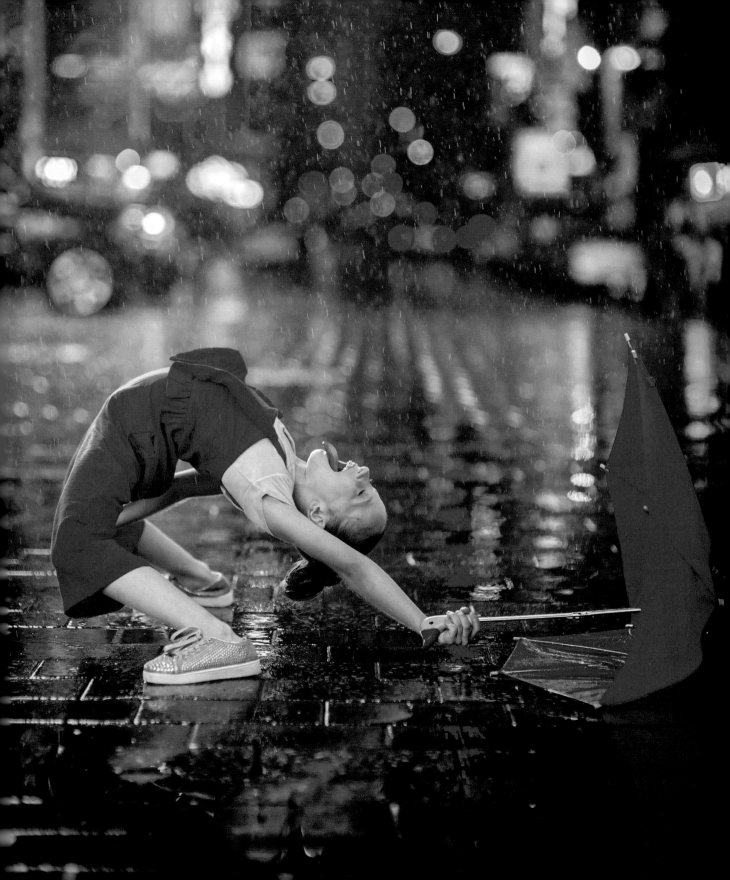

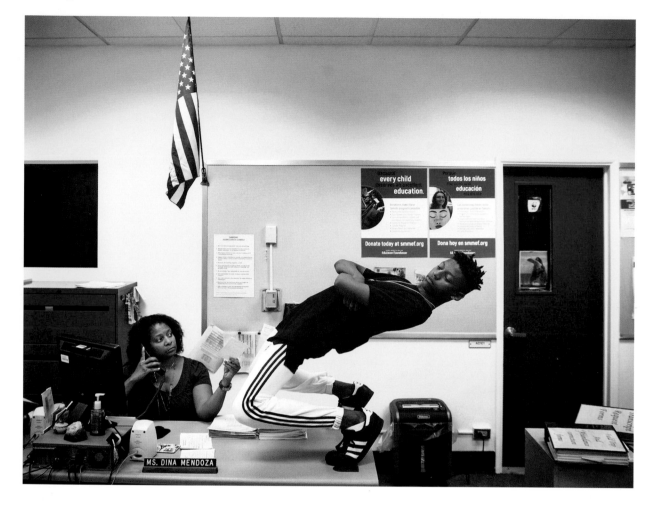

"I hold it, that a little rebellion,
 now and then, is a good thing."

Thomas Jefferson

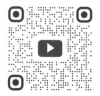

Check out the video!

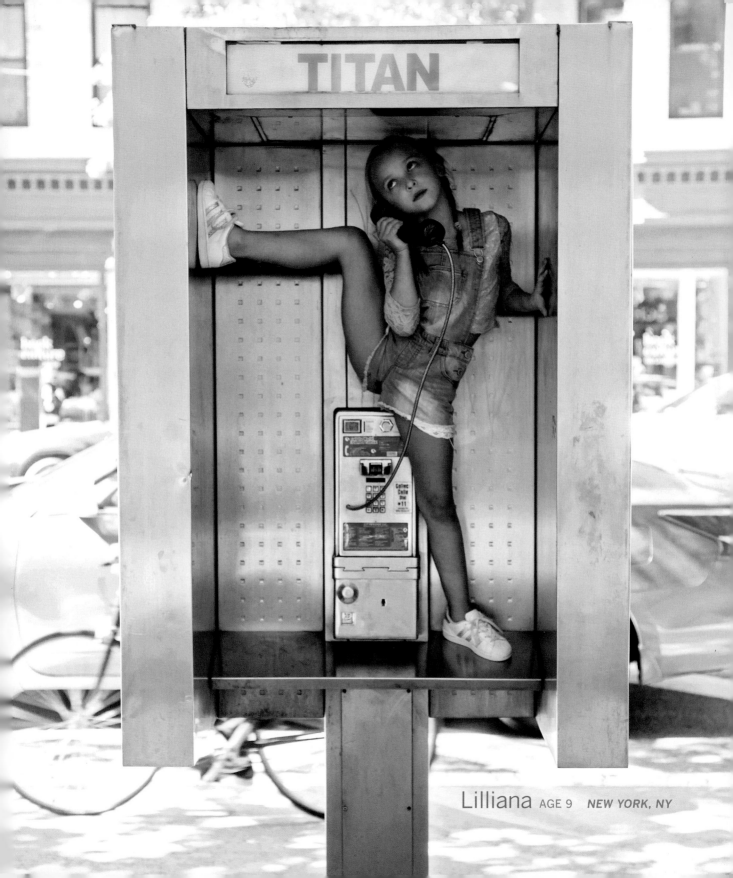

TITAN

Lilliana AGE 9 NEW YORK, NY

"Sometimes things happen that make you want to cry—or laugh. Laughing is more fun."

..

Ava AGE 16 *MIAMI, FL*

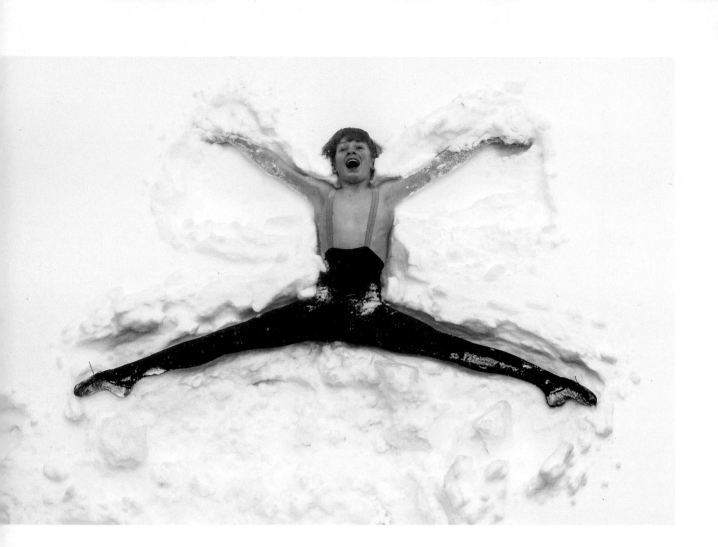

"I'd rather do the unexpected and have fun than have good manners and be predictable."

···

Angus AGE 10 *NYACK, NY*

Check out the video!

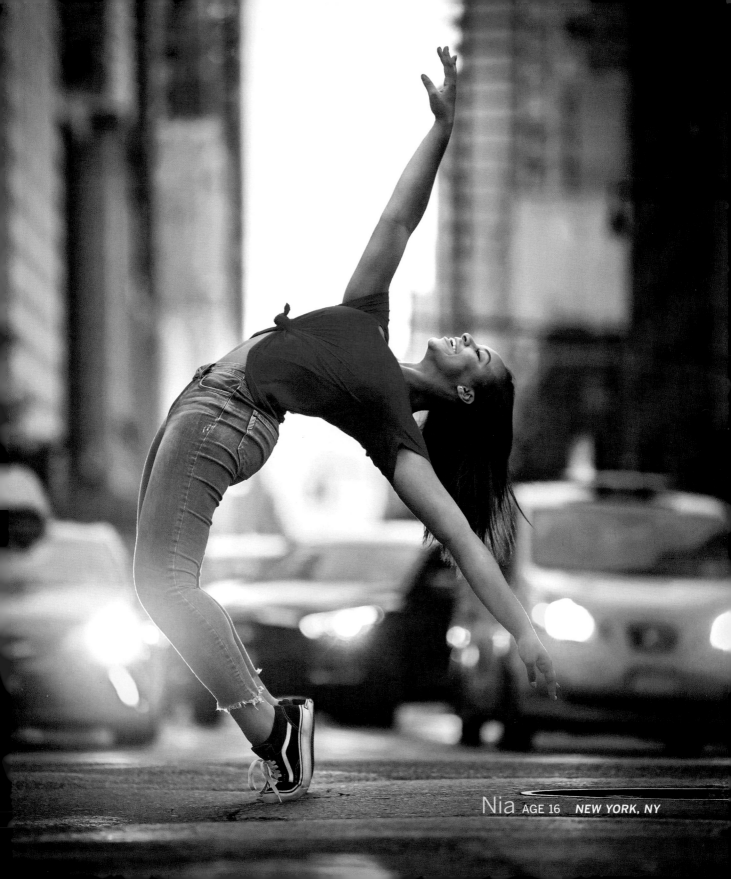

Nia AGE 16 *NEW YORK, NY*

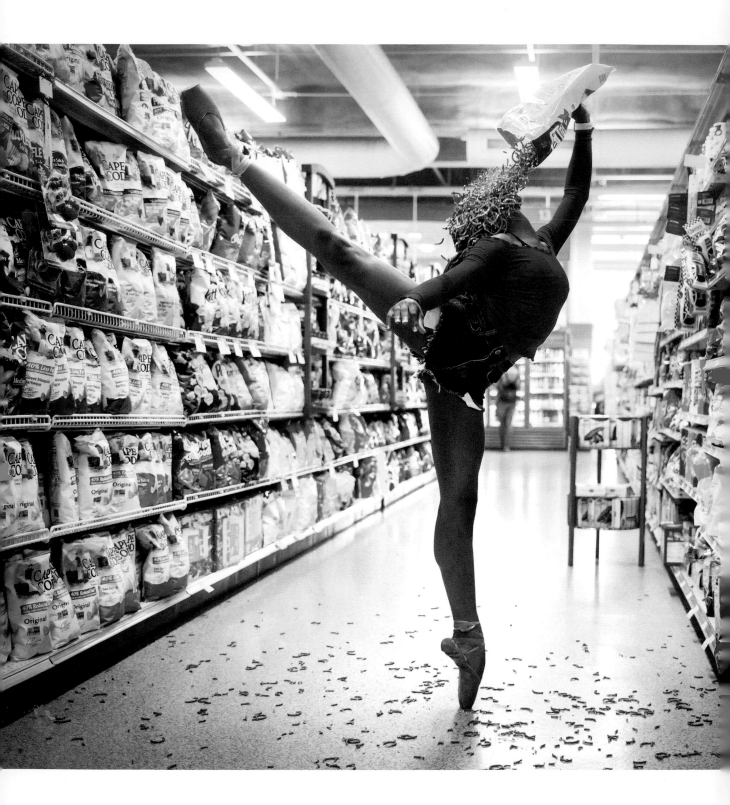

"Mistakes are the price we pay for pursuing our dreams. It is better to say 'oops' than to wonder, 'what if.'"

..

Maddie AGE 12 *MIAMI, FL*

Check out the video!

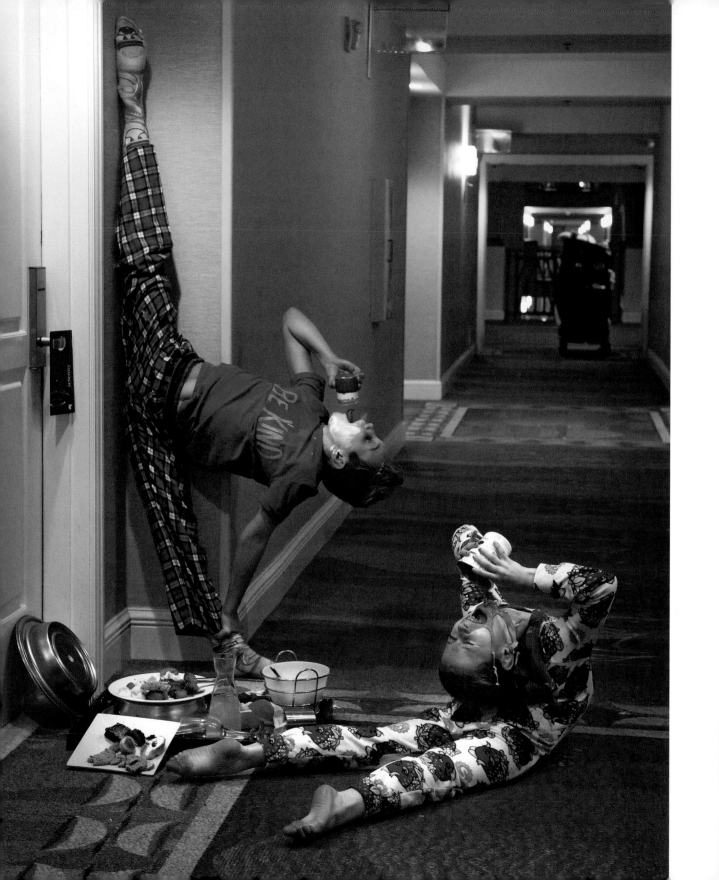

Elliana AGE 10 Brady AGE 12 *PHOENIX, AZ*

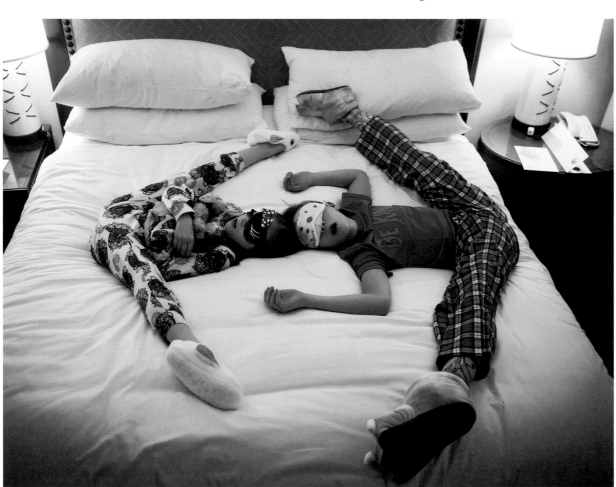

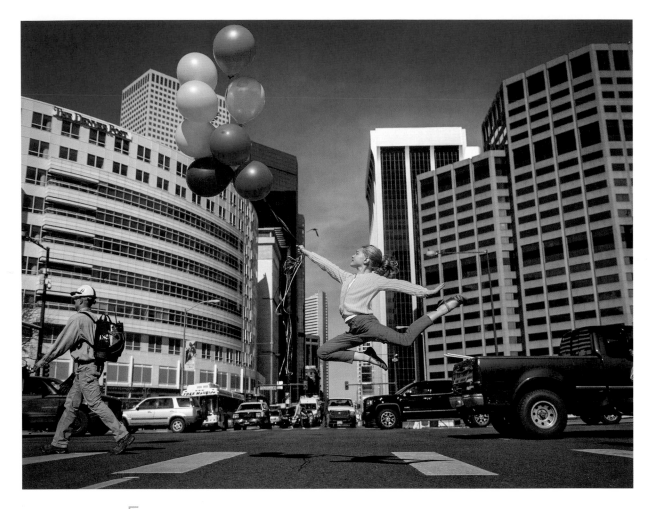

Emmy AGE 9 *DENVER, CO*

Camryn, Faith, Daija, Jaylene AGES 17 TO 18 *JACKSON, MS*

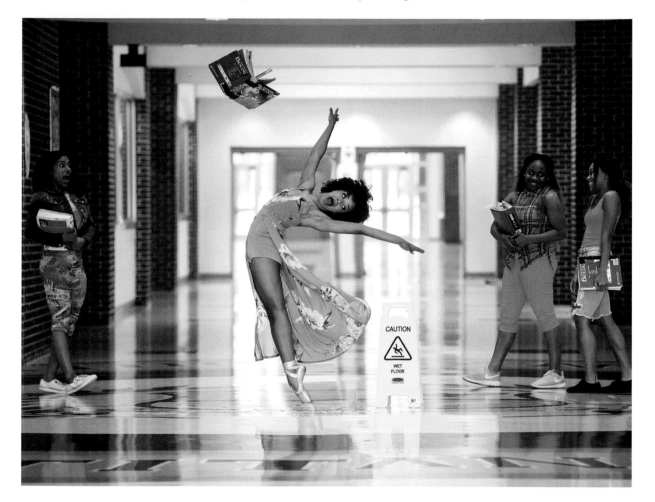

Check out the video!

"When you feel like you missed out on something, just remember, a bus makes a lot of stops."

...

Elliana AGE 10 NYACK, NY

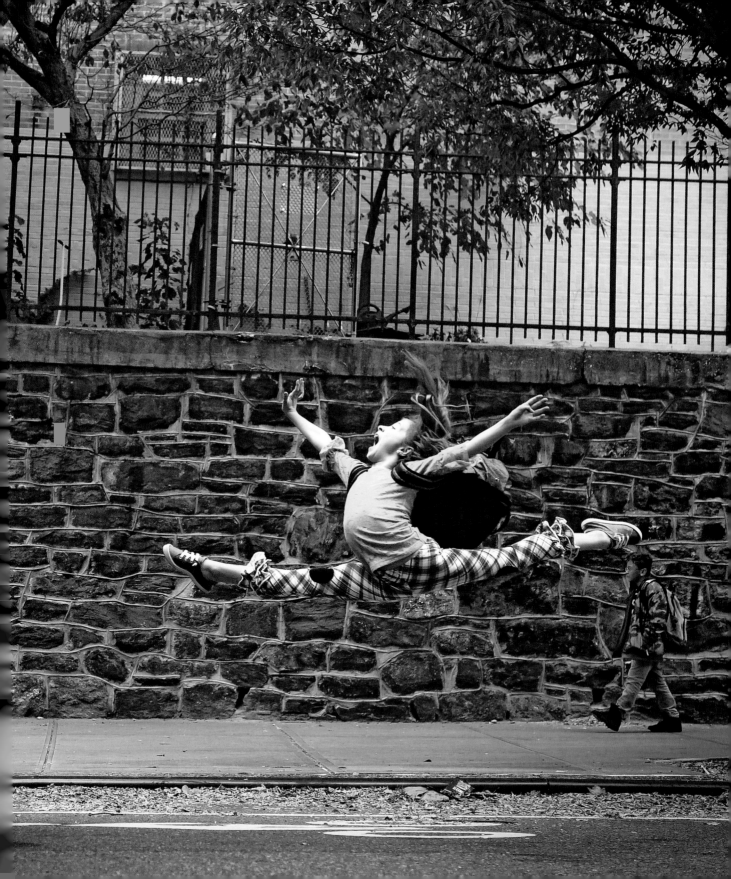

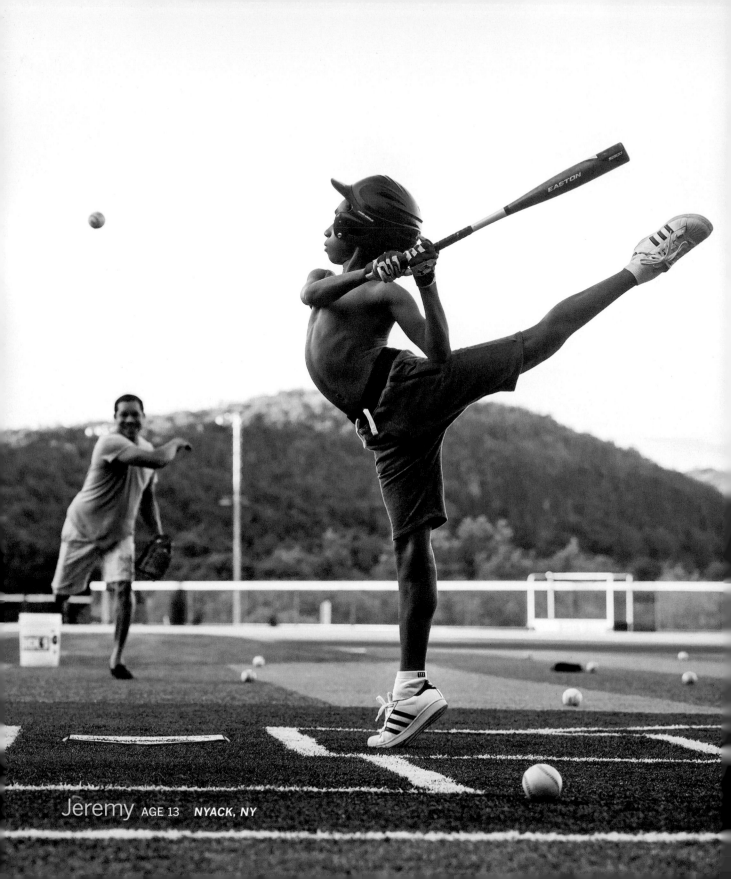

Jeremy AGE 13 NYACK, NY

"i can do it"

My son ran toward the plate and then stopped suddenly. He adjusted his helmet and gripped his bat tightly, the only indication that he was feeling the pressure. It was the last inning, bases loaded, two outs. He took two deep breaths and stepped into the batter's box.

Hudson was one of the youngest kids in a league of skilled players, and he was seeing limited playing time as a result. It was torture to watch him navigate the emotions I remember so vividly—the fear of failure, the pain of ridicule, the burden of self-doubt. Yet he made a commitment and had to see it through. There were valuable lessons to be learned through struggles like this.

As he stepped into the batter's box, I hoped he would remember what we had practiced. He was so close to where I was standing that I could just call out to him, remind him of his mechanics or give him words of encouragement. But this was his moment, his challenge. He didn't look at me, and I said nothing. He swung three times, tentatively, and the game was over. The helmet hid his face, but his body couldn't hide his pain.

On the drive home he was hysterical, determined to never play baseball again. We tried to talk about getting back up after you fall down and the pride we felt in his effort, but he heard nothing.

Jalyn AGE 13 **LOS ANGELES, CA**

I learned two immensely valuable lessons through baseball—repetition and resilience. If you work hard enough and refuse to quit or be discouraged by failure, you will succeed. I realized that words were not helping Hudson learn these lessons, so I turned the car around.

"What are you doing?" he mumbled.

"I'm taking you back to the field."

"What? No, Dad, really. Please," he pleaded.

I parked the car. Hudson was apoplectic. He had no choice but to follow me, but I couldn't make him swing. He stood at the plate, enraged, refusing to take the bat off his shoulder. I threw pitches. He glared at me. It was a stand-off.

"I can't do it. I'm terrible," he screamed.

I wanted to give him a hug and absorb his pain. "It doesn't matter," I said instead. "You don't have to be better than anyone else, you only have to try to be better today than you were yesterday. Can you do that?"

"I don't know." He swung softly and missed.

"You can do it! You're a little stronger than you were yesterday, a little bigger, a little tougher. Can you swing a little harder?" I implored.

"I don't know!" he yelled. He swung hard and missed.

"That was it!! You did it. You couldn't swing that hard yesterday!" I yelled back.

His eyes flared, and he attacked the next pitch. He sent it into the outfield. His tension relaxed, just a bit. "I can do it," he mumbled.

"Can you do it again?" I asked.

He swung harder, and sent it flying farther. I looked at him. He smiled. We stayed for an hour, and the next morning he woke me up early for batting practice.

When Hudson played in the last game of the season, he came up to bat again with two outs in the last inning. The pitcher was the best in the league. He ran confidently to the plate. I was standing in the same spot, and this time he looked right at me.

"I can do it," he said.

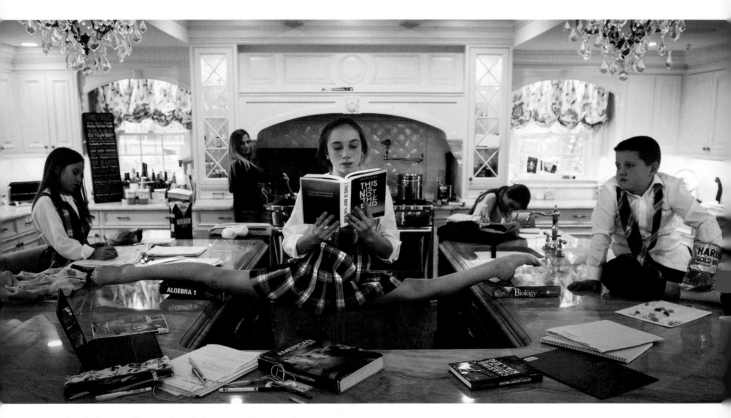

Ashley, Sarah, Hannah, Luke
AGES 8 TO 13 *NORTHPORT, NY*

"Follow your heart and do it. Don't let anyone stop you. If you've got the passion for it, you can accomplish anything."

Sofie AGE 16 *HOLLYWOOD, CA*

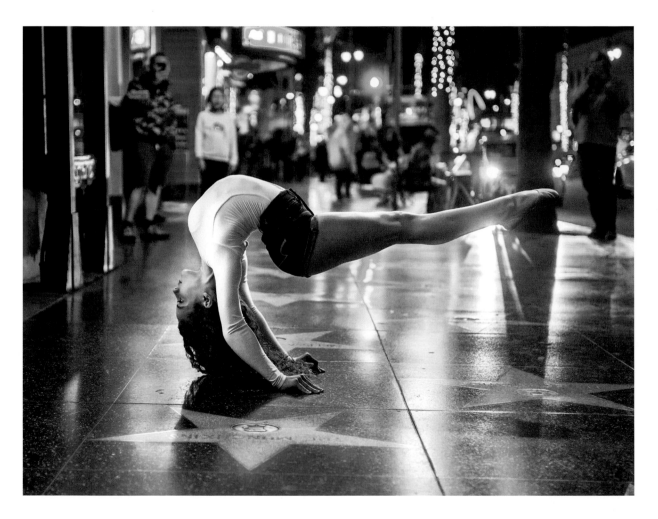

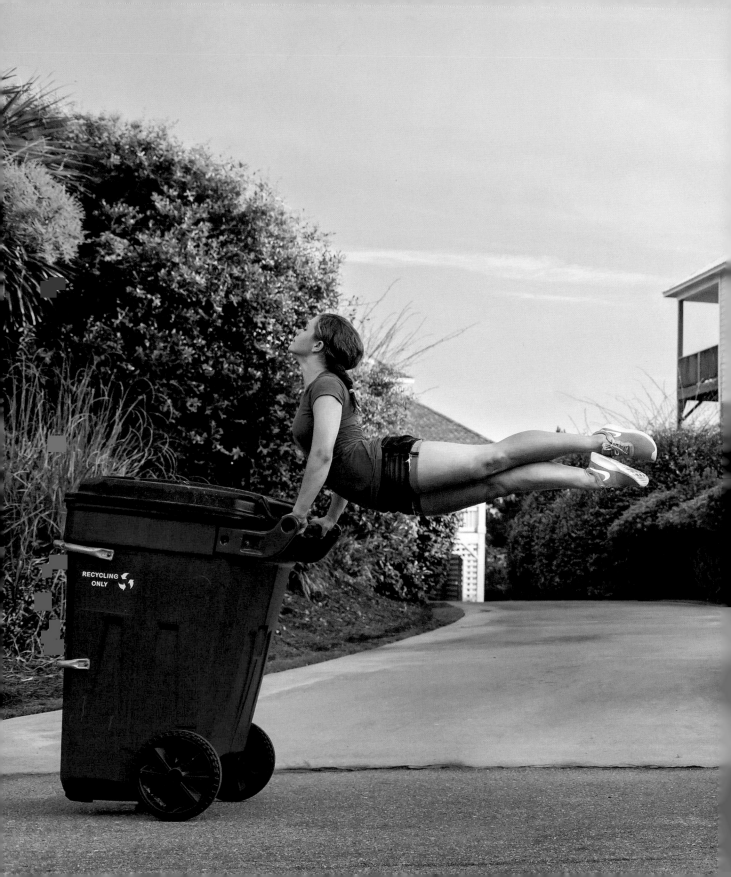

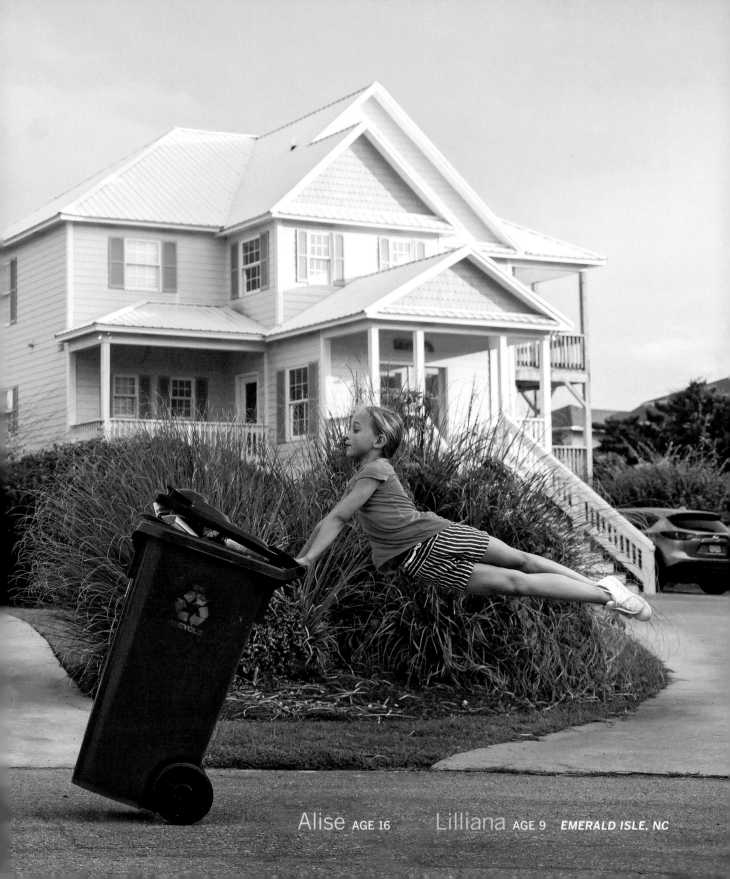

Alise AGE 16 Lilliana AGE 9 EMERALD ISLE, NC

"When I was first diagnosed with leukemia, I had a lot of anxiety about the future, but a special nurse gave me amazing advice, which was not to worry about the things I can't control. I truly believe that those are words everyone should live by. They apply directly to me and how I can't spend the rest of my life in fear of relapse. It also applies to the dance world, where all you should worry about is practicing, working hard, and conveying your passion."

Aliyah AGE 18 *NEW HYDE PARK, NY*

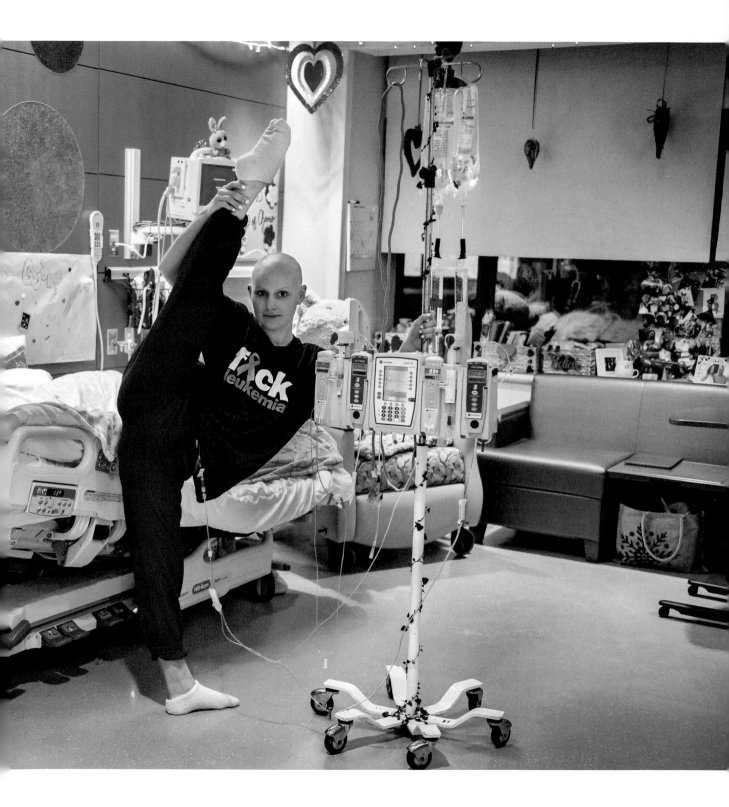

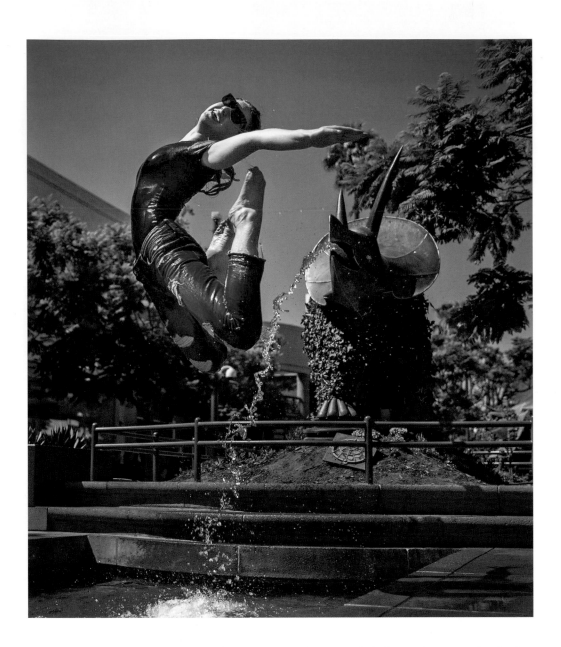

"To anyone who has ever been told that they can't do it, that they shouldn't do it, or they aren't good enough— ignore it, do it anyway, and prove them wrong."

Chloe AGE 15 *LOS ANGELES, CA*

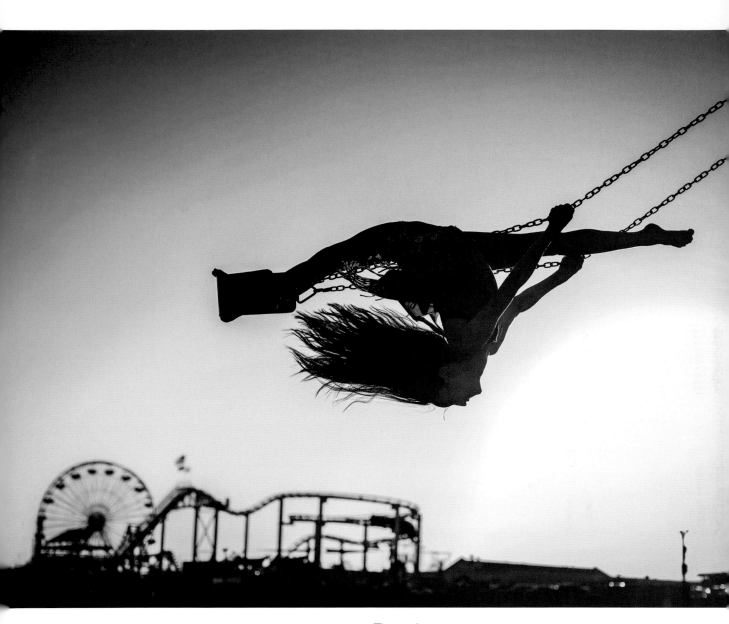

Perris AGE 12 *SANTA MONICA, CA*

> "Life isn't just about taking in oxygen and giving out carbon dioxide."

Malala Yousafzai

Soleil AGE 9 STEAMBOAT SPRINGS, CO

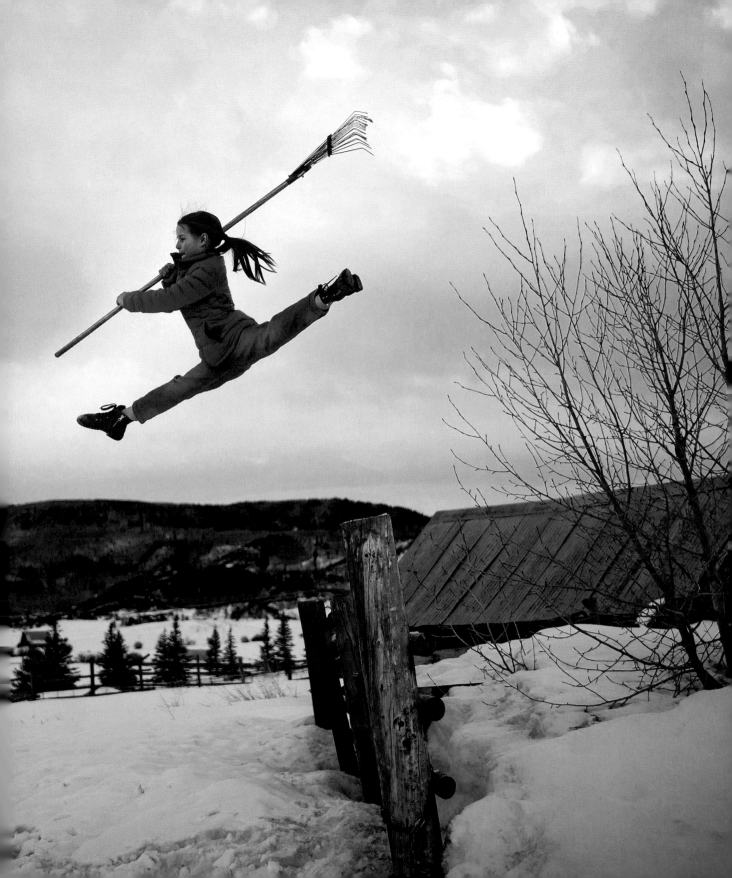

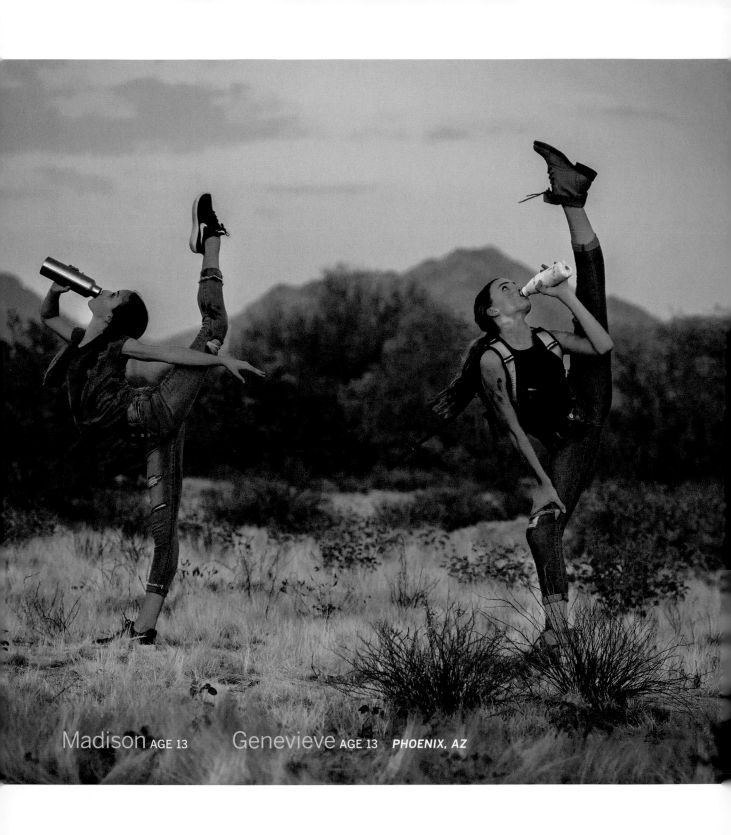

Madison AGE 13 Genevieve AGE 13 PHOENIX, AZ

"Everybody needs beauty as well as bread, places to play in and pray in, where nature may heal and give strength to body and soul alike."

John Muir

Salish AGE 8 *NYACK, NY*

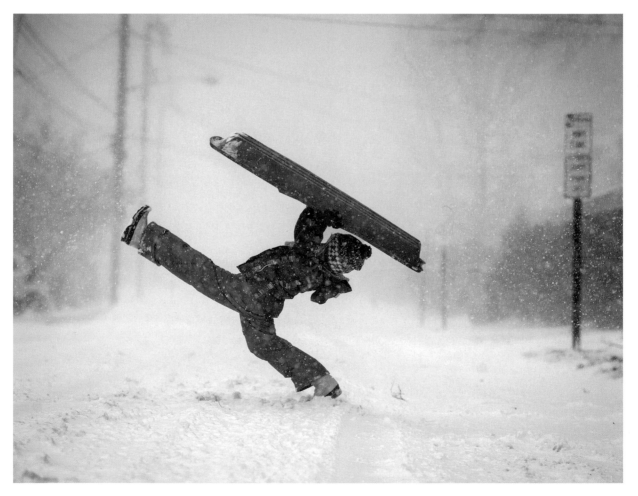

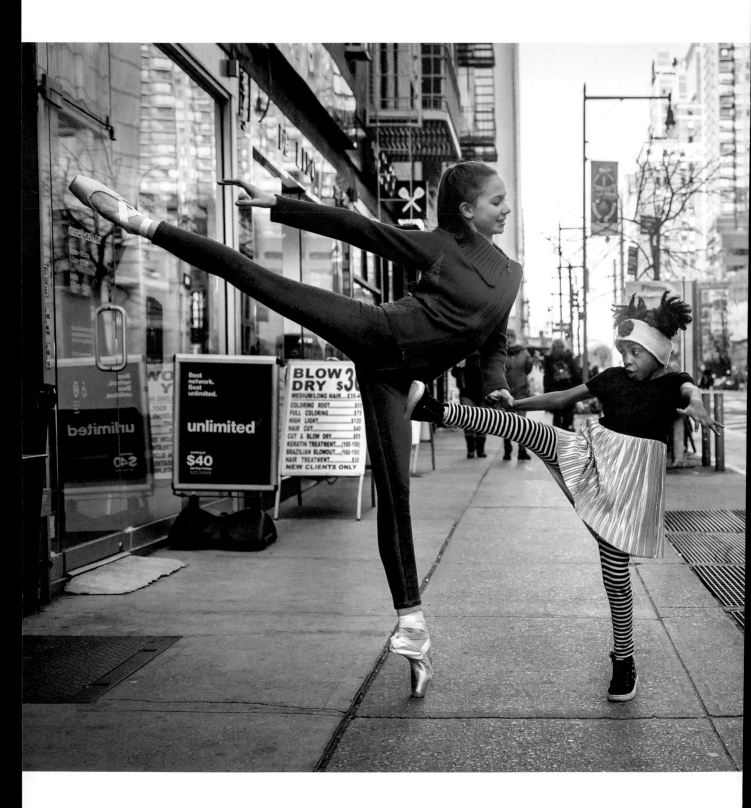

Jamie AGE 16 *PRINCE EDWARD ISLAND, CANADA*

"Those who make no mistakes are making the biggest mistake of all—they are attempting nothing new."

···

Anthony de Mello

Dakota AGE 12 Gloria AGE 5 *NEW YORK, NY*

"My parents always told me, 'If you have a dream, you can make it happen.' I was the first Indonesian to be invited to the Youth American Grand Prix Finals at Lincoln Center. I was really scared because I felt as if I had the weight of my country on my shoulders. And then I won first place! We do not have enough money for my parents to travel to see me compete, but I know they are proud of me."

Rebecca AGE 11 NEW YORK, NY

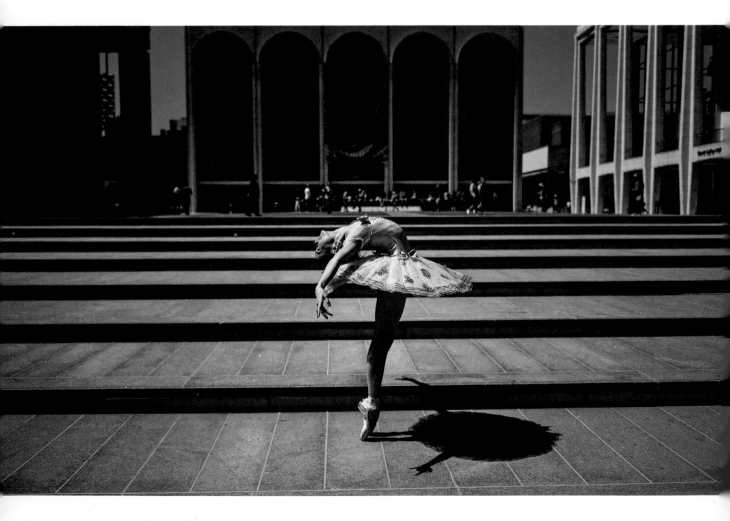

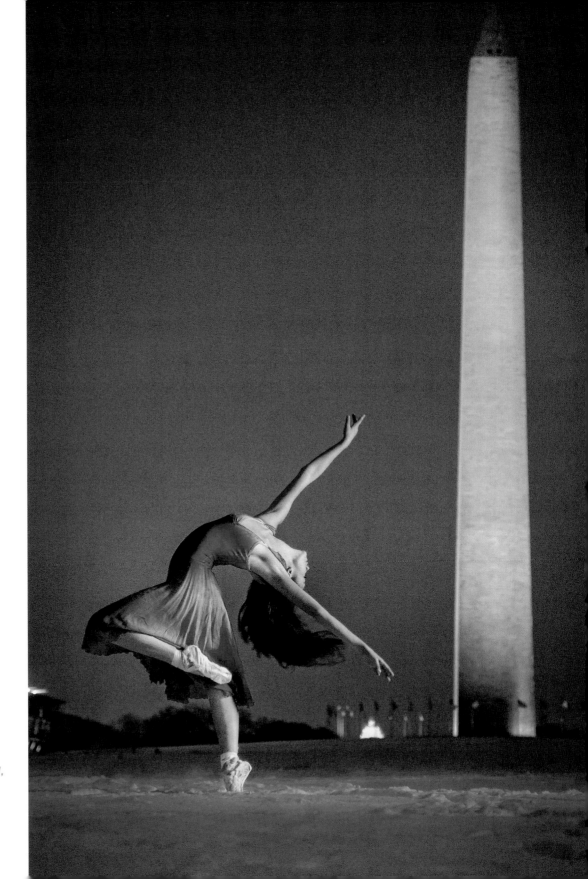

Jessica
AGE 14
*WASHINGTON,
DC*

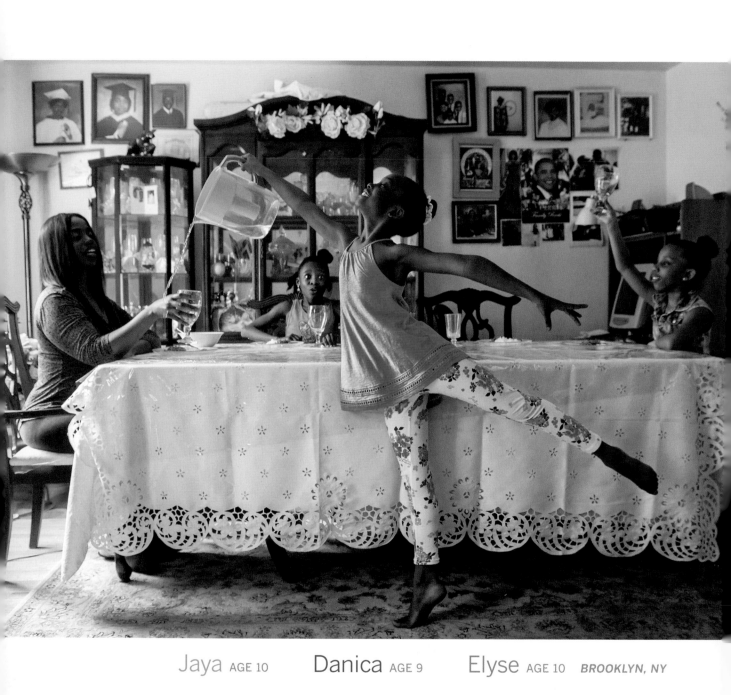

Jaya AGE 10 Danica AGE 9 Elyse AGE 10 *BROOKLYN, NY*

Caroline AGE 14 *EMERALD ISLE, NC*

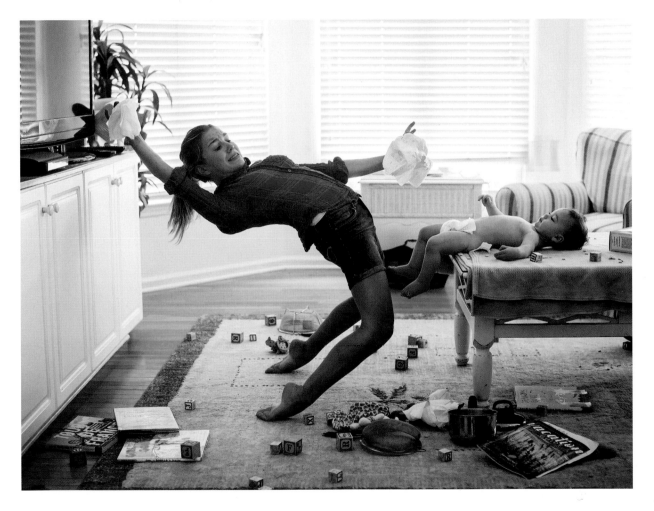

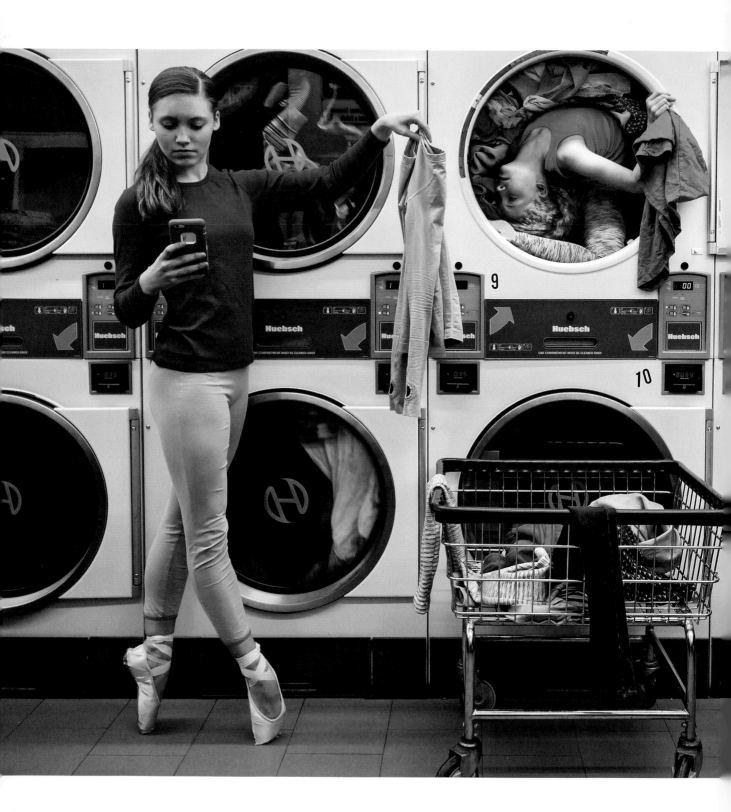

Michelle AGE 17
Rachel AGE 11
NEW YORK, NY

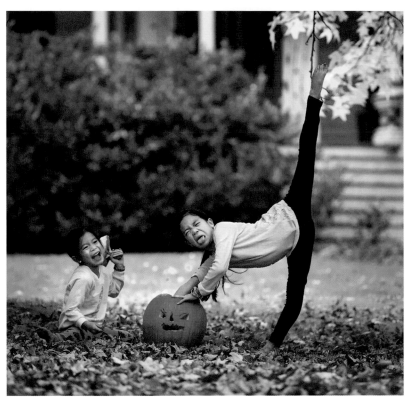

Naomi AGE 7 Michaela AGE 11 **NYACK, NY**

"Every child is different. But if an eight-year-old in pioneer times could chop firewood, yours can certainly put his underwear in a drawer."

Unknown

> # "What we learn with pleasure we never forget."
>
> Alfred Mercier

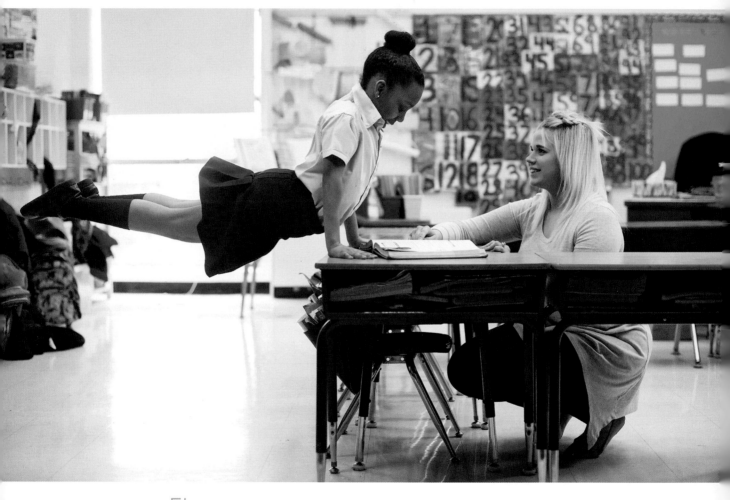

Elyse AGE 10 *BROOKLYN, NY*

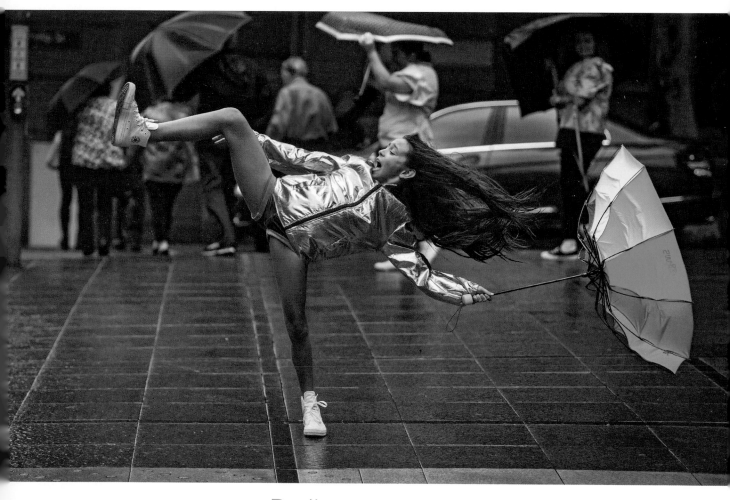

Baylie AGE 12 *SYDNEY, AUSTRALIA*

"The only real mistake is the one from which we learn nothing."

John Powell

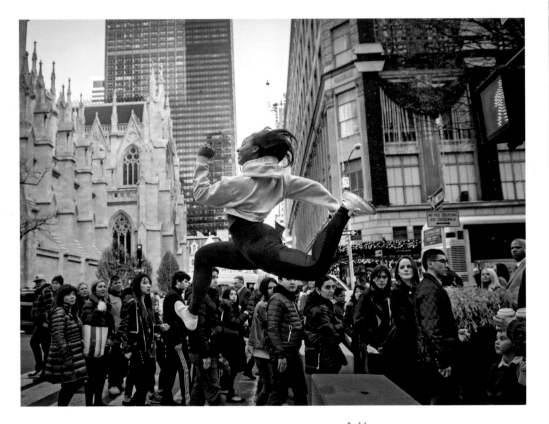

Nia AGE 16　*NEW YORK, NY*

Check out the video!

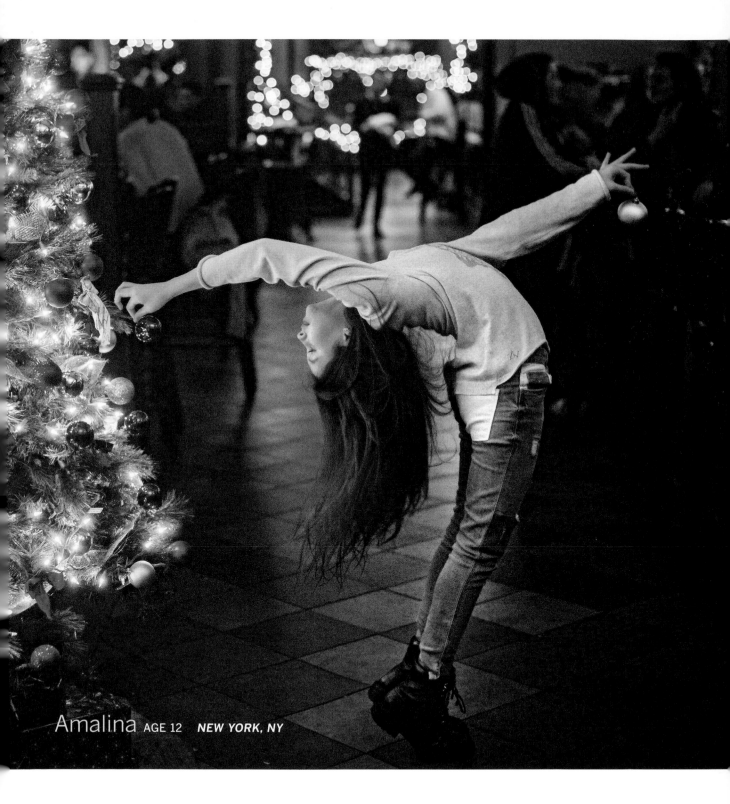

Amalina AGE 12 *NEW YORK, NY*

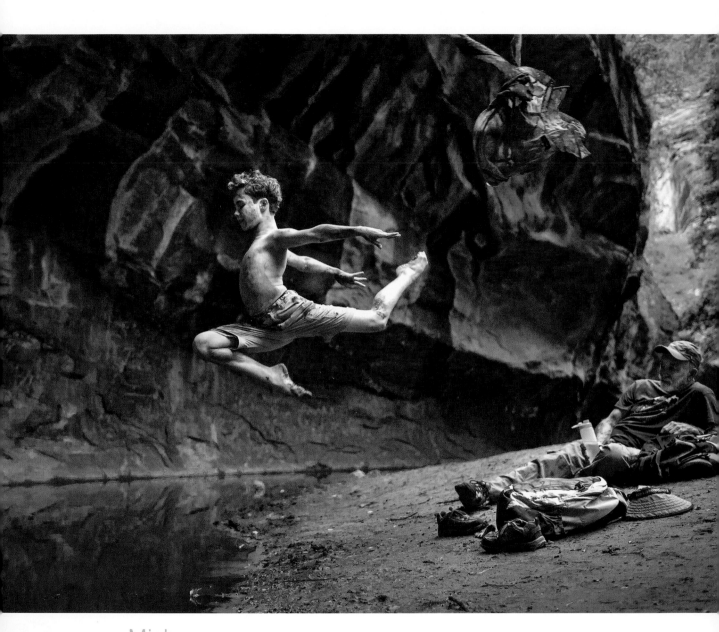

Misha AGE 12 *SEDONA, AZ*

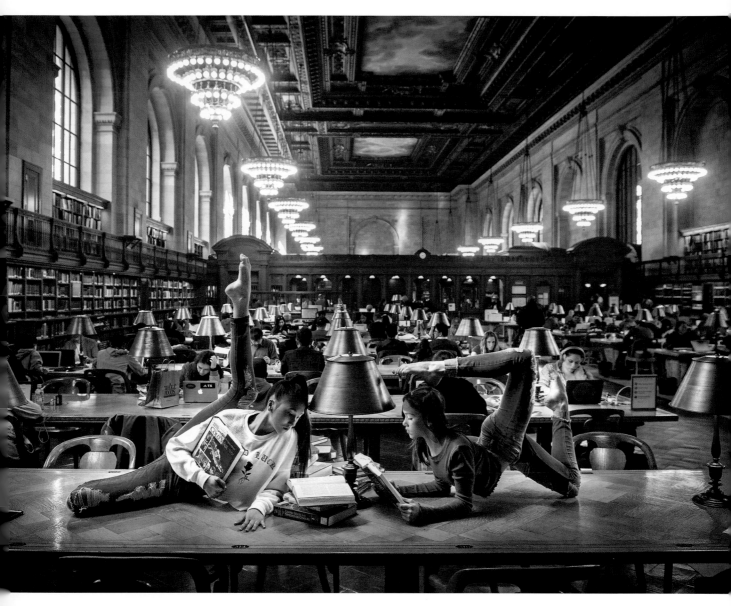

Check out the video!

"Most dancers are skinny, and I'm not. I think a lot of people can relate to me because of that. I've been told to quit dance multiple times and I haven't. Dance is something I've wanted to do forever. If I'm a good dancer, I don't think my body type should affect my opportunities."

Lizzy AGE 16 *NEW YORK, NY*

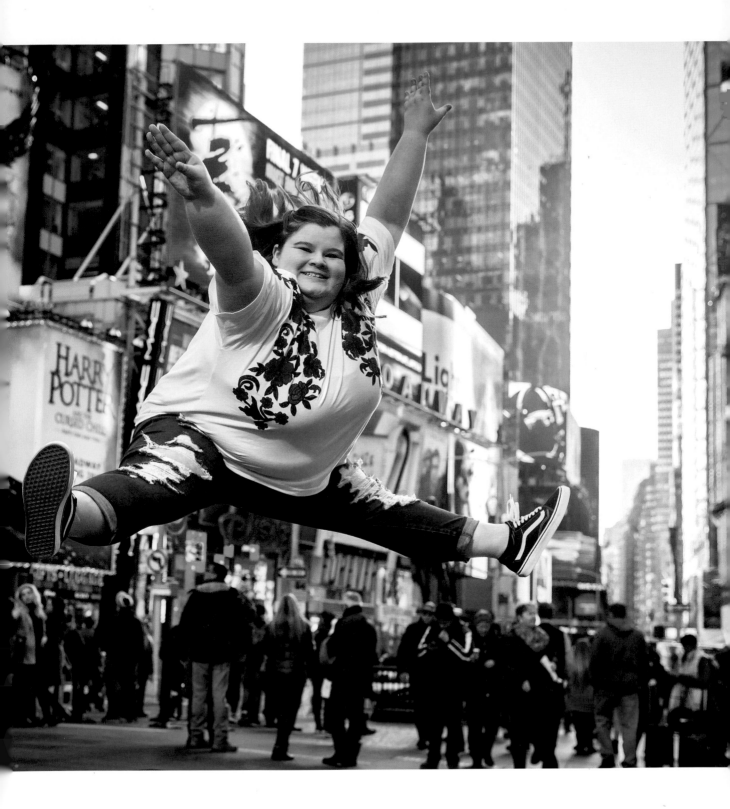

Z'Yanah AGE 11 BROOKLYN, NY

"i'm such a nerd"

Chris was my best friend in middle school. We were utterly inseparable. We met on the baseball field, and spent summers on the beach and weekends in town. His family was stable, and mine was chaotic. He lived in an awesome house, and I lived in a motel room. He was a total nerd. And so was I.

The two coolest kids in school, Doug and his older brother, Jerry, ruled the halls of Malibu Park Junior High. They were blond, athletic, tough, and popular with girls. To say we ran in different circles would be a comical understatement. I never even dared to look at them, unless from a distance. They were middle school gods.

One spring weekend my father surprised me with a rare gift—I was going to baseball camp. He told me the night before that Sheriff Tom would pick me up at 8:00 a.m.

I panicked. Everyone knew Sheriff Tom. He was Doug and Jerry's father.

"Why is he picking me up?" I mumbled.

"He's taking his kids," he replied, "so I thought you'd like to ride with them."

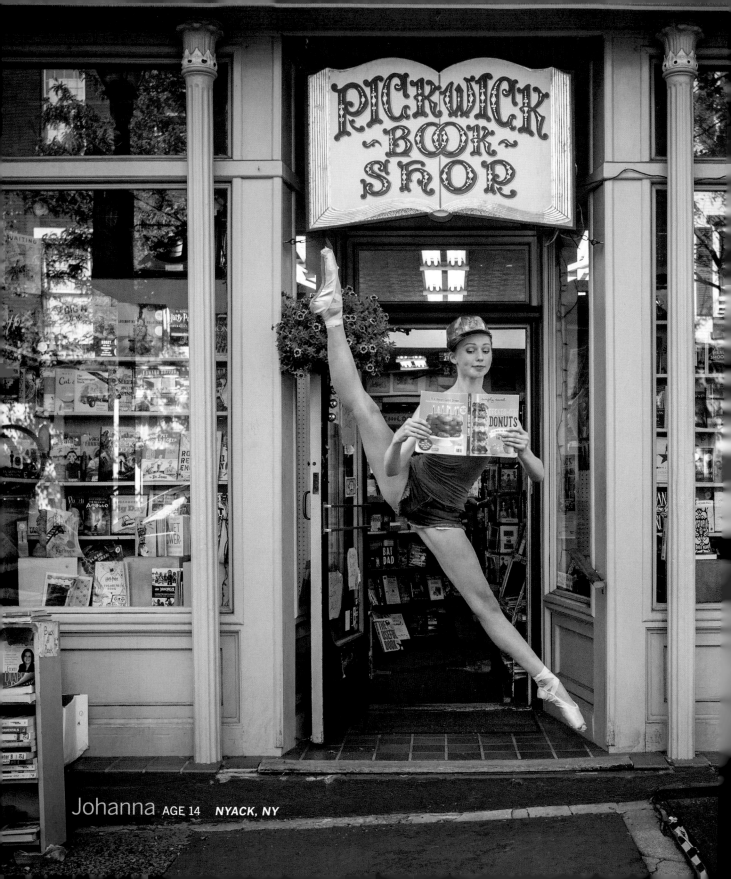

Johanna AGE 14 NYACK, NY

I woke up an hour early, tried on ten different baseball caps and drank three glasses of milk. The blast of a car horn startled me. I grabbed my baseball card collection and ran through the door.

The ride to camp was awkward. I showed off my Hank Aaron baseball card, and Jerry looked at it like it was a blank piece of paper. We sat in silence.

It was sweltering as we stood in line at camp. Without thinking, I did something that would have made Chris roar with laughter—I poured water down my shirt. Doug smiled. Emboldened, I poured more down my pants. Doug laughed. Even Jerry smirked. Suddenly, I realized that I didn't have to be cool. I could be funny.

What happened when I got back to school still haunts me. I ditched Chris. I ran the opposite direction at lunch, and I stopped meeting him after school. I was Doug's friend now, entertaining him and the cool crowd with silly antics. I cut Chris from my life without explanation.

Popularity is a drug. For adolescents it can feel like the most important thing in the world, and they will be ruthless in their pursuit of it. Yet the nerds, the ones who are not preoccupied with adoration at every turn, are allowing their minds to develop more fully. Kids flock to the gods and cheer their every gesture, yet the ease with which attention comes to them can make them lazy. It is the nerds who flourish as they mature into thoughtful teens, and they are the ones who should be celebrated.

Many years later I reconnected with Chris on Facebook. He is a sucessful entrepreneur and a volunteer at an after-school program. It is no surprise he found fulfillment in his life. After all, he was a nerd.

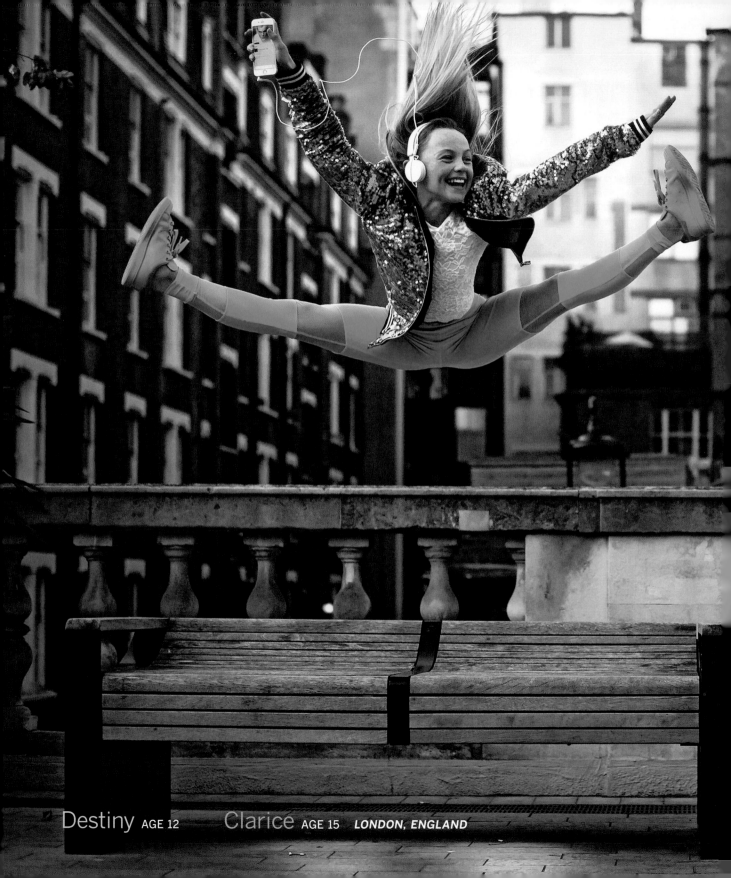

Destiny AGE 12 Clarice AGE 15 **LONDON, ENGLAND**

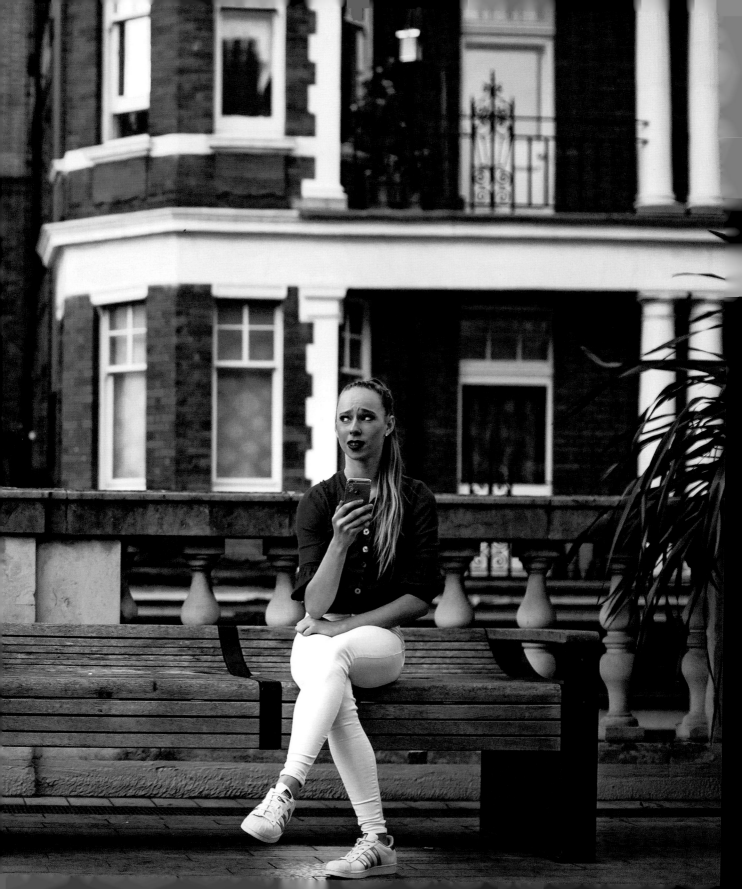

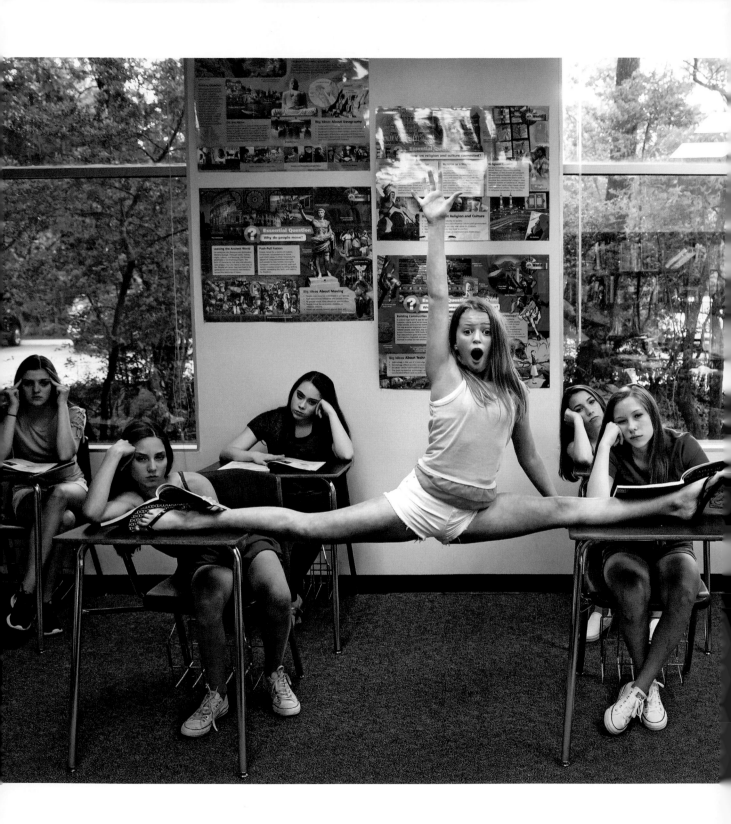

> **"The wildest colts make the best horses."**
>
> Plutarch

Maggie AGE 11 *THE WOODLANDS, TX*

> "Now I am not a nerd or anything, but I can use the CFOP method of F2L, OLL, and PLL to solve a Rubik's Cube in under 20 seconds."

Misha AGE 11

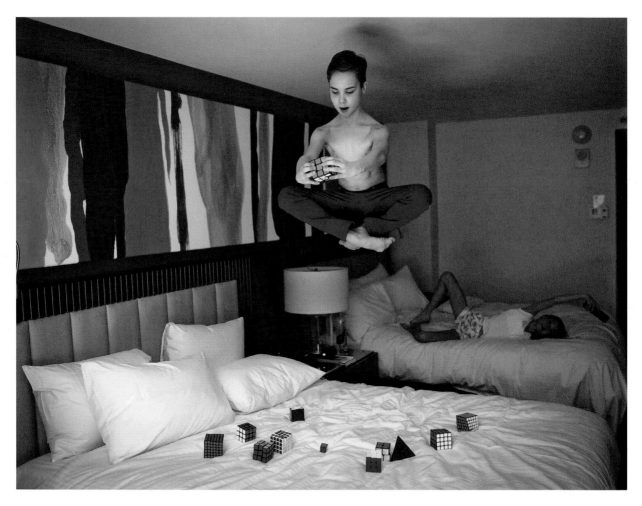

Misha AGE 11 Ava AGE 12 *NEW YORK, NY*

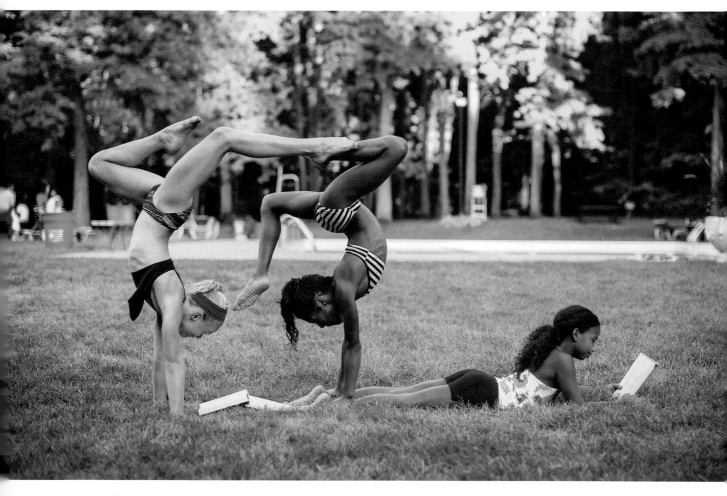

Cornelia AGE 10 Annalise AGE 10 Eliana AGE 9 *PALISADES, NY*

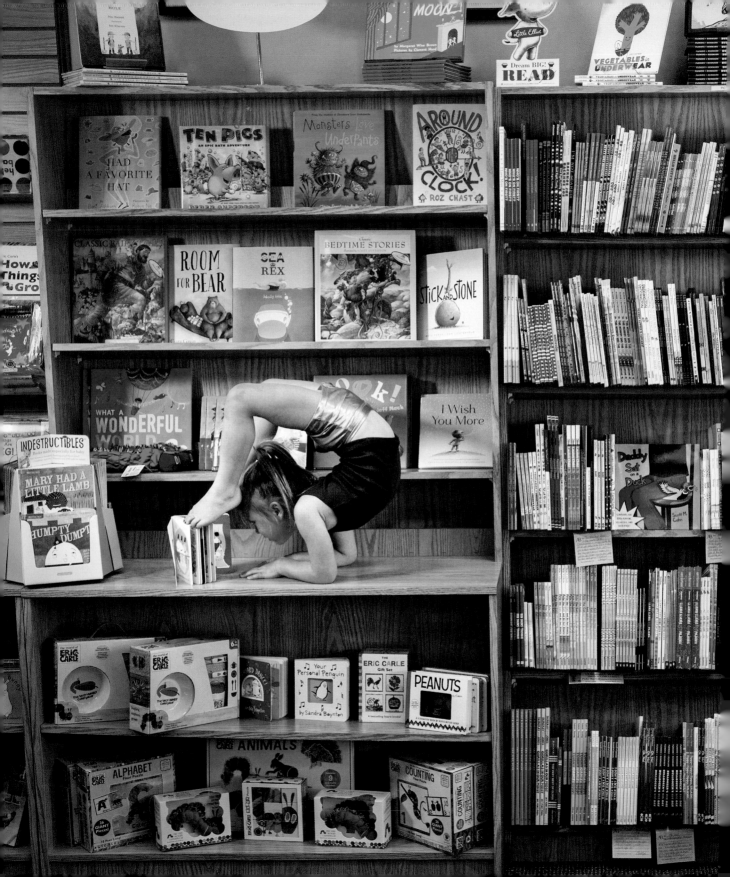

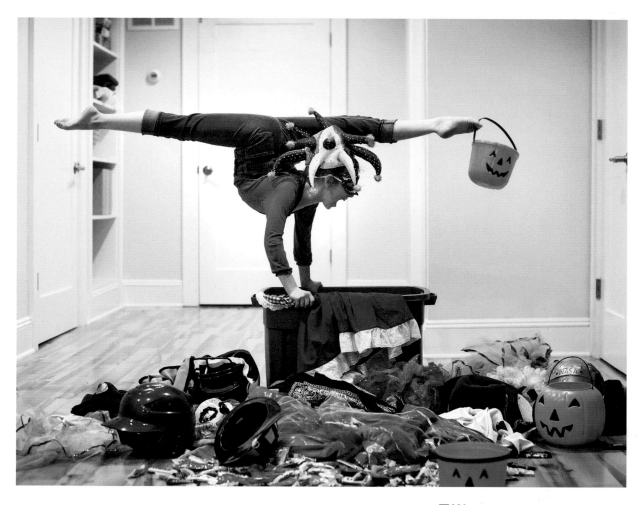

Elliana AGE 10 NYACK, NY

"Invention . . . is 93 percent perspiration,
6 percent electricity, 4 percent evaporation,
and 2 percent butterscotch ripple."

Roald Dahl

Adeline AGE 4 CHICAGO, IL

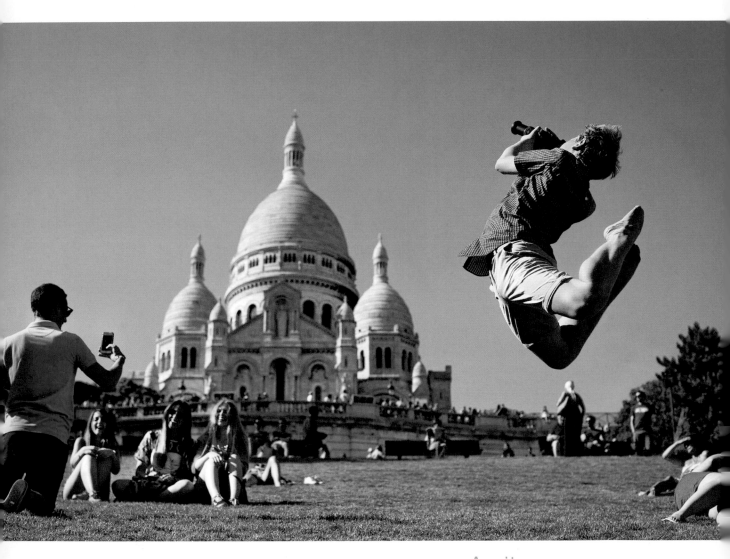

Amit AGE 13 *PARIS, FRANCE*

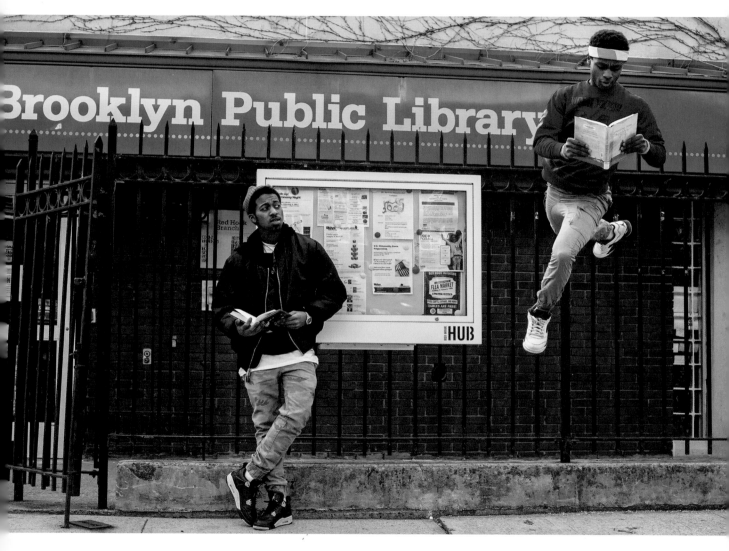

"I've noticed that when I choose to be myself and move to the beat of my own drum, that's when I'm the happiest and when I find true friends and true success."

Alexandra AGE 12 **NYACK, NY**

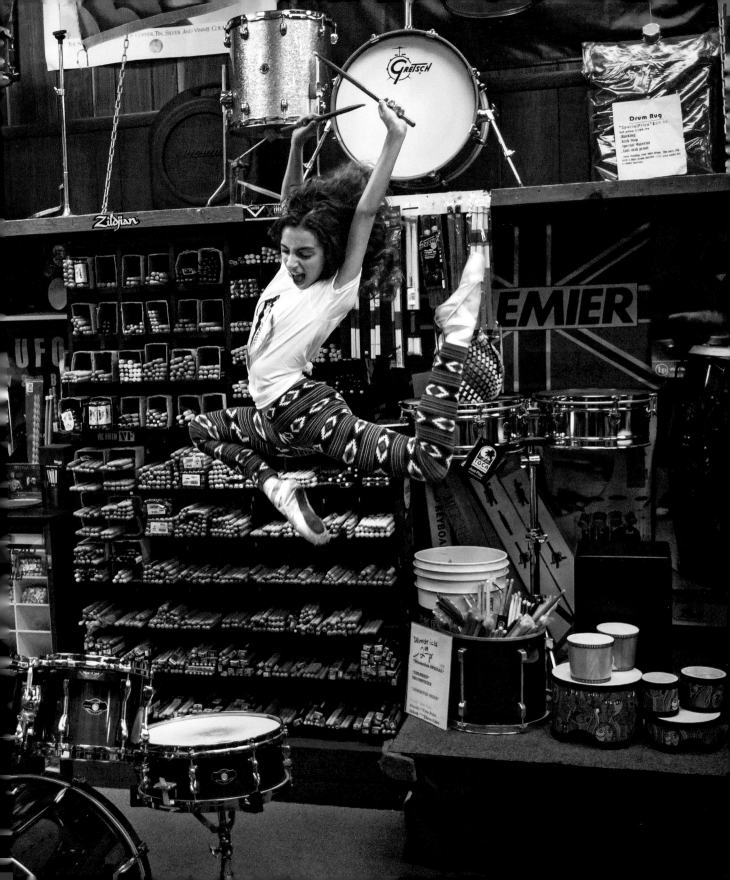

Brady AGE 12 Mason AGE 13 *MIAMI, FL*

"The brain is like a muscle. When we think, we feel good."

..

Carl Sagan

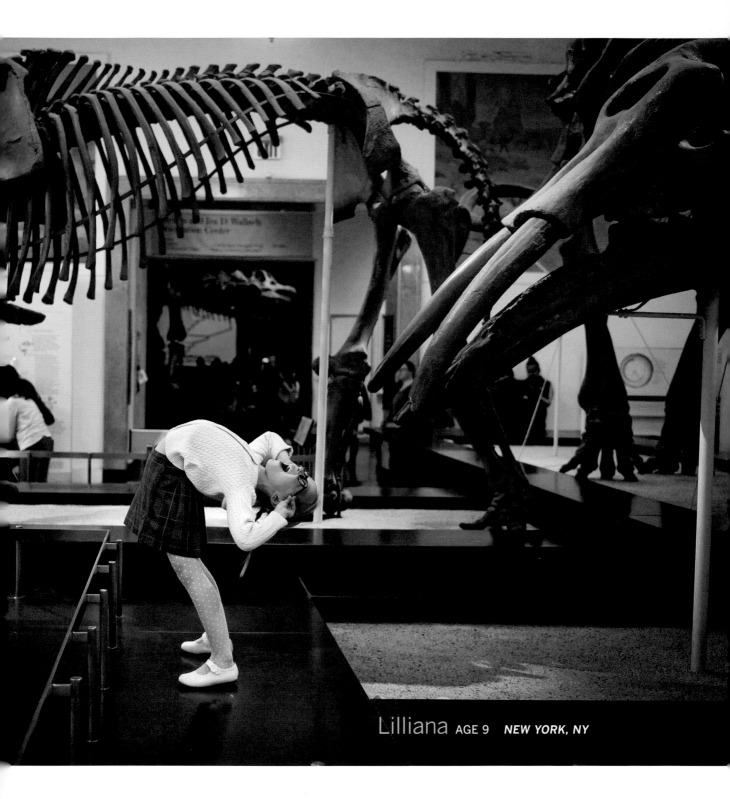

Lilliana AGE 9 NEW YORK, NY

Caroline AGE 13 Lily AGE 14 *RYE, NY*

Check out the video!

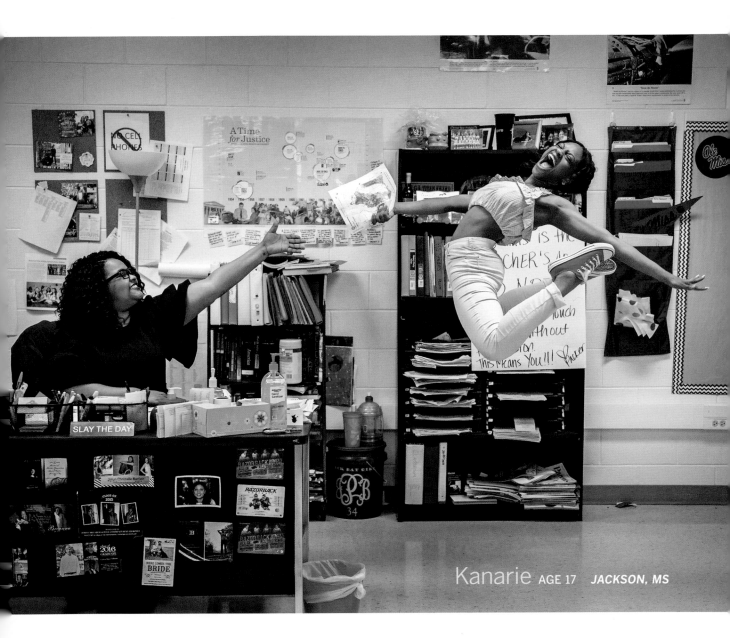

Kanarie AGE 17 *JACKSON, MS*

"That is happiness; to be dissolved into something complete and great."

Willa Cather

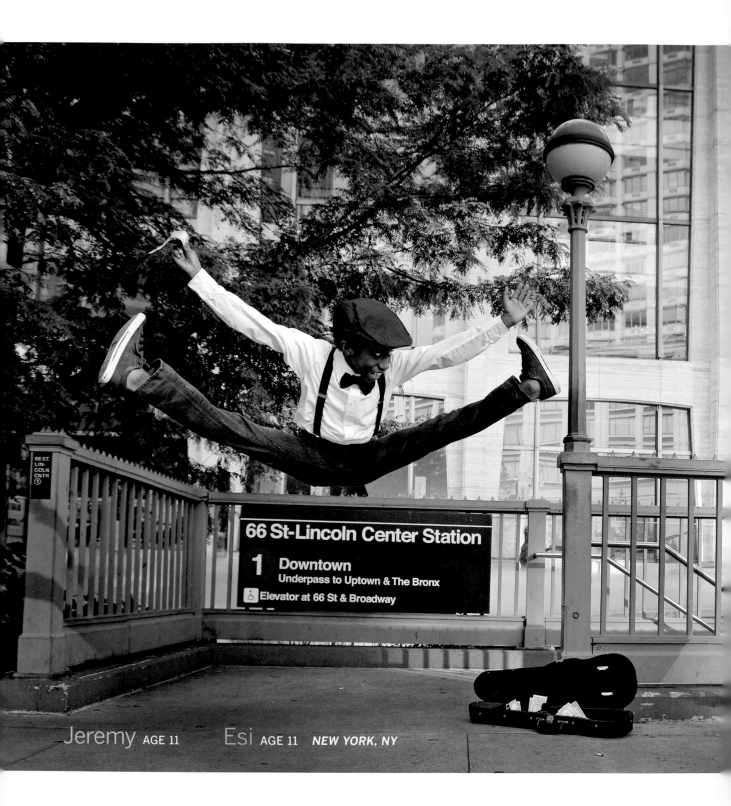

Jeremy AGE 11 Esi AGE 11 NEW YORK, NY

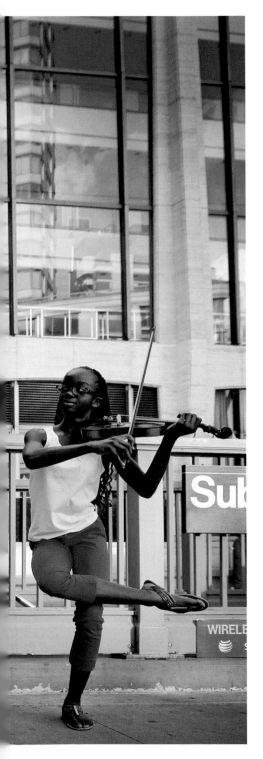

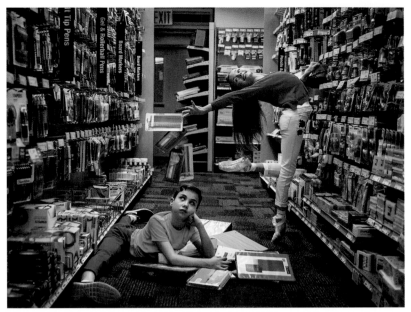

Misha AGE 11 Ava AGE 12 *NEW YORK, NY*

"Be the kind of person who makes other people step up their game."

Jeremy AGE 11

"Nerds are the new 'it' group. We're smart, and we make thick-framed glasses look good."

Dakota AGE 12 *NEW YORK, NY*

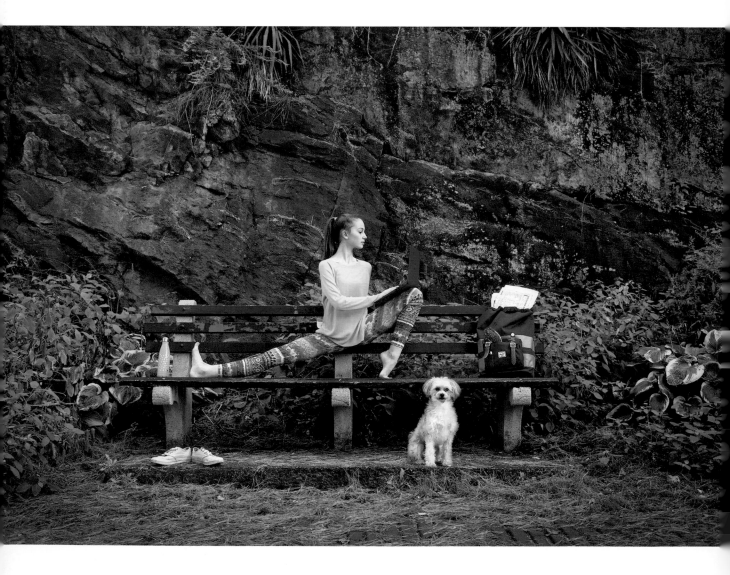

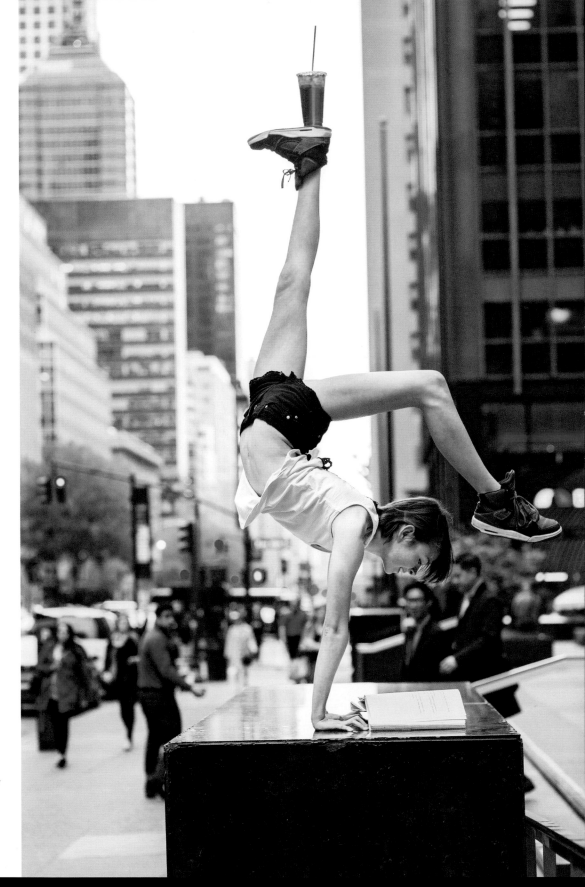

Maria
AGE 14
NEW YORK, NY

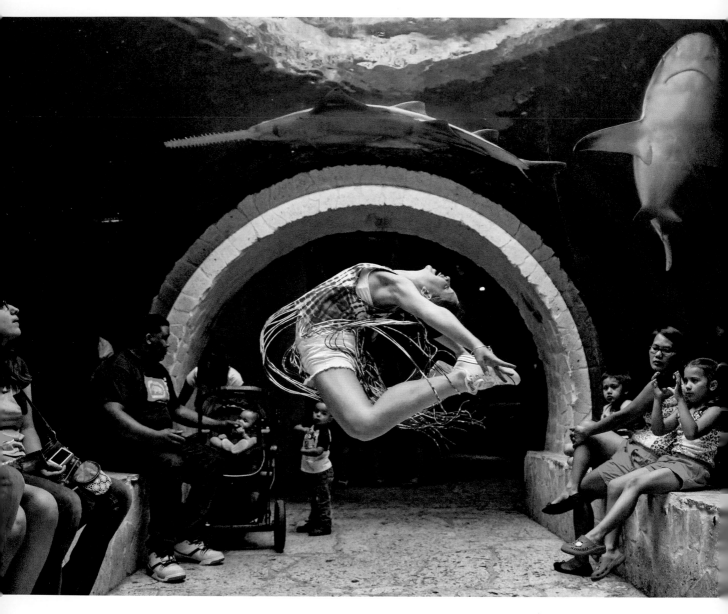

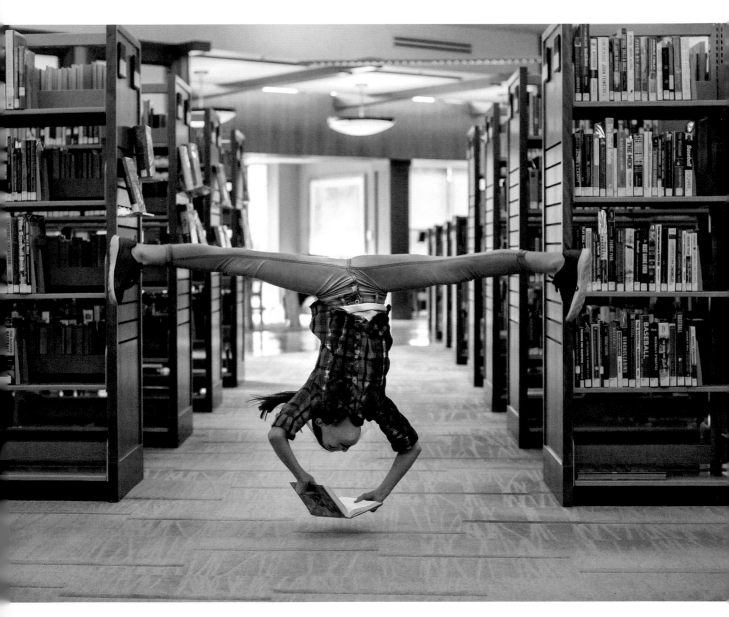

Soleil AGE 9 *STEAMBOAT SPRINGS, CO*

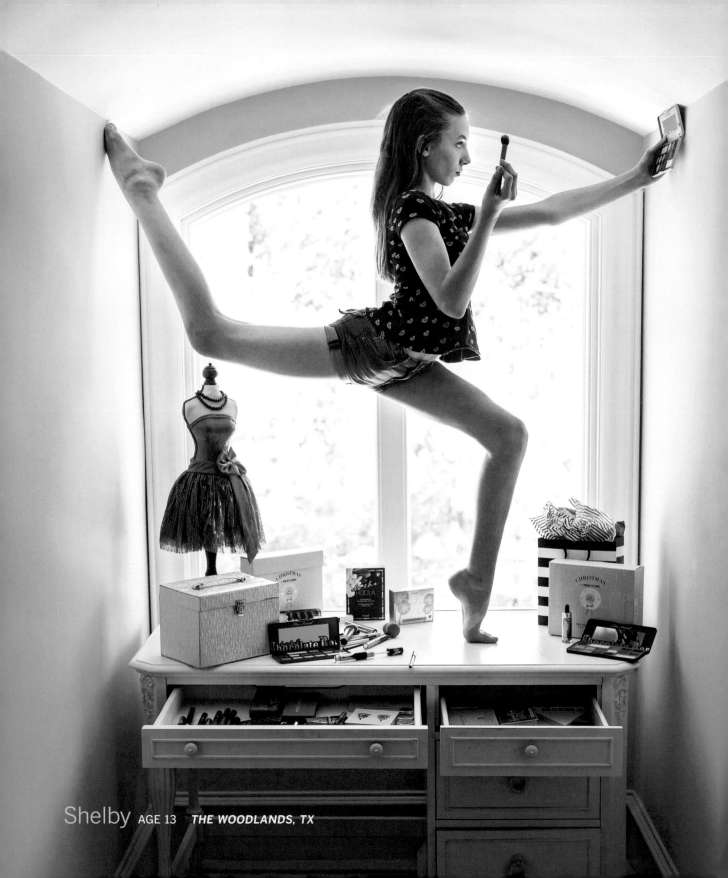

Shelby AGE 13 *THE WOODLANDS, TX*

"do they like me?"

I was a twelve-year-old boy sitting on a school bus, fighting back tears as I pretended not to notice that my hair was being tied in knots. The entire bus seemed to shake with laughter. The interminably long ride finally ended with showers of spit raining over me as the bus pulled away.

When I got home, my father was waiting with a baseball bat. "Want to go hit some balls?" he asked.

"Oh yeah," I said, my teeth clenched and my hair still in knots.

I had been bullied for as long as I could remember. I was a shy, skinny kid with bright red hair and a funny name, a million freckles covering an otherwise alabaster

body. Always the new kid in town, I was an irresistible target. Yet no matter how difficult my day had been, I found solace on the baseball field, where I had one simple objective: to learn how to hit the ball as hard and as far as I possibly could. Over the years, I spent countless hours pursuing that goal.

I had a good swing, but I missed many more balls than I hit. Luckily I had a willing partner in my father, and the sheer volume of pitches he threw taught me more about life than any parental wisdom he could impart. I kept on hitting. The years of practice allowed me to discover greater potential than I knew existed. My skills grew, as did my confidence. The bullying stopped. Paramount to my athletic accomplishments is the lesson I learned during those late afternoons on the field: Find what you love to do, and the mere repetition of that act will instill in you a confidence that will become infectious to everyone around you. I stopped caring if people liked me once I realized that I liked myself.

Dancers often tell me a similar story. The personal qualities that draw them to dance—artistry, creativity, and sensitivity—are easy to mock, and they can find themselves subjected to intense cruelty. Ironically, dancers are among the most confident and interesting people I know. Spending their days in the studio, building and reinforcing their skills and character, shields them from the pettiness and negativity that usually define adolescence. As a result, they often have a mature perspective on life and a greater capacity to feel and express joy.

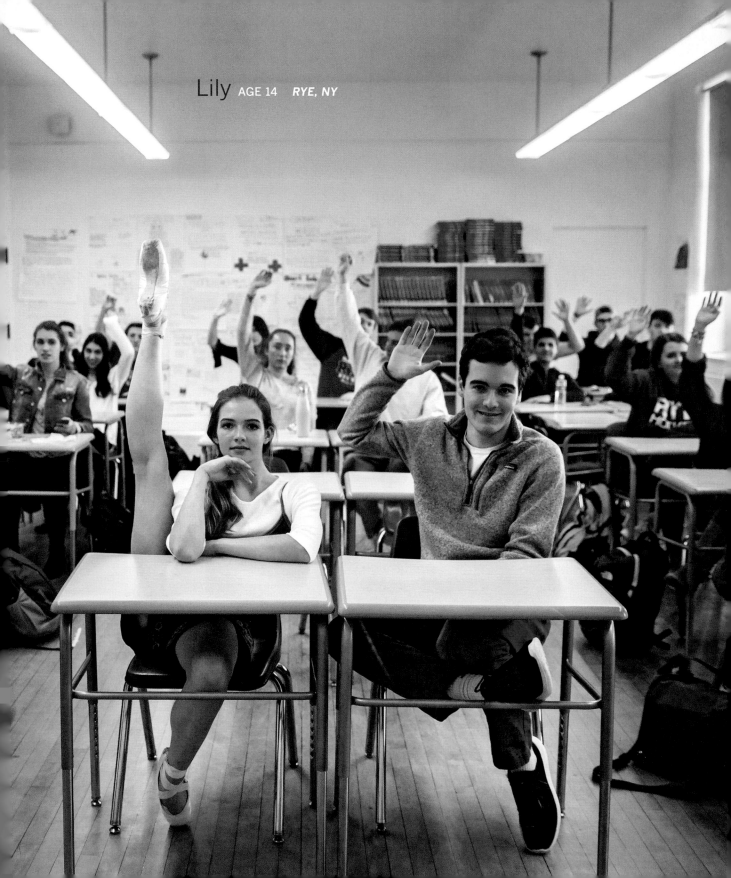

Lily AGE 14 RYE, NY

Ryan AGE 14

Reina AGE 13 PHOENIX, AZ

"The best feeling is when you look at him and catch him staring. Then he quickly looks away."

Reina AGE 13

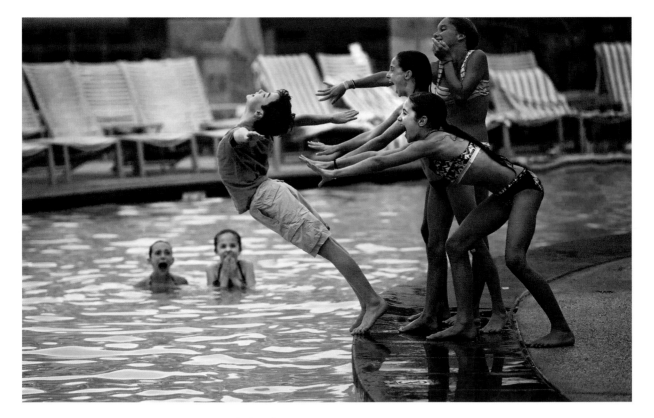

Misha AGE 12 *PHOENIX, AZ*

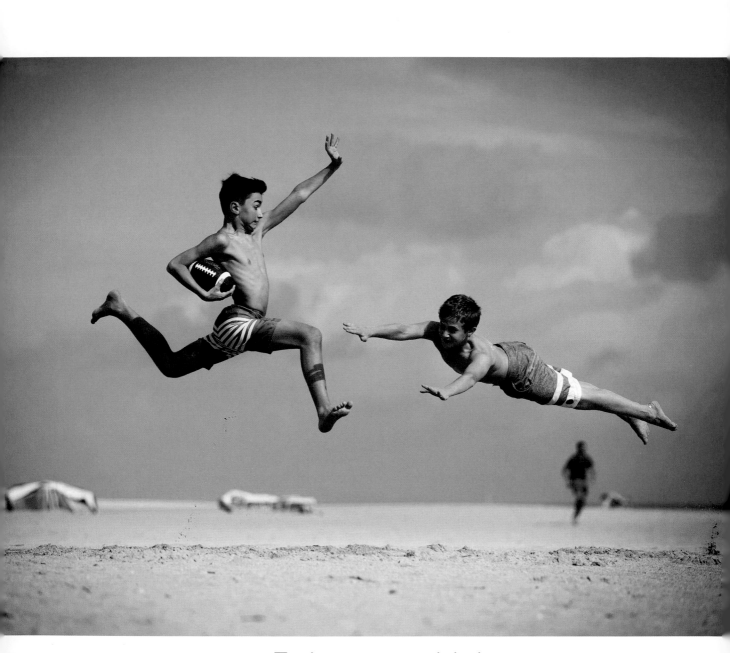

Tucker AGE 12 Jakob AGE 13 *FT. LAUDERDALE, FL*

Elizabeth, Neve, Celeste, Elizabeth AGES 12 TO 26 *SAN FRANCISCO, CA*

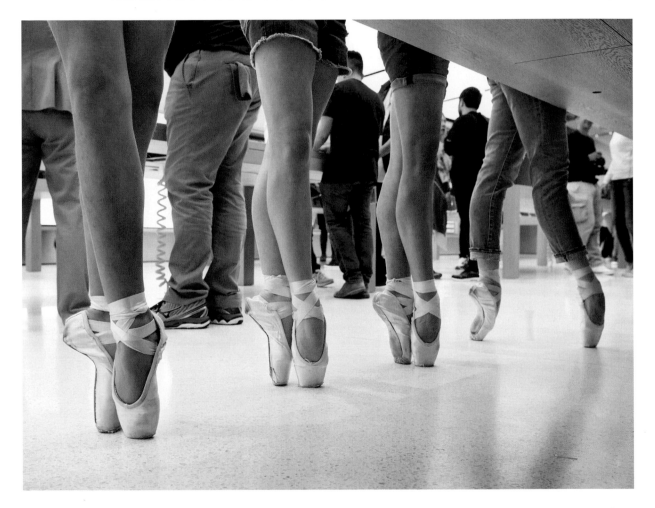

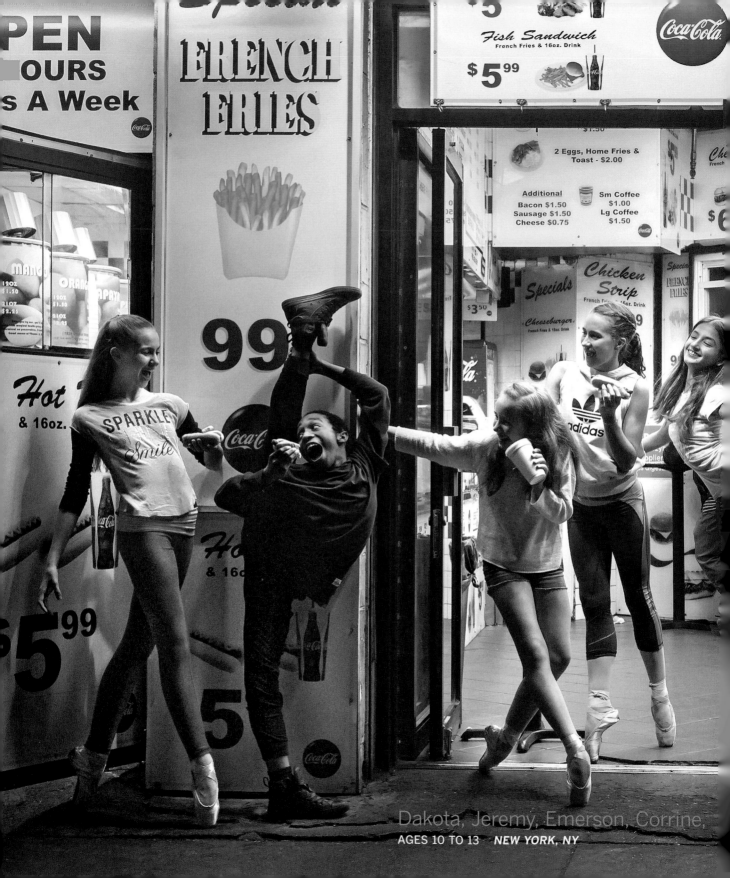

Dakota, Jeremy, Emerson, Corrine,
AGES 10 TO 13 NEW YORK, NY

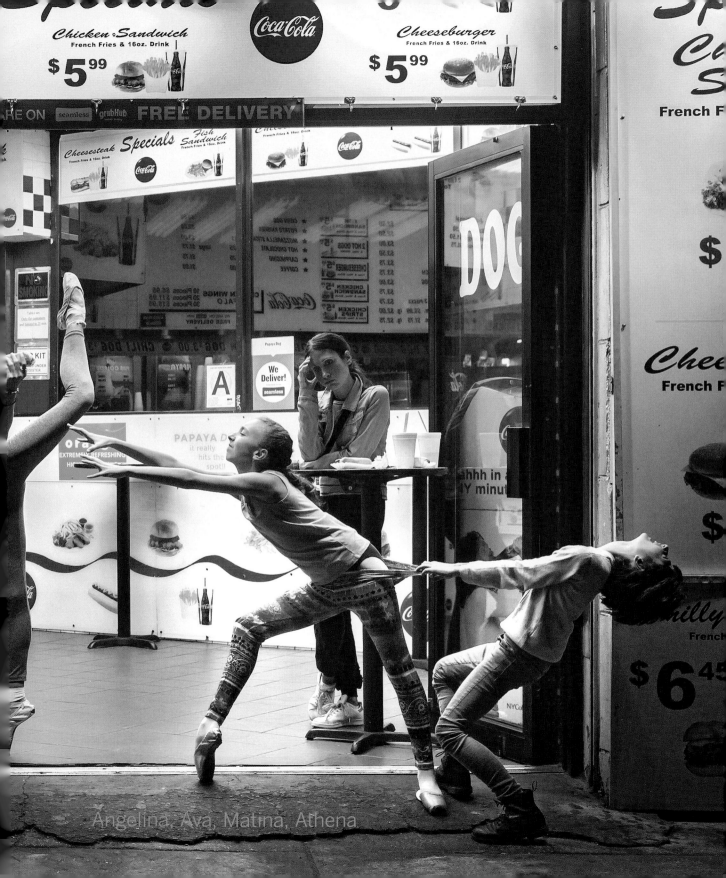

> **"Sometimes you will never know the value of a moment until it becomes memory."**
>
> ··
>
> Unknown

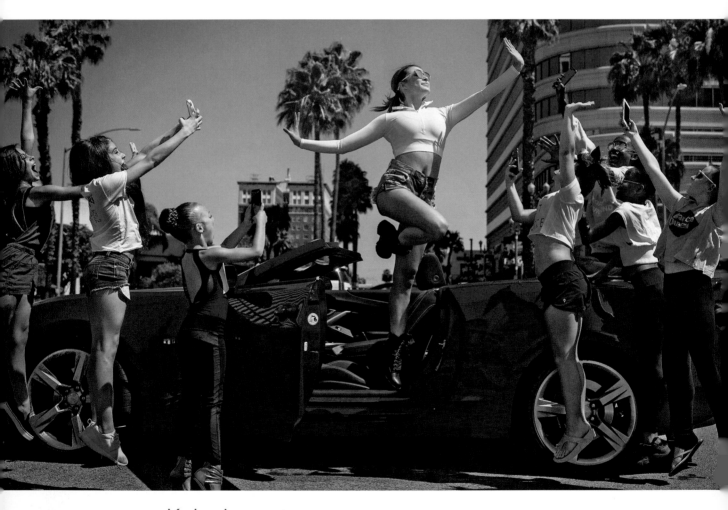

Kalani AGE 16 *LONG BEACH, CA*

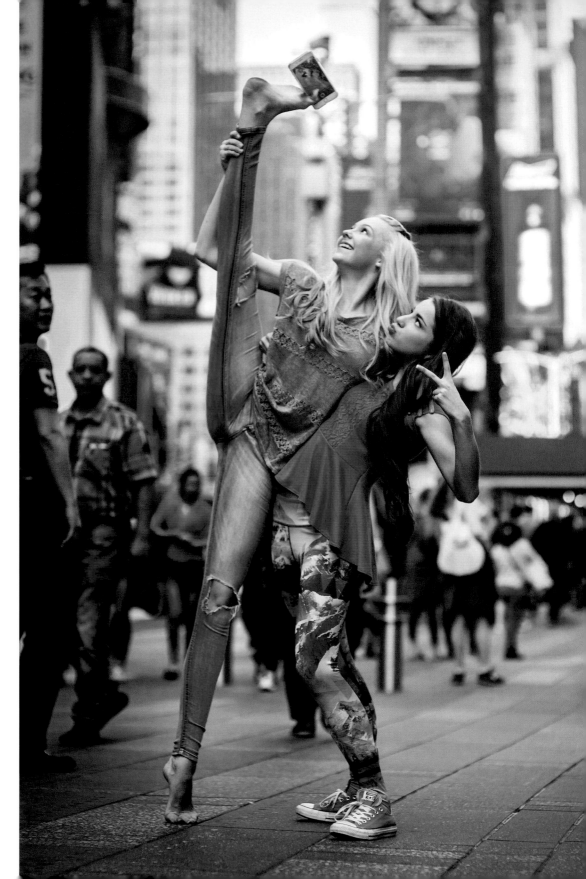

Rylee
AGE 15

Sophia
AGE 15

NEW YORK, NY

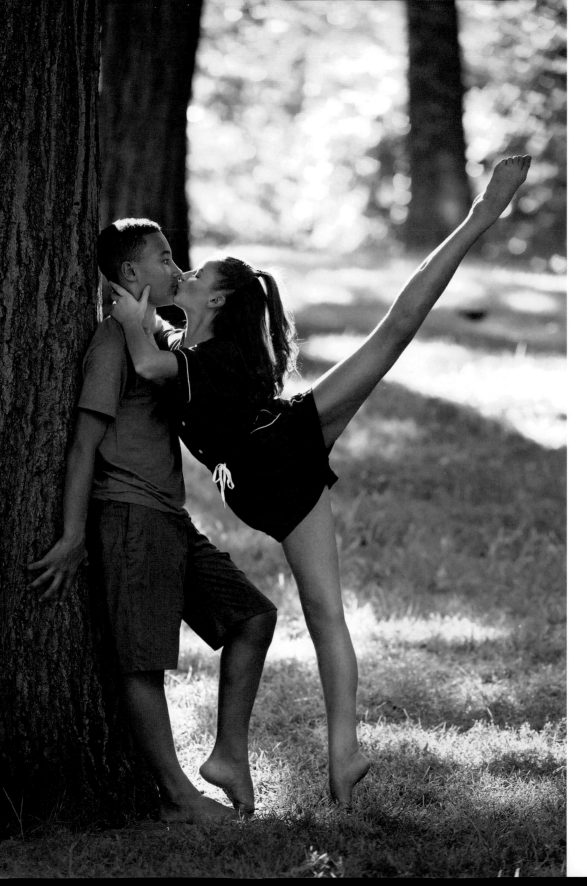

Mason
AGE 13

Gabby
AGE 13

NEW YORK, NY

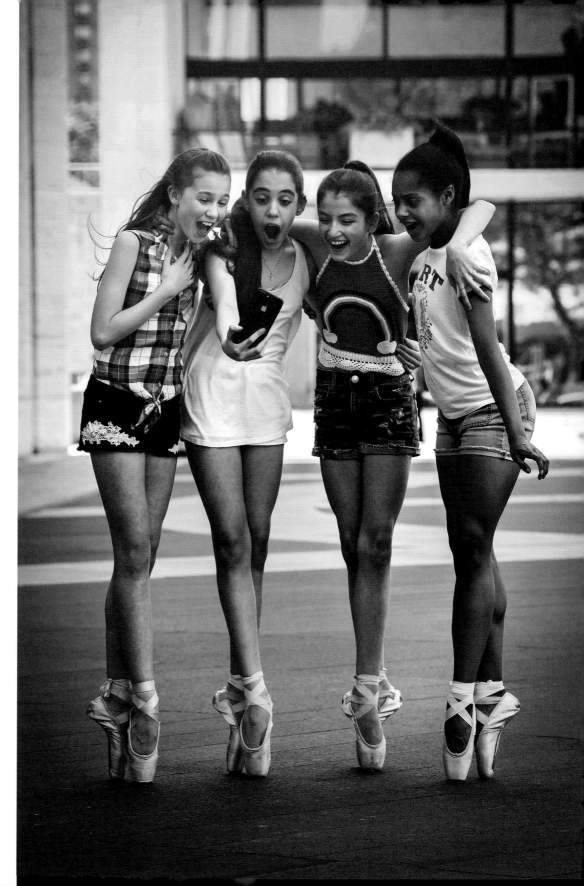

Dakota
AGE 12

Maria
AGE 13

Angelina
AGE 12

Ashlee-
Paige
AGE 13

NEW YORK, NY

"The world would be a pretty boring place if we were all made from the same mold. I'm almost six feet tall. I spent so many years trying to slouch in dance class and in pictures with my friends. I felt like a freak. I've finally learned to love myself just the way I am. If people judge you on the way you look, then they aren't worth your time anyway. It's what's on the inside that counts. Plus, I want to be a role model for others, so being tall ensures that people look up to me!"

Kaeli AGE 16 *NEW YORK, NY*

Check out the video!

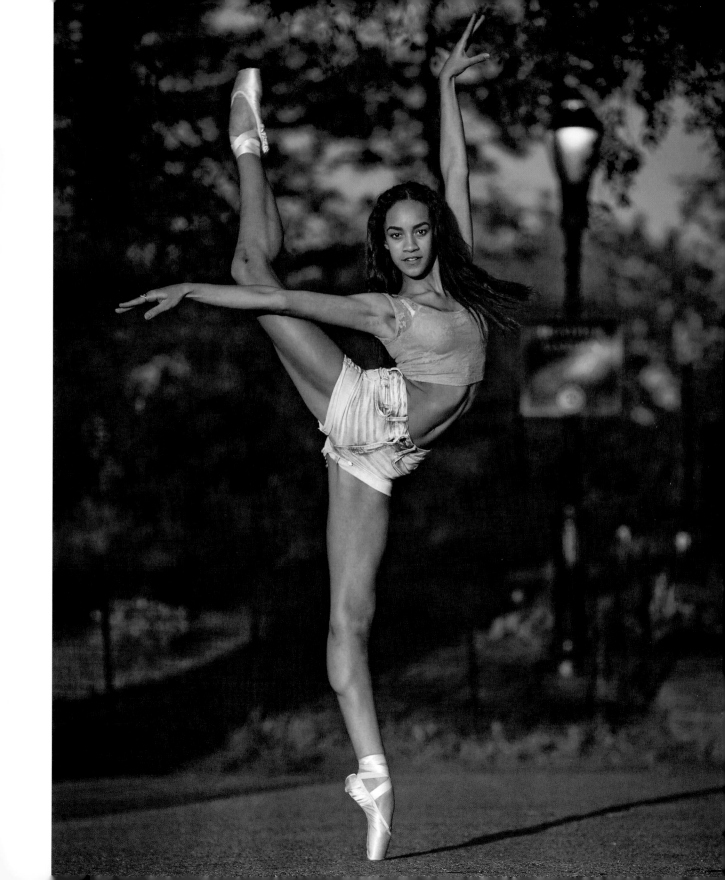

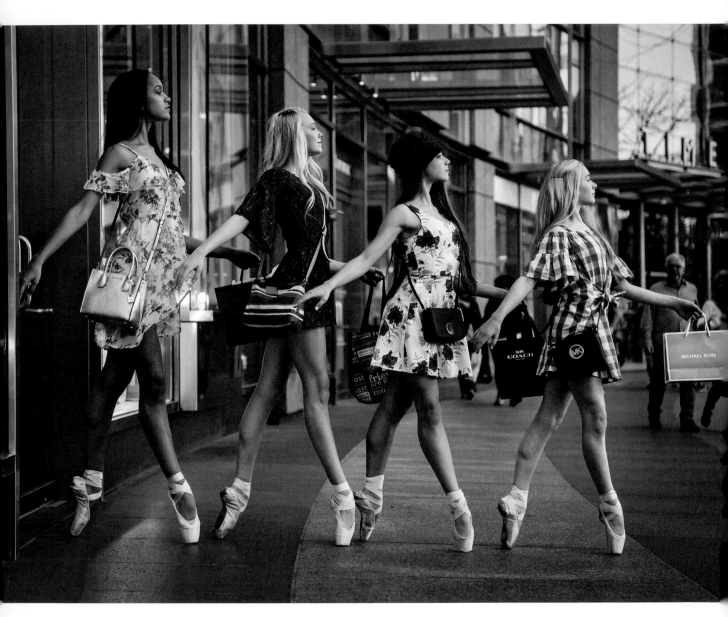

Kaeli, Rylee, Sophia, Brooke AGES 13 TO 16 *NEW YORK, NY*

Brynn, Kendall, Nia AGES 13 TO 15 *SANTA MONICA, CA*

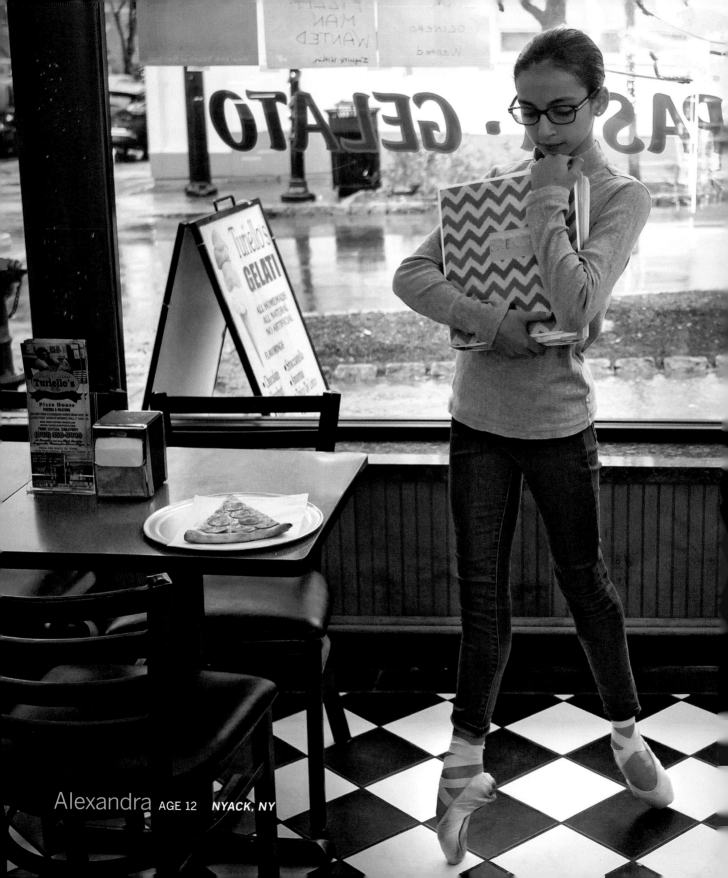

Alexandra AGE 12 NYACK, NY

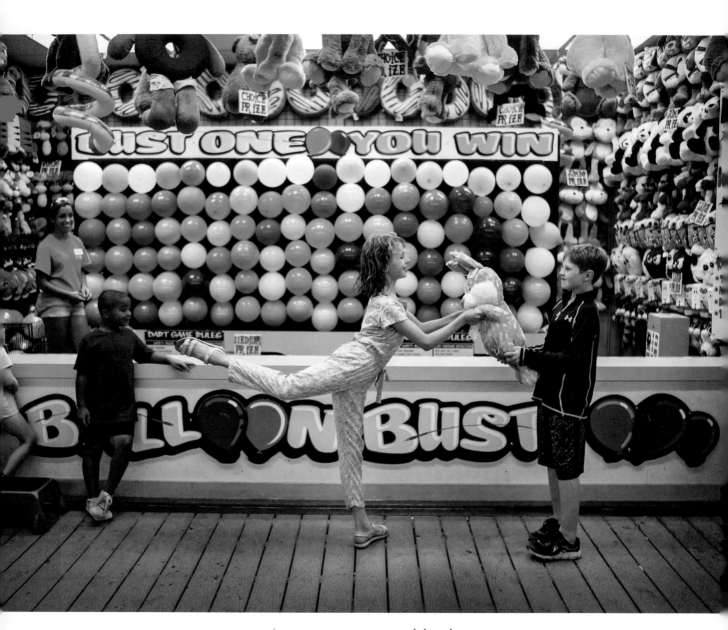

Luna AGE 10 Hudson AGE 10 *POINT PLEASANT, NJ*

Misha AGE 12 Ava AGE 12 *PHOENIX, AZ*

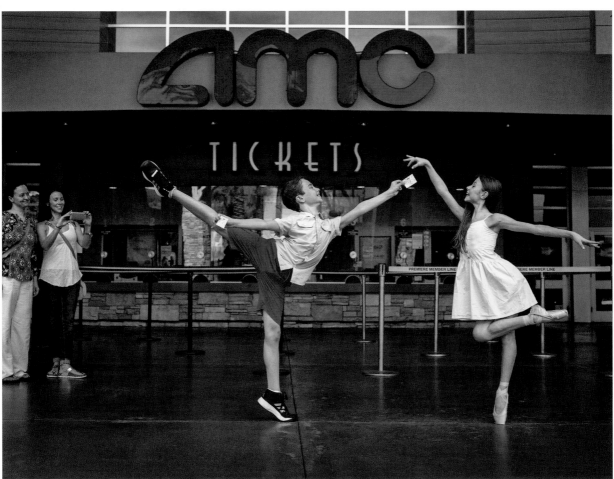

FITTING ROOMS

Amanda
AGE 16
LONG BEACH, CA

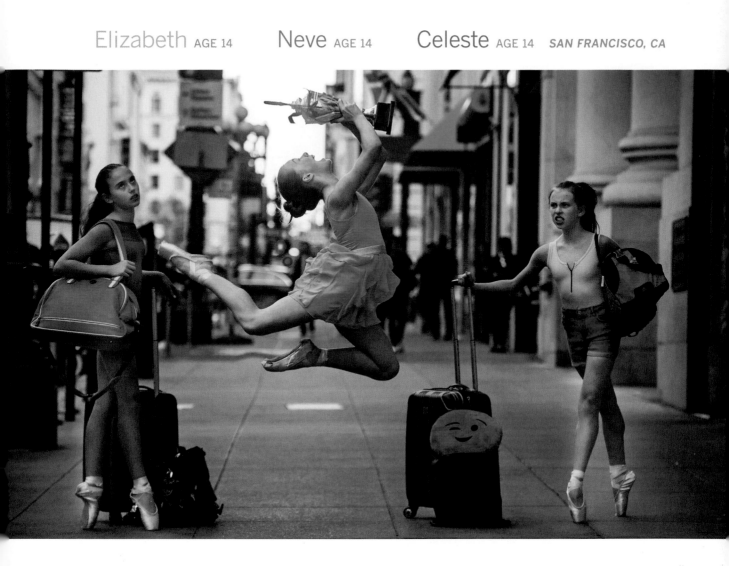

"Why fit in when you were born to stand out? People change who they are to fit into society's standards and to feel loved and accepted. But me—I'd rather be hated for who I am than loved for who I'm not."

Amanda AGE 16

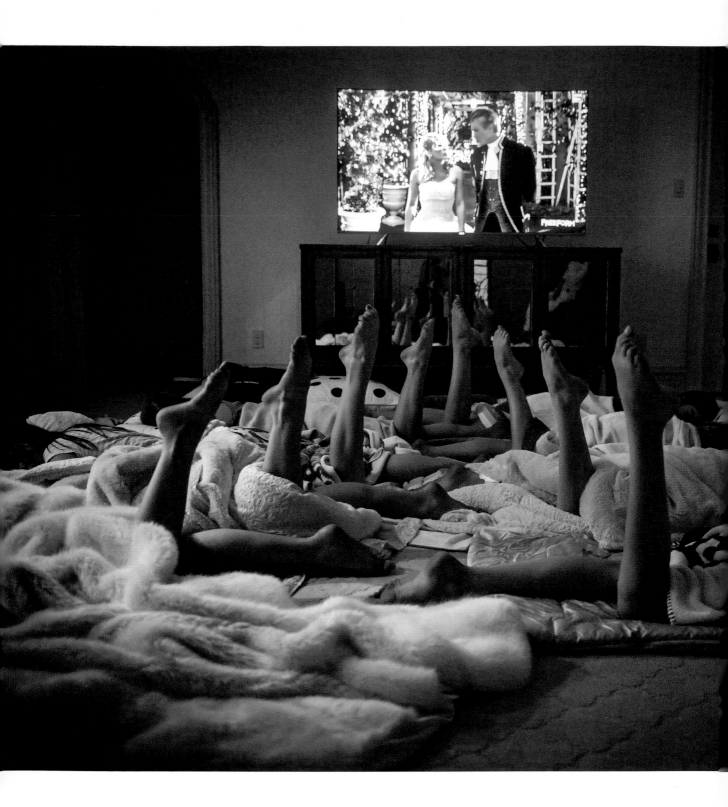

"do they like me?"

Aimee, Celle, Sarah, Kendall, Sydney, Peyton, Sophie, Shelby
AGES 12 TO 15 *THE WOODLANDS, TX*

"At the end of the day, all friendships are different. It doesn't matter if you always like one another, it just matters that you are lifting each other up and never pushing each other down. To do that, you must accept one another completely. You are not just a friend, you are their greatest fan, their inspiration, and their partner!"

Sarah AGE 14

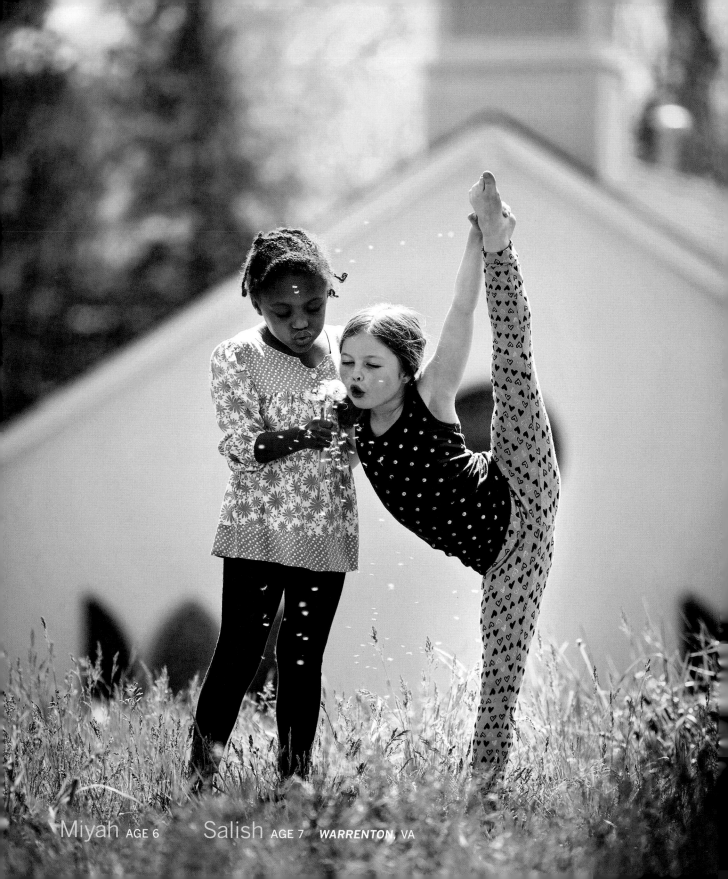

Miyah AGE 6 Salish AGE 7 WARRENTON, VA

"i love you"

One afternoon shortly before giving birth to our first child, my wife remarked, "I hope we love our son as much as we love our dog." I thought about that for a moment and said, "I don't think that's possible." The absurdity of that exchange is perfectly clear now, but in the moment we were genuinely concerned. How could our hearts possibly open wider to allow for more love?

Each new stage of love is a surprise. The fundamental need I had for my parents' love was wholly different from the enchantment of a new kitten, the comfort of a best friend, or the infatuation of a first crush. Each feeling was unique. When I met my wife,

those diverse forms of affection all joined together into one big LOVE, never to be equaled—until my son was born, and he redefined everything. A few years later, my daughter came along and rocked my world again. At every turn, my heart expanded a little more, and I was shocked to discover how much space I have in there.

Sharing your heart with others is a true gift, but let's not forget one more very important person to love—yourself! Loving oneself is as important as loving anyone else. Childhood is usually brimming with self-love. Young kids are proud of what they do, and who they are, and declare themselves awesome at everything. Then adolescence comes along and tries to annihilate that self-love. Suddenly you value the opinions of others more than your own. Fight that temptation! You are a unique person. That makes you crucial to the whole picture of the world. When you change yourself to fit in with others, you're limiting your potential and unbalancing the beautiful picture of individuality. So don't hide your individuality, embrace it! Start learning to love yourself again and I promise your heart will expand a bit more to let you in.

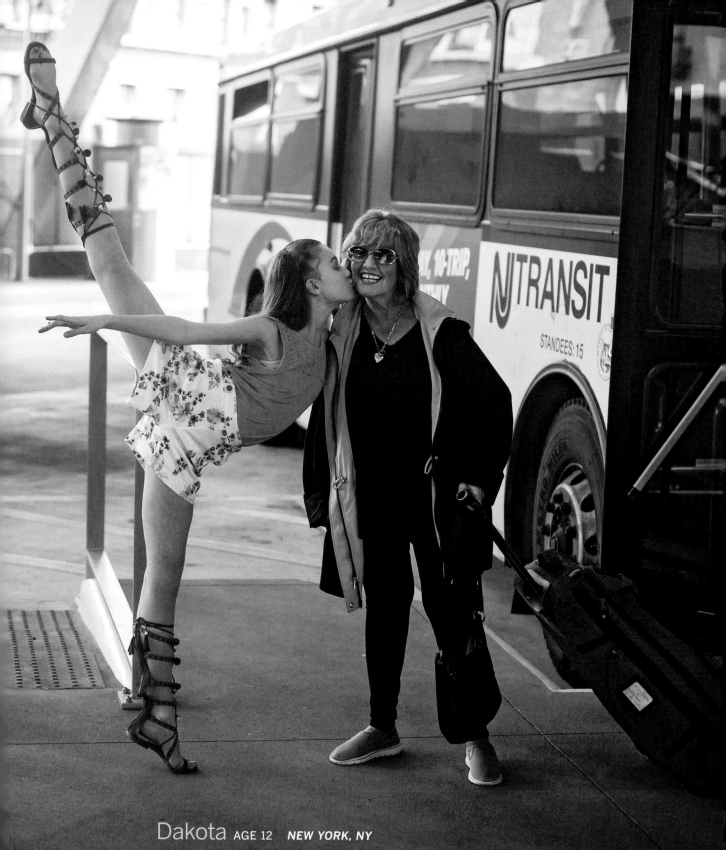

Dakota AGE 12 NEW YORK, NY

"I was diagnosed with stage-3 germ-cell cancer when I was eleven years old. I was dancing every single day throughout my treatment, even telling the nurses I had to get out early so I could go to class. I wasn't hearing no for an answer—I had to go. The doctors still say today that dancing saved my life."

...

Stephanie AGE 13

Check out the video!

Stephanie AGE 13

Amelia AGE 6

NEW HYDE PARK, NY

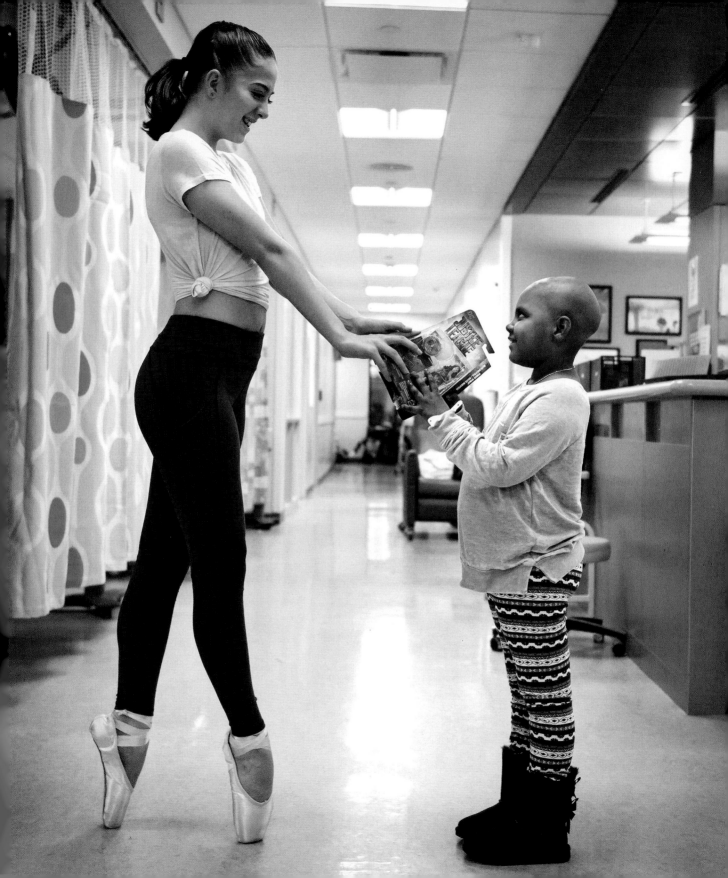

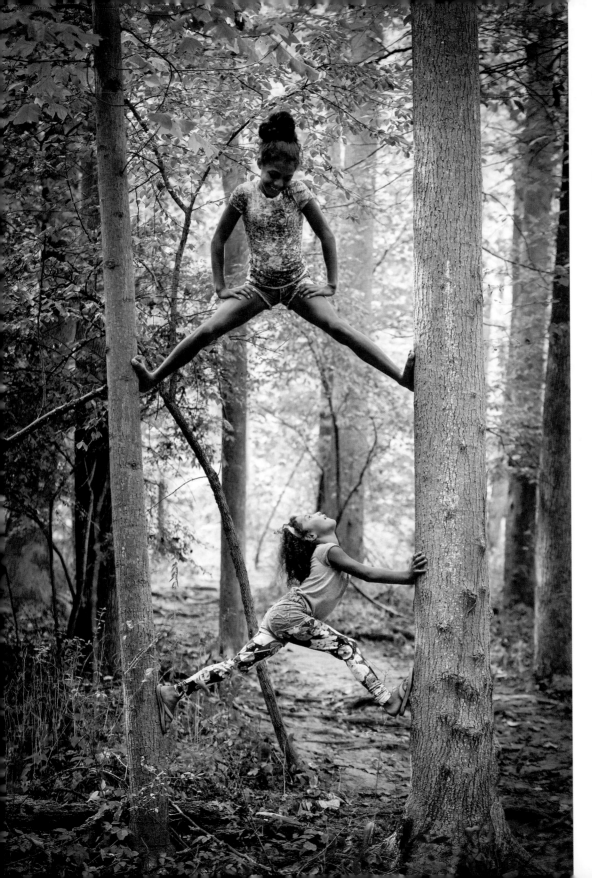

Annalise
AGE 10

Lirit
AGE 8

NYACK, NY

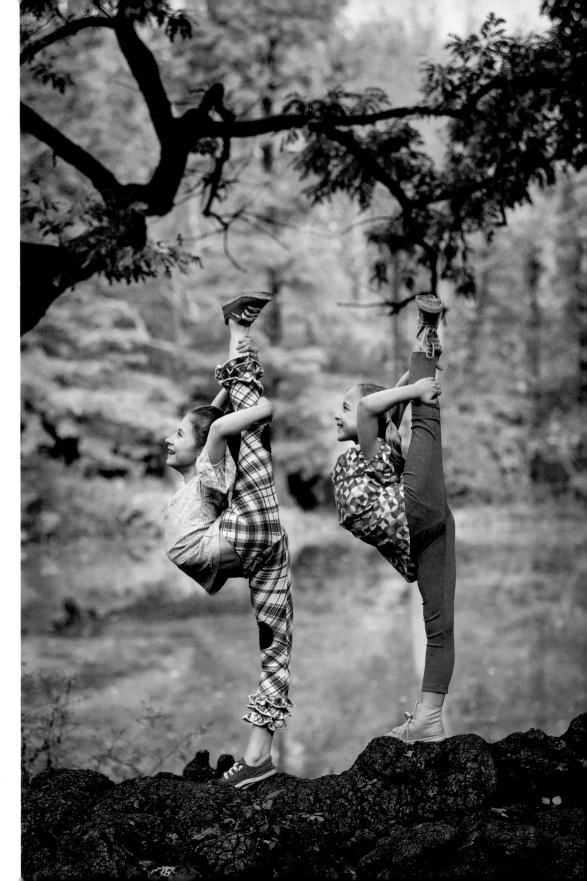

Elliana
AGE 10

Lilliana
AGE 9

NEW YORK, NY

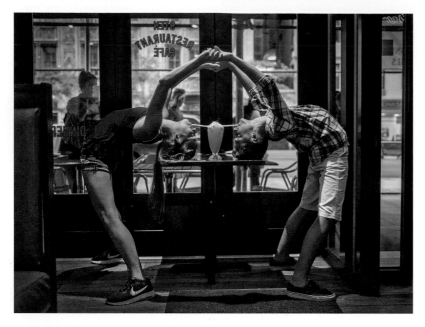

Alexi AGE 13 Tucker AGE 12 *NEW YORK, NY*

"I feel very lucky to have
grown up in a time when
society is more accepting of
who I am and who I love."

Jack AGE 16

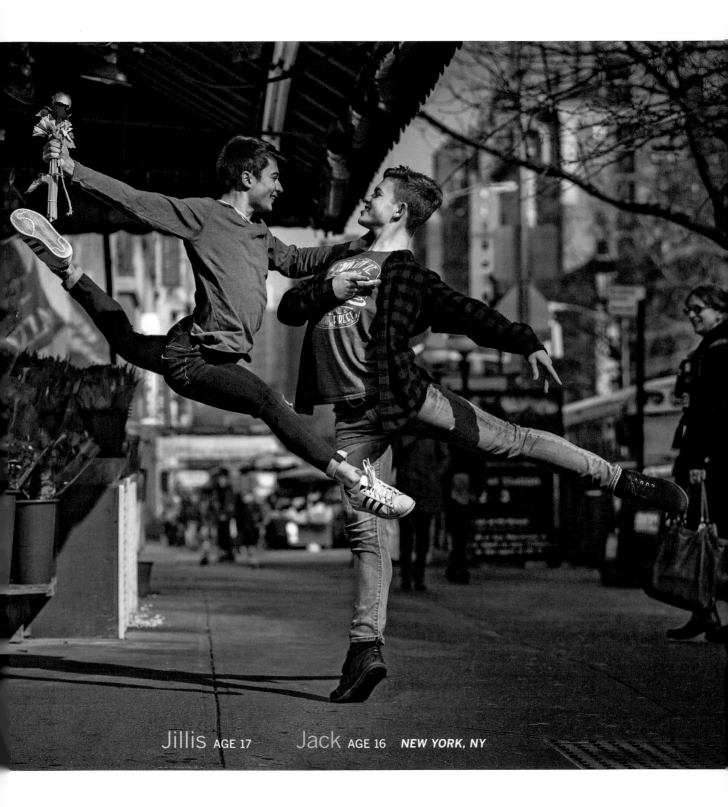

Jillis AGE 17 Jack AGE 16 NEW YORK, NY

"People say that love can be scary . . . But I'm really excited to find out for myself."

Mason AGE 12

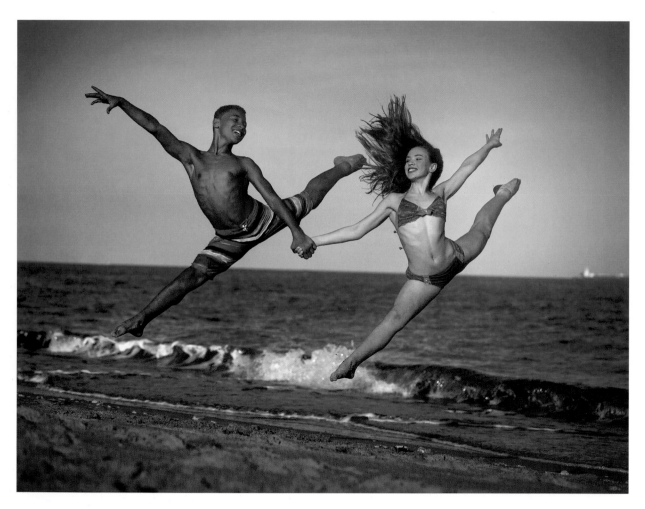

Mason AGE 12 Jade AGE 12 *FT. LAUDERDALE, FL*

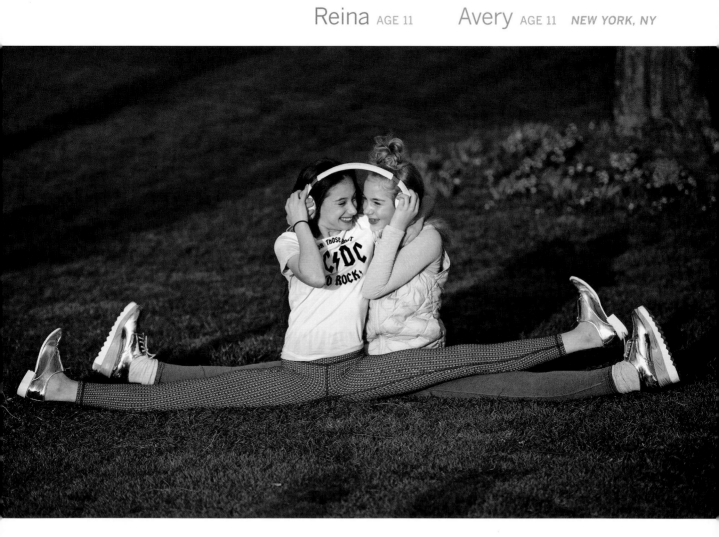

"How can we love our country and not our countrymen?"

Ronald Reagan

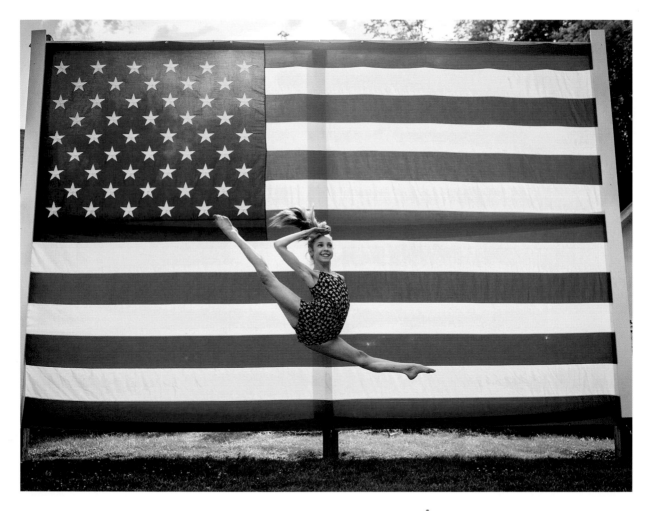

Anna AGE 15 *PIERMONT, NY*

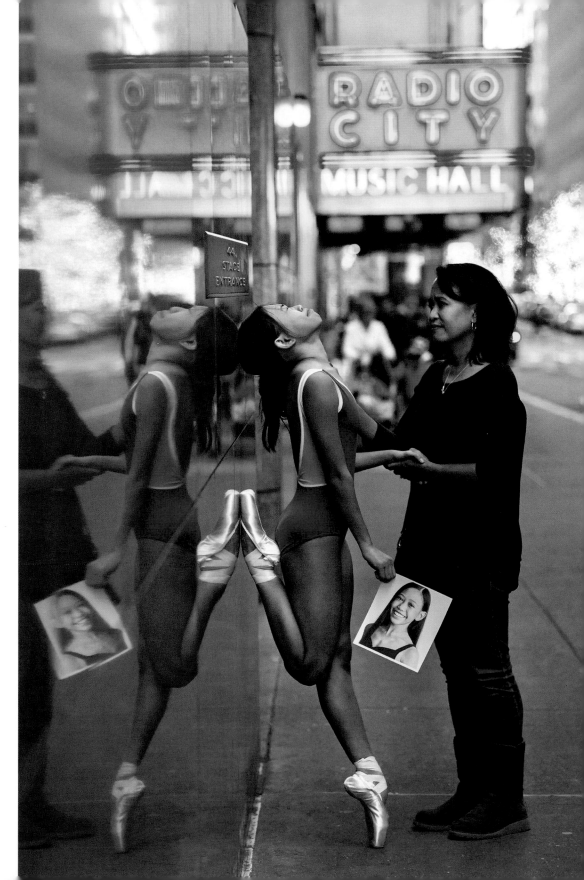

Makena
AGE 15
NEW YORK, NY

Avery AGE 16 PHOENIX, AZ

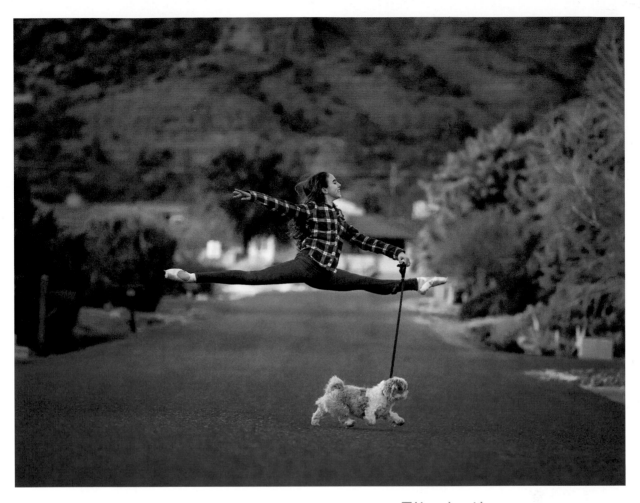

Elizabeth AGE 16 *SEDONA, AZ*

**"Distance doesn't separate
people. Silence does."**

Jeff Hood

Dakota AGE 12 *NEW YORK, NY*

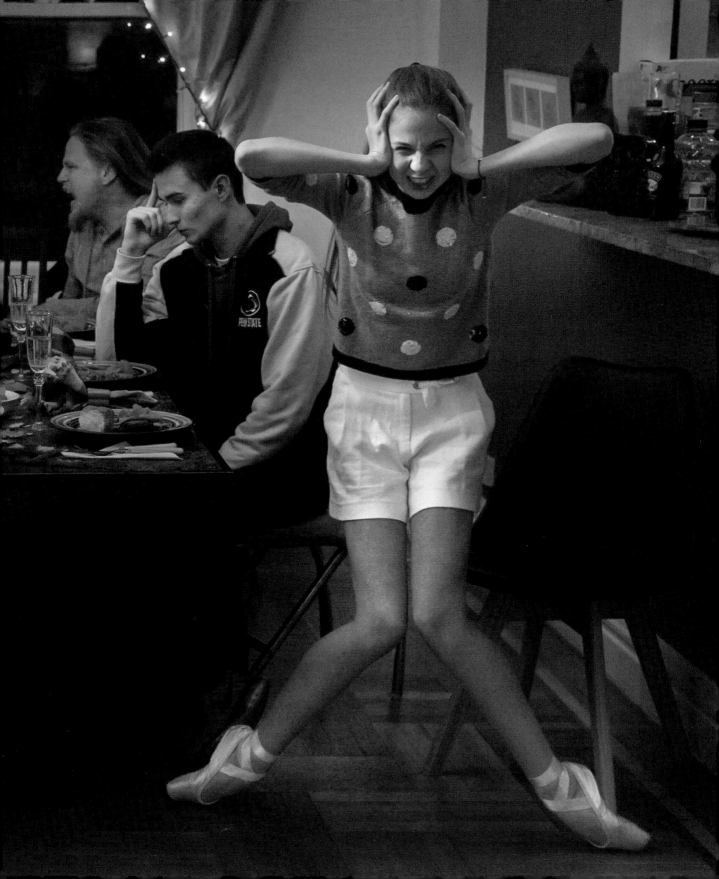

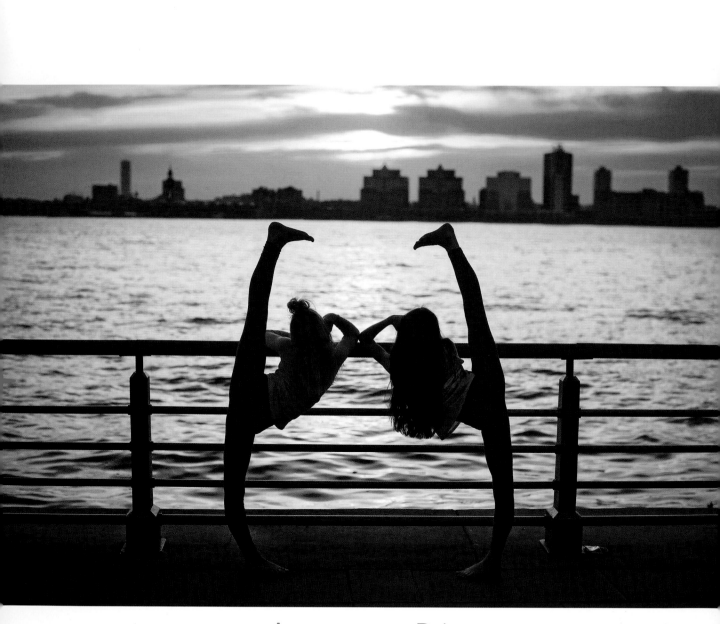

Avery AGE 11 Reina AGE 11 *NEW YORK, NY*

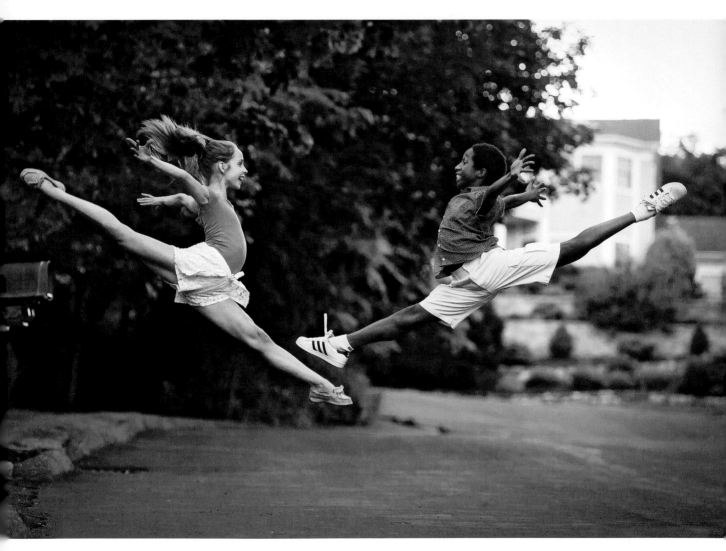

Anna AGE 15 Jeremy AGE 13 *NYACK, NY*

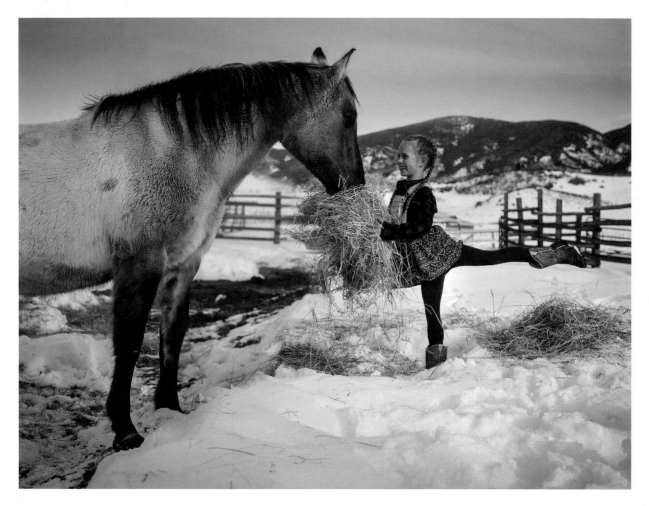

"My sister died of leukemia when she was four. Dance helped me through some very hard times, and I hope my dancing can help kids through similar struggles."

Hanna AGE 10 NEW YORK, NY

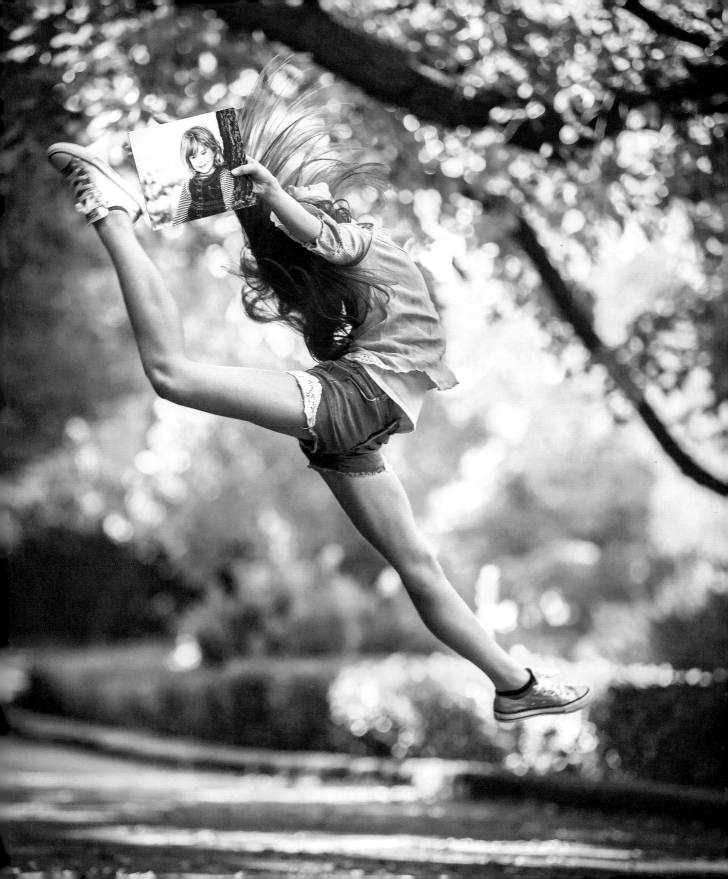

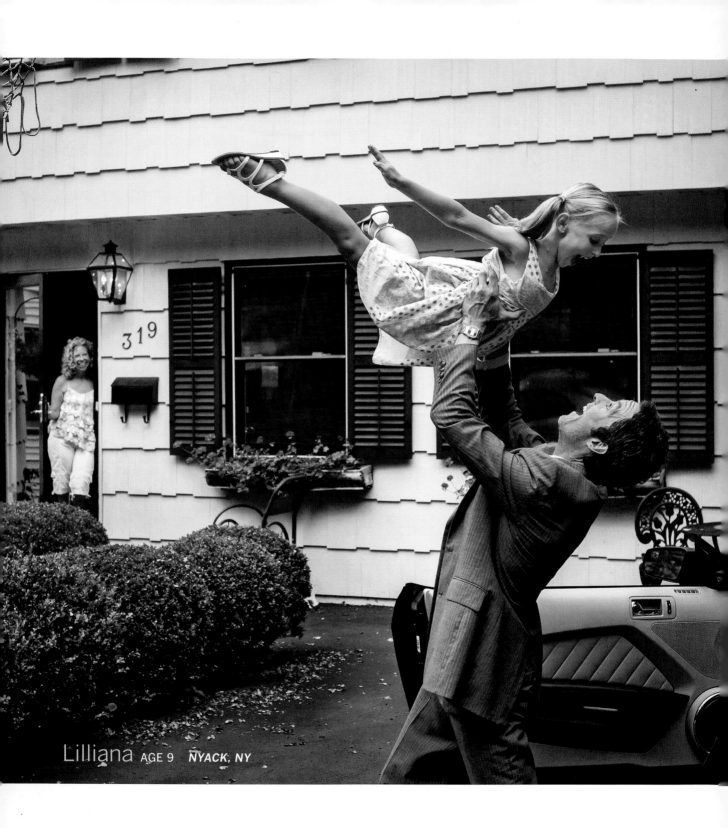

Lilliana AGE 9 NYACK, NY

Liv AGE 14 *MELBOURNE, AUSTRALIA*

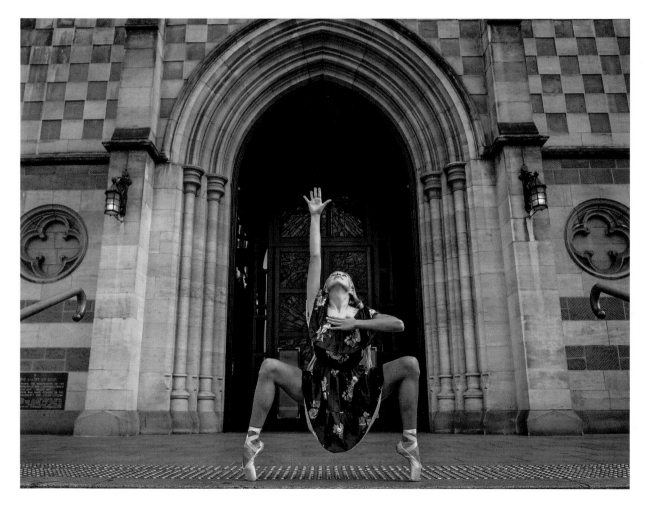

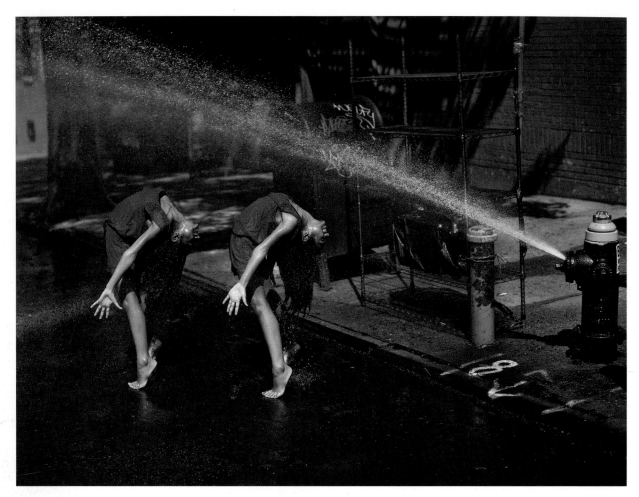

"**Those who follow the crowd usually get lost in it.**"

Rick Warren

Check out the video!

Sophie
AGE 14
MELBOURNE, AUSTRALIA

"I must really love my brother because I wouldn't share my burger with anyone else."

Sofie AGE 16

Check out the video!

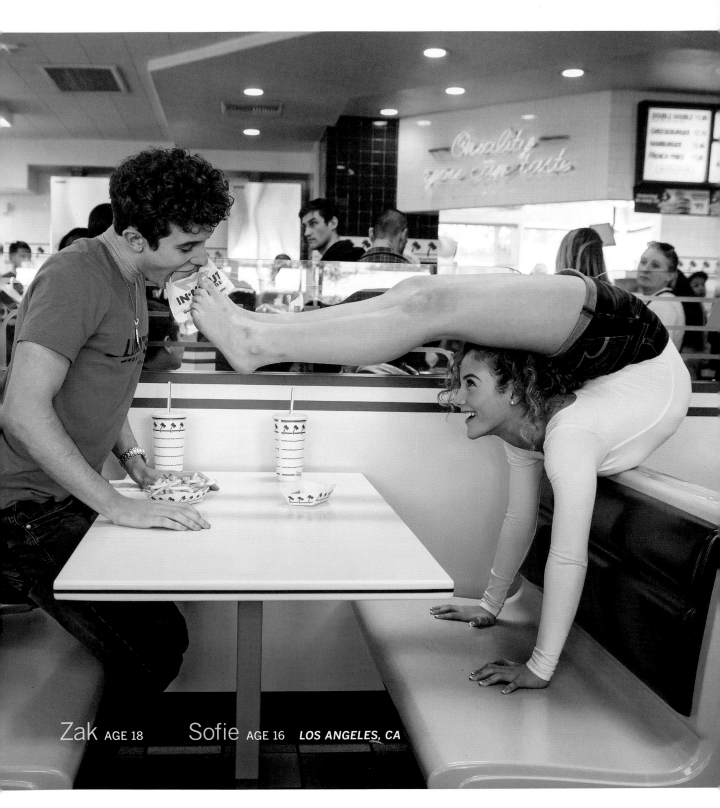

Zak AGE 18 Sofie AGE 16 *LOS ANGELES, CA*

"When I dance I know my dad is watching from Heaven, which is why I will NEVER STOP DANCING."

Janai AGE 11 *FARMINGDALE, NY*

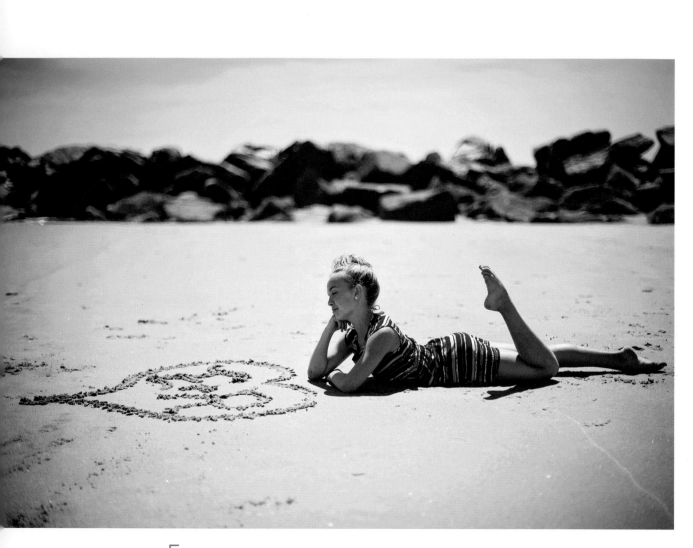

Emma AGE 11 *SANTA MONICA, CA*

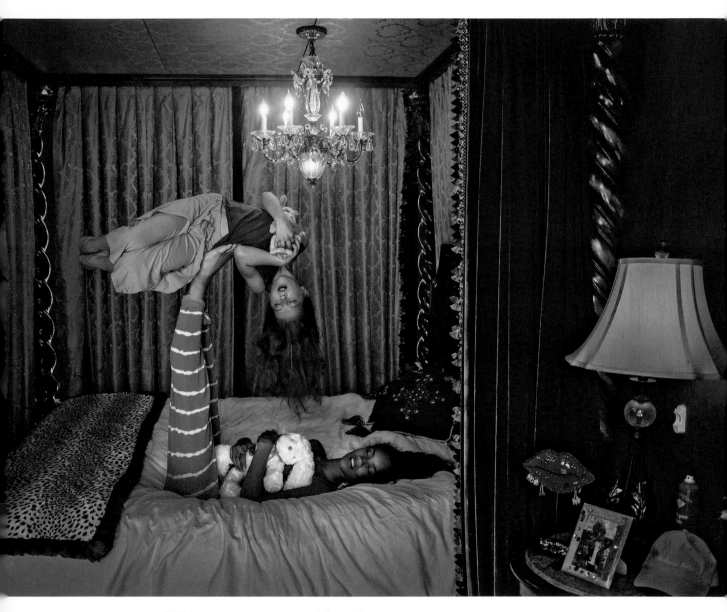

Elliana AGE 9 Kaeli AGE 15 *MALIBU, CA*

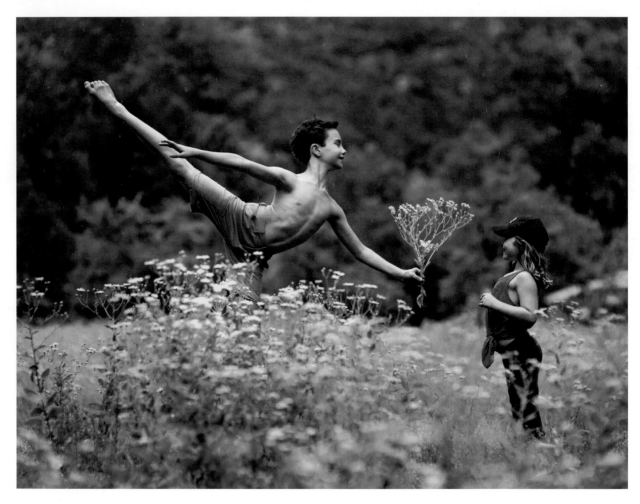

Misha AGE 11 Salish AGE 6 *SEDONA, AZ*

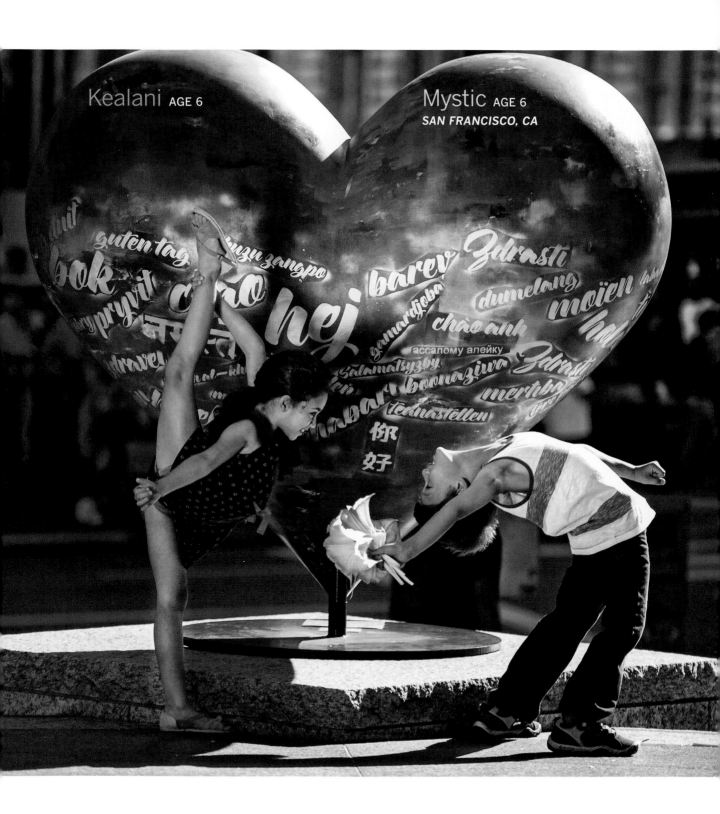

Kealani AGE 6

Mystic AGE 6
SAN FRANCISCO, CA

"thanks, mom and dad"

Let's think of a typical young dancer's schedule: Up early, go to school, quick bite, then straight to the studio for several hours of training and rehearsal, quick dinner, homework, pass out, repeat tomorrow. While most kids get weekends off, dancers take to the road for competitions. It is an exhausting lifestyle, but they're kids, right? They're young, so they have tons of energy. You know who isn't young with tons of energy? *The parents!* You know who never gets a week, a day or even an hour off? *The parents!* You know who logs more miles and travel time than most pilots? *The parents!* When a child loses a competition, who is there to hug them? When a kid struggles with their homework, who drops everything to help them? When it's impossible to get out of bed in the morning, who is their alarm clock? You guessed it—THE PARENTS!

Remember, kids: Your parents once had full, active lives with their own interests and ambitions. They willingly put much of that aside once you were born. Speaking as a dad, I can honestly say that the rewards outweigh the challenges, but that doesn't make it easy. Many parents have one full-time job at work and then another one at home, and sometimes there is not a spouse to help with the responsibilities. Look at photos of your parents before you were born, then look at them today. I'll bet you'll see a little gray hair now, maybe a few more wrinkles and a couple of extra pounds. They have sacrificed without complaint, because being a parent is an incredible adventure. But it is frigging EXHAUSTING, both mentally and physically!

So kids, put this book down. Right now! Give your parents a big hug and thank them for everything they do for you. It will mean the world to them.

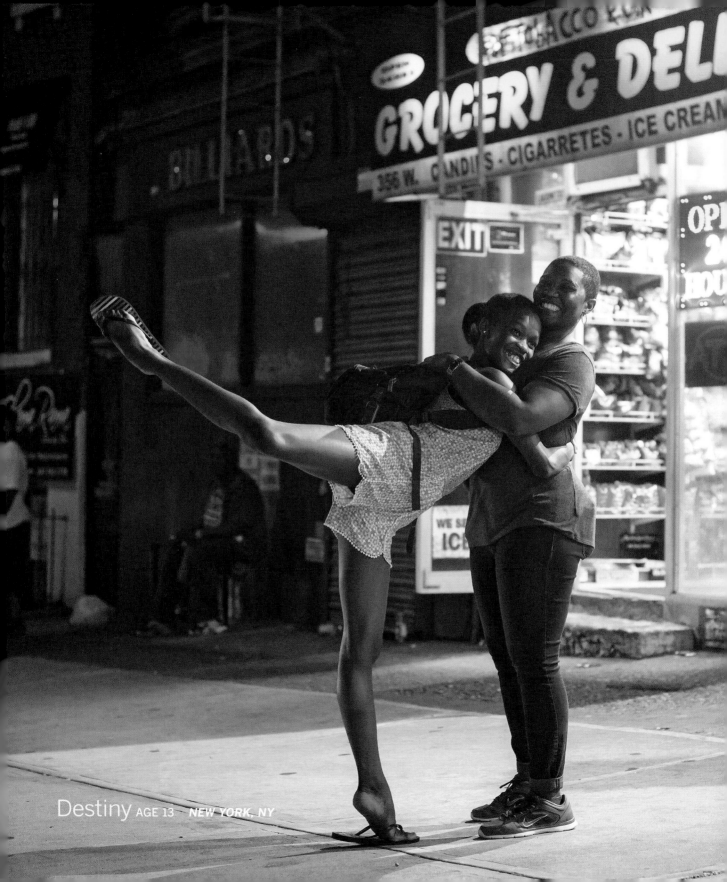

Destiny AGE 13 NEW YORK, NY

acknowledgments

When I conceived of *Born to Dance*, I had photographed very few young dancers. I assumed I would have to get the shots quickly before they got bored, or that I would need an iPad to keep them entertained between takes. Boy, was I mistaken. From ages two to eighteen, these kids are among the most focused, hardworking, dynamic people I know. They have inspired me as an artist and as a parent. I can't even begin to thank them for the huge impact they have made on my life.

Thousands of young dancers have posed for me over the years, and most of them are not featured on these pages. I have struggled with that reality; the majority of kids I've photographed may feel disappointment when they open this book. The most difficult part of this process was editing out photos. I hated every minute of it, and yet it was a necessity. Though only a small percentage of kids were selected, it has nothing to do with skill. There are just too few pages to fit all the talent.

As a fledgling photographer in Brooklyn, I found my first muse in Mrs. M. She was an elderly neighbor who lived directly above my apartment. Her face was a map of her extraordinary life, and it was likely responsible for my initial obsession with photography.

She had many words of wisdom, but one thing she said particularly stuck with me: "Whenever you're doing something, you're not doing something else." She did not tolerate wasted time. I have tried to follow her lead and fill my days with productive and inspired choices. Many years too late, I thank Mrs. M. for lighting my initial spark and guiding me toward a rewarding career.

If I had endless pages to fill in this book, I would do two things: 1) include every kid's photo, and 2) thank each person who has made a significant impact on my life. But instead, I have only a few more words left on this page, so I will simply express my gratitude to some of the many important people who helped make this book a reality: Lauren, Hudson, Salish, Mary Ellen, Galen, Suzie, Barney, Honor, Laura, Heather, Shana, Chris, Sandy, Grace the Intern, Tabby the Intern, Juliet, Yolanda, Ellie, Dakota, Glo, Stacy, Michael, Megan, Elliot, Julianne, Kristen, Sarah, Holly, Nia, Dwana, Ella, Zara, Amanda, Zork, LV, Lesley, DanceWorks London, Skylum, Capezio, Nikon, YouTube, *Dance Moms*, *Bring It!*, and Workman Publishing.

To everyone else,

THANK YOU!

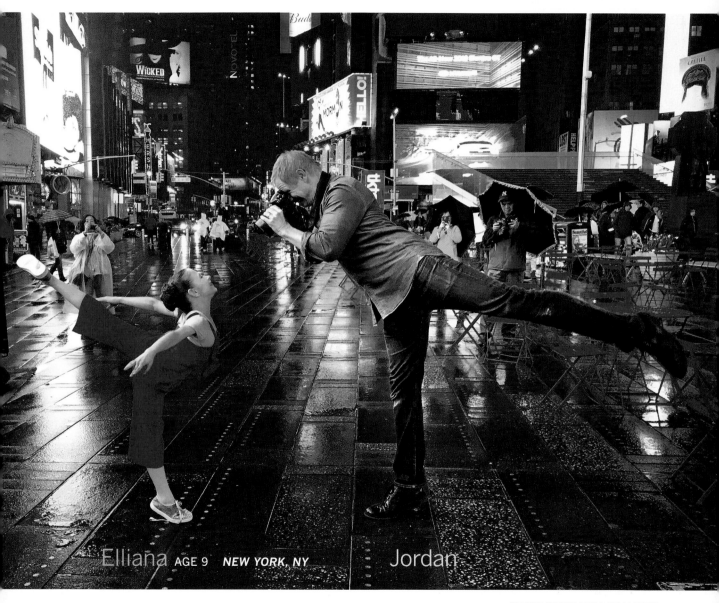

Elliana AGE 9 *NEW YORK, NY* Jordan

PHOTO BY YOLANDA WALMSLEY

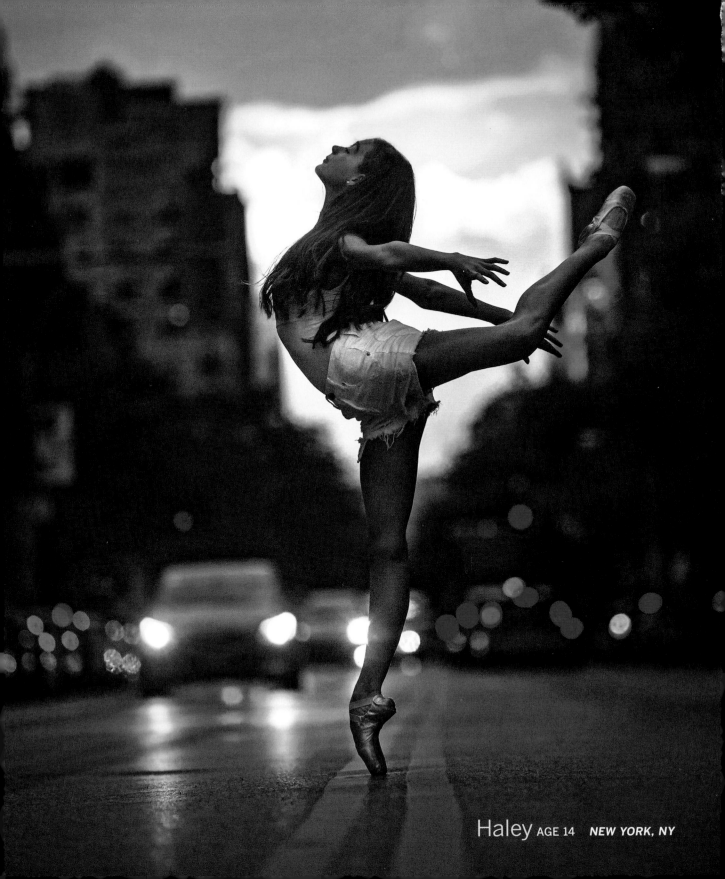

Haley AGE 14 NEW YORK, NY

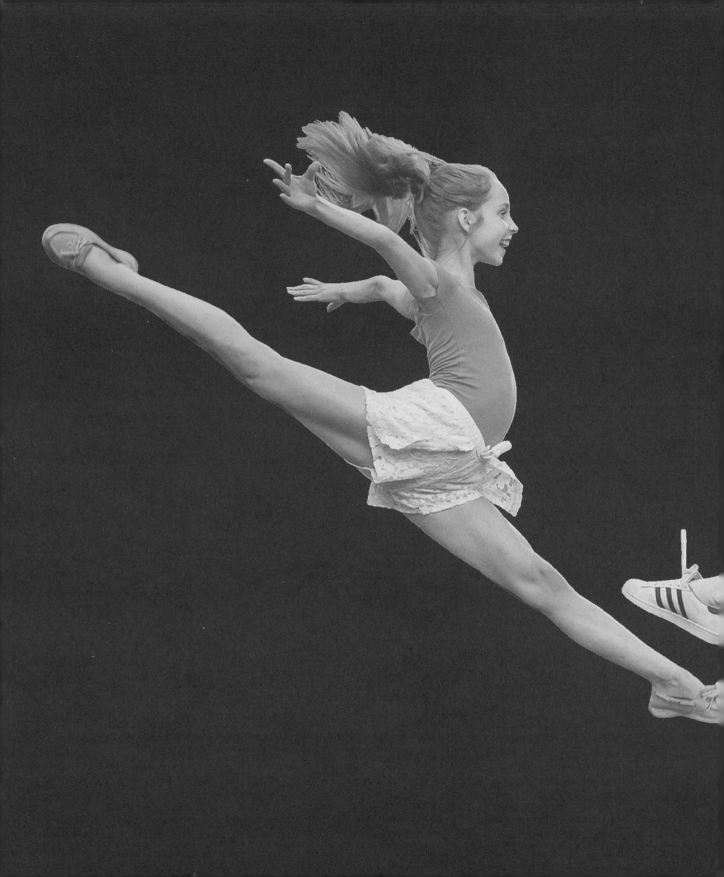